To Robin and Frank,
whose friendship I treasure,

Virginia Adair

Eighteenth Century Pastel Portraits

Eighteenth Century Pastel Portraits

Virginia and Lee Adair

JOHN GIFFORD LTD.
LONDON
1971

© Virginia Adair 1971

First published in Great Britain 1971
by John Gifford Ltd.
125 Charing Cross Road
London WC2

SBN 70710033-X

Printed in Great Britain

For
Dick, Cameron
and Dixon

Contents

ACKNOWLEDGEMENT

We wish to express our gratitude to the following museums for allowing us to reproduce pastels from their collections:

Accademia Museum, Venice
Bayerisches National Museum, Munich
Beaux-Arts Museum, Bordeaux
Ca' Rezzonico Museum, Venice
Estense Gallery, Modena
Kunsthistorisches Museum, Vienna
Lécuyer Museum, Saint-Quentin
Louvre Museum, Paris
Museum of Art and History, Geneva
Museum of Dieppe, Dieppe
Museum of Dijon, Dijon
National Gallery of Ireland, Dublin
National Gallery, London
Ostia House, London
Rijksmuseum, Amsterdam
Royal Hunting Palace of Stupinigi, Turin
Royal National Hospital, Bath
Royal Pavilion, Brighton
Sabaudia Gallery, Turin
Schönbrunn Palace, Vienna
Tate Gallery, London
Uffizi Palace, Florence
Versailles Palace, Versailles
Victoria and Albert Museum, London
Victoria Art Gallery, Bath
Zwinger Museum, Dresden

Foreword

Shortly after my forty-ninth birthday, I visited a certain Madam G –, a spiritualist, who flatly told me I had nothing new to say to the world! I received this flotsom of intelligence from the 'other side' almost with relief. It was as though some vague burden had suddenly dropped from my shoulders, leaving me free simply to write about a subject which has always interested me – eighteenth century pastel portraits – without fear of inciting intellectual revolutions or even stimulating an awkward amount of controversy. It is a most comfortable feeling.

The trouble with authorities is they tend to tell the reader more about a given subject than he cares to assimilate, and often end by leaving him in a state of total pedantic exhaustion. At the onset, let me reassure you that this book in no way pretends to be authoritative, definitive, or that most presumptuous of descriptions – comprehensive. It will try only to remind you, through the reproductions included, of the charm and delight of the medium of pastel – a medium so little used today, but which once knew dizzying heights of glory in eighteenth century portraiture. We shall select only a few of its greatest masters, take a quick look into their varied lives, and learn what we can of those elegant gentlefolk who sat for them.

Finally, in justification of this diletante effort, let me add that portraits in pastel, as in no other medium, seem always destined to evoke but one particular moment in time – giving them the piquant quality of an all-but-forgotten souvenir.

So if, alas, I have nothing new to say to the world, perhaps it is my mission to remind.

Virginia Adair

Introduction

My fourteen year old collaborator insists that all stories should begin with 'Once upon a time – ', and so shall this one. Once upon a time portraits were done either in crayons, mosaics, water colors, or oils, clay, bronze, wood, stone or marble. At the close of the fifteenth century, however, another medium was added to the list – pastels – colored pigments, finely ground into a chalk and held together by a modicum of adhesive. This unstable material possessed great versatility and charm, but was badly neglected for nearly two hundred years – with only an occasional portraitist trying his hand at it. Pastel's big moment was a long time in arriving.

The techniques of the use of pastel have always varied with the artist. Some preferred to rub it on in small amounts and then smear it over the surface, adding the lineal drawing and highlights on top of these smeared surfaces. Other artists used the method of applying strokes, either of the point or the side of the pastel, layer over layer, the topmost layer being modified by the layer immediately beneath. Still a third method was to place the strokes lightly side by side, so that the paper itself could show through. Of the three methods, the first was most widely used by our eighteenth century portraitists; and it was their superb draftsmanship which saved the final effect from being merely trivially 'pretty' or overly smooth.

The Russian philosopher, Gurdjieff, once said man consists of two parts, "essence" and "personality" – "essence" being a man's own true self, the something with which he is born. His "personality," on the other hand, is created by outer influences, imitation of or resistance to people around him, his education, his environment, the culture in which fortune places him. Thus, in the best of portraits, one may catch a glimpse of the "essence" of the subject, as well as the overlay of "personality". There can be the fleeting remnant of a small shy boy in the arrogant glance of an armoured warrior, deep melancholy in the eyes of a jovial courtier, a poverty of spirit in the face of the finest gentleman clothed in velvets. Of all the mediums, pastel seems best suited to seek out and record the "essence", to give us an elusive glimpse of the real behind the mask. A look at the plates will reveal that pastels in the hands of the master portraitists could create not only decorative drawing room ornaments, but penetrating psychological studies as well.

Whenever pastels are discussed the inevitable question of their preservation looms ominously. By nature fixatives are moist, and moisture of any kind alters colors. As Leonard Richmond describes it, fixative somehow destroys the "bloom", which is the great charm of pastel. The light reflected from each minuscule bit of chalk dust is suddenly lost when the surface is saturated with a fixative. A subtle change takes place. Sadly, in some of our greatest masterpieces – which were fixed – the deterioration is slowly continuing; while others, sadder yet, were irreparably damaged at the onset by experiments with various fixing mixtures. Ah well, there is always the reverse side of any coin, and all mediums have their particular limitations. Fortunately, though, if a pastel is properly framed, does not receive too much jarring, and is protected from dampness, it can, and will – without fixative – live happily ever after.

For simplification, in many cases, we have given the English equivalent of names and titles to persons mentioned in the text. In presenting the illustrations, however, each museum's own catalogue listing of the works has been used, to assist the reader in finding them.

The Italian School

ROSALBA CARRIERA
(1675-1758)

Italy in the eighteenth century, still basking in the afterglow of the Renaissance, loved, honored, and cherished her artists—but was likely to think of them in the masculine gender only. Females, exhibiting creative talents, were encouraged to content themselves with embroidery, weaving, or the designing of laces. It is all the more surprising then that pastel should owe its sudden acclamation to a young Venetian woman—Rosalba Carriera—the first to make the world aware of this exquisite medium.

Sorting through the artist's memorabilia—old letters, diaries, journals—Vittorio Malamani in the early twentieth century put together perhaps the best collage we shall ever have of Rosalba's life, a life filled with friends, riches, adulation—and countless hours of hard work at a little wooden easel.

Our heroine was "given to light", as the Italians say, in the parish of S. Basilico at Venice, in the year 1675, the daughter of modest parents—a dry statistic auguring an uneventful future, unless one reckons with that spark of genius tucked into the tiny head, and those so called "modest parents". In an era when young ladies of even the finest lineage had little more education than a serving girl, the remarkable Carrieras gave their daughters, Rosalba, Giovana and Angela early instruction in music, French, Latin and an appreciation of art. In time, the advanced education of the Carriera sisters became a source of local pride throughout the entire parish. When the eldest, Rosalba, began to fill the margins of her school books with skilful, life-like drawings, her observant father recognized a precocious talent. He bundled his daughter off to the studios of Giuseppi Diamantini for serious study, and later placed her with Antonio Balestra to learn anatomy. A less perceptive father, and the world might have missed Rosalba Carriera completely.

The young artist began her career by making copies in oil of old masterpieces, which she sold to augment the family's meager finances, and by decorating snuff boxes. The latter prepared her for the exquisite miniatures she began to paint with such success in her early twenties. The exact beginning of her acquaintance with pastel is uncertain—perhaps she was introduced to it through the Venetian "diletante of pastel"*, Gian Antonio Lazzari. In any event, the medium was little known or appreciated at that time, and few artists bothered with it at all. We do know that a friend of the Carrieras, a wise old master, Cannon Ramelli, was sending Rosalba assortments of pastels from Rome in the early 1700's, and that her first authentic work in pastel was a feminine head commissioned by Count Fernando Nicoli of Bologna, in 1703. The count was enchanted.

*"Il Museo Correr di Venezia" pp. 47

Typical of those capable and dedicated amateurs flourishing in eighteenth century England was one Christian Cole, who, having sat for his portrait, began to exercise a marked influence over Rosalba's career. It was he who advised her to concentrate on pastel, and even had special chalks ground for her by Roman workmen. Under their joint supervision, extremely thin dyes were added to obtain more and more delicate nuances of color, which perhaps accounts for the soft, lymphatic skin-tones in Rosalba's portraits of women. Her work was early characterized by a glowing sense of color, an indescribable luminosity, and great delicacy of form. Rosalba heeded Cole's constant urging, and decided to work almost exclusively in pastels, for which the world owes the Englishman a debt of gratitude. To appease Cole, the shy young artist even allowed herself to be proposed for nomination to the Academy of San Luca. She was unanimously elected to membership when the illustrious group met at the Campidoglio in September of 1705—a triumph not only for her art, but for womanhood, itself.

By 1706, the Wars of Spanish Succession had all of Europe in a depressing state of tension. Princes and diplomats, in increasing numbers, began making sojourns through Italy, in an effort to calm their nerves and to distract themselves from this ever present worry.

Many such a gentleman eventually found his way to Venice and to Rosalba's studio on the Grand Canal. A particularly eminent traveler arrived one day—Maximilian II of Bavaria—desiring not only a portrait of himself, but pastels of the most celebrated Venetian beauties as well. The latter, no doubt, were needed to soothe his troubled spirits! Rosalba's exciting career was well under way.

At about this time, Charles II, recently repatriated, invited our

gifted young artist to court. The invitation was reinforced by his eloquent advisor, who described a delicious fantasy of riches and glory, and even offered Rosalba the hospitality of his own family. She immediately wrote for the advice of her old friend, Cannon Ramelli, the same who first sent her pastels from Rome. In a touching, what-would-your-mother-say? sort of letter, he reminded her of the dangers of life at court, as well as the difficulties of a long journey in time of war. He closed by gallantly stating that, though she would surely be the most honored woman at court, she should content herself to be "queen in your own house and in a city where all the world will come to honor you". Rosalba was deeply moved by his letter, and, no doubt, somewhat flattered. She decided to follow his council and quickly went back to work on the many commissions awaiting her, turning her back on all exciting blandishments from abroad.
*Malamani, V. "Rosalba Carriera" pp. 31

Various pastels were soon in progress for the Princes, Frederick of Walter and Frederick Weyberg—portraits of the fairest faces in Venice, as well as portraits of themselves. The two young gallants were both sincere lovers of art, and in them Rosalba found devoted friends, who, for years afterwards, wrote her long extravagant letters of praise.

Early in 1709, during a sojourn in Venice, Frederick IV—the handsome king of Denmark and Norway—became completely infatuated with Rosalba's pastels. He was often at her studio posing for portraits, which he later gave as souvenirs of himself to the various patricians appointed to court him during his stay. It seems that he, too, ordered pastels of the twelve most celebrated Venetian gentlewomen—probably the very same ones whose portraits had been drawn at the behest of the German princes, allowing for a few variations of taste. One can only conclude that in this, and in other instances, Rosalba had to make a great many reproductions of the same original. Such commissions, though highly amusing, sometimes presented difficulties. One lovely Venetian, not wishing to have her portrait make the long trip to Denmark in the company of rivals, flatly refused to pose. After much discussion, her royal admirer wrote to Rosalba, advising, "We'd better let her alone"!*
*Malamani, V. "Rosalba Carriera" pp. 32

By now a member of the Academy of Bologna, Rosalba was soon to receive other honors. Grand Duke Cosimo De Medici III asked her to paint a self portrait for his famed collection at the Uffizi, and it was no surprise when membership in the Academy of Florence shortly followed.

Having great impact on her already successful career were her connections with the Prince of Saxony, later Augustus III of Poland, and her friendship with Pietro Crozat, rich and

knowledgeable art collector and official escort of the court of France. From 1712 to 1717 the Prince of Saxony made three trips to Venice, each time wanting portraits of himself in various poses, as well as certain miniatures and pastels his father, Augustus II, had requested. Thanks to this wise young prince's appreciation of Rosalba's genius, an entire room of the royal gallery in Dresden was one day to be filled with her glorious pastels—some fifty in all.

The other "impact", Pietro Crozat, came into Rosalba's life in 1716, when he suddenly appeared in Italy, hoping to spur along the paintings, carvings, and cameos ordered for his celebrated collection in Paris. A man of taste, great heart, and buoyant spirits, Crozat was deeply impressed by Rosalba. Their first meeting in Venice marked the beginning of a long and enriching friendship for them both—and a turning point in Rosalba's career.

When a young Venetian was planning a visit to Paris, Rosalba gave him a letter of introduction to Crozat, along with two small pastels to deliver in her name. Upon the youth's return to Venice, he described the trip in such glowing terms that the artist's curiosity was greatly aroused. She wrote to Crozat in gratitude for his kindness to her young friend, and Crozat's reply was an urgent invitation to come and see Paris for herself that very spring. With her beloved father dying, Rosalba dared not leave Venice so soon; but a second invitation the following year was gleefully accepted. She decided to go in the company of her mother and her unmarried sister, Giovanna. Angela and her artist husband, Gian Antonio Pellegrini, were already living in France, which gave an added incentive to the adventure.

Preparations for the journey were immediately begun. While Signora Carriera vanished in a flurry of fittings—so as to make a "bella figura" in the fashionable capital—Giovanna packed the enormous trunks, and Rosalba worked frantically to complete her unfinished commissions.

At the beginning of April, 1720, the excited trio arrived in Paris—Rosalba clutching a little sachel containing pastels, which were to cause such a furor in only a matter of months. Crozat esconced the Carrieras in his sumptuous Rue Richelieu palace, and was soon presenting them to the most distinguished members of the arts and aristocracy.

One illustrious name after another was added to Rosalba's list of new Parisian friends. It was, however, Pier Giovanni Marietti, an unassuming young art critic and collector of prints and drawings, who gave her the greatest moral support during her stay—and in the years that followed.

Having been presented to the Regent, one of Rosalba's first works in Paris was a miniature of Louis XV. Even her most ardent disciples could hardly have dreamed of the great success that was to follow. From this miniature she made copies in pastel, and soon her name and the new medium were the talk of the city! The vogue for a pastel by Rosalba Carriera became almost a frenzy. Outside the doors of her studio a long procession of polished carriages began to pause, as one by one, the rich, the titled, the elegant—coiffed and perfumed—came seeking portraits of themselves in the new colored chalk. Rosalba's studio was soon to be one of the most aristocratic meeting places of the eighteenth century. Her diary of those busy days was filled with only the briefest entries. Typical is the one of July 25, 1720:

"Went with brother-in-law to finish the King; at the same (time) three small accidents occurred; the easel fell, the parrot died, and something happened to the little dog".*

*"Journal de Rosalba Carriera Pendant Son Séjour a Paris en 1720 et 1721"

As Rosalba's fame increased daily, the Academy of Painting and Sculpture could no longer ignore such a resplendence of feminine genius. Though it had firmly decided not to include women in its ranks, the old prejudice was waived in this particular case, and Rosalba Carriera, the Venentian, was elected an Academician on October 16, 1720—only six months after her arrival in Paris!

Wanting to show the citizens of Paris yet another facet of his protégé, Crozat arranged at his house an elaborate benefit concert. Rosalba, performing with other musicians, played the violin, and her sister, Giovanna, sang. As the guests included virtually all the aristocracy of Paris, more accolades now rested on Rosalba's brow.

After a year and a half of this exhilarating life, and at the very height of her success, Rosalba decided to return to Venice. Crozat was leaving for a business trip to Holland, her mother was homesick, and Rosalba, herself, felt it was time to go.

Once again at home on the Grand Canal, she started work on a pastel to send back as a gift to the Academy. It represented a Muse in the form of a lovely blond maiden; her hair was sprinkled with roses, her arms were bare, and in her left hand she held a laurel wreath. To accompany the work, Rosalba sent a charming letter, saying: "I have tried to create a young girl, knowing that one forgives the faults of the young. She also represents a nymph of the Apollo group who is going to make a gift to the Academy of Paris of a laurel wreath, judging this the only thing worthy of bringing to it. She is determined to stay in this city, prefering more to occupy the last place in this illustrious Academy than the top of Mount Olympus."*

*Malamani, V. pp. 56

The Muse was highly praised by the critics, who spoke of its "exact drawing", Rosalba's "light and precious touch", and the "happy harmony of color only she knew".*
*Malamani, V. pp. 56

In an effort to encourage her faithful friend, Mariette, to marry, Rosalba made a portrait of the young lady whom he was considering. She was able to flatter the subject to such an extent, and to make her appear so disarmingly lovely, that poor Mariette could no longer resist. Rosalba, however, was unable to attend their wedding in Paris, as a serious illness had suddenly attacked her eyes.

After weeks of rest, the artist had recovered sufficiently to accept an invitation to the court of Modena, which was again to involve her in a labyrinth of matrimonial intrigue. It seems that the Duke Renaldo D'Este, in an effort to find suitable husbands for his daughters, Benedetta, Amalia, and Enrichetta, had enlisted the aid of his various diplomats. The cleverest and most discreet of these, the Marchese Rangone, Modenese Ambassador to the court of France, decided that the eldest should be united with her cousin, the Duke of Brunswich, and the youngest, Enrichetta, with the Duke of Bourbon. Planning first to win over the respective mothers of the two young men, he wrote to the Duke D'Este, telling him of Rosalba Carriera's great success in Paris and suggesting that, should he have portraits of his daughters made by the celebrated artist and sent to Paris, they would certainly excite the "admiration and curiosity of the most distinguished persons*—namely the two mammas.
*Malamani, V. pp. 60

Finally, after much urging from the elderly Duke, Rosalba was seen arriving at Modena in the summer of 1723, carrying her easel and her sachel of pastels. She began making various portraits of the three princesses, but, for her part, a constant repetition of the same subjects soon became a deadly bore. The situation was scarcely helped by the girls' repeated chant, "You work too much. You work too much". Rosalba wrote to her sisters and to Crozat that she longed for her house on the Grand Canal.

When the portraits were finished, Rangone arranged for them to be sent to the Duchess of Brunswich—whom he managed to work into a fever of excitement over their anticipated arrival. Meantime, the clever old diplomat found an excuse to call on the Duchess of Bourbon. Glancing around the drawing room at the portraits of her childern, Rangone asked slyly if they were the works of Rosalba Carriera. The Duchess confessed that, unfortunately, during the entire time the artist had been in Paris, she was unable to get one single portrait done by her—a cause for deep regret. Now was the auspicious moment for Rangone to mention the Rosalba pastels of the

Modenese Princesses, en route that very day to the Duchess of Brunswich. Falling headlong into the trap, the Duchess of Bourbon showed enormous curiosity, and urged him to have the Duchess of Brunswich allow her to see the portraits the minute they arrived. She even displayed some annoyance that they hadn't been sent to her first!

Though this particular batch of portraits went astray, as Rosalba had made several of each Princess, three more were quickly dispatched. The end of the intrigue was somewhat ironic; the portraits were indeed greatly admired in Paris, but more for the genius of Rosalba than for the charms of the originals—and—each of the two mothers wanted the same Princess for her own son. Enrichetta, the fairest of the three, could have had two husbands as a result of the plot, while her sisters found none. As it turned out, Enrichetta married neither the Duke of Brunswich nor the Duke of Bourbon, but was later wed to the Duke of Parma. Rangone's scheme was a complete flop!

A pastel done for the Count of Morville, Minister of Foreign Affairs in Paris, caused a great stir in aristocratic circles, and resulted in an invitation to return. Ever the faithful daughter, Rosalba felt her mother was too old to leave, and this time declined to go.

Even so, the following months were exciting ones. A chance meeting with the entronage of Charles VI at Friuli ended with an invitation to the Court of Vienna. After being presented to His Majesty, Rosalba was soon at work on his portrait. Rumor has it that the King expressed fierce royal disappointment that the famous Rosalba Carriera was no great beauty, which doubtless afforded the artist considerable amusement, for poor old Charles, himself, was a positive gargoyle. In any event, her large impressive pastel of him inspired a host of commissions for Rosalba, from Vienna's most notable citizens.

Rosalba had long since found out that the practice of portraiture could be as endlessly fascinating as human nature itself. She must have been highly entertained when the Princess Trivulzi, previously thrilled with her portrait, decided, after losing some weight, that the pastel no longer resembled her. Proud of her new image, the Princess wrote from Lione and asked Rosalba to make three more portraits of her (in miniature!) in her now more slender state. These she wished to give as reminders to friends. Scarcely able, from miles away, to discern just how many pounds had actually been shed, Rosalba could only guess; and when the miniatures were finished, our petulant Princess still found herself far too plump. Rosalba patiently went back to work again, and reduced the little darling even further in a second pastel—this time to be accused of "making a skeleton"* of her!

*Malamani, V. "Rosalba Carriera" pp. 87

Despite her many pressing commissions, Rosalba constantly made drawings to send to her cherished friends, Pietro Crozat, Pier Mariette, and others. Indeed her busy life was filled with friendship, and thanks to her wise and gentle nature, she luckily escaped the jealousy of her fellow artists. They all adored her,and eagerly sought her advice. Though small in stature, her energy was indefatigable. Her generosity and kindness became a legend; for it was said that no one who came to her for help was ever turned away.

The years were gradually mounting up, and when her sister, Giovanna, died, Rosalba suffered such a deep melancholy she was unable to work. Commissions promised were completely forgotten. It was only after a surprise visit from Frederick Christian, son of her great admirer, Augustus III, that she felt inspired to paint again. The Crown Prince chose forty pastels from the collection that adorned her studio walls, to take back to his father, now the King of Poland. These were to be added to those the sovereign had already acquired for the Royal Gallery at Dresden so many years ago, when he,himself, was the young Crown Prince.

Rosalba accepted two more commissions from Augustus III for pastels, to complete his series "The Four Elements", but wondered if she'd ever be able to finish them. The illness which had attacked her twenty years before had insidiously returned. Cataracts were now forming on both eyes—and these exquisite pastels, destined for the gallery at Dresden, proved to be her last. This was in 1746.

Rosalba waited patiently for three years for the surgery which might possibly save her sight. The operation was tried twice, and for a time it was thought she would recover; her letter to the faithful Mariette was full of hope. The next year, however, she dictated a note to him saying, "I see no more than if I were in the darkness of night".*

*Malamani, V. "Rosalba Carriera" pp. 94

To the silent heartbreak of those around her, Rosalba's remaining days were marked by the tragic decline of her brilliance into a quiet, pathetic senility. Death, like all who came her way in life, proved to be a friend.

Yes, there were others in Italy working in pastels in the 1700's, but the energetic Venetian genius so far outshown the rest that history makes little or no mention of anyone, save Rosalba Carriera.

The illustrations

"LUDWIG XV VON FRANKREICH ALS DAUPHIN"
Rosalba Carriera

Louis XV was only five years old when he ascended to the throne of France, and was about ten when Rosalba Carriera made this striking portrait of him in pastels. The work was an immediate success, and served to introduce Paris to the exciting new medium. Rosalba often spoke of the boy in her diary, and referred to this as the "little portrait of the King".

The artist made several copies of the masterpiece, this particular one belonging to the famed collection of Augustus III of Poland.

It is interesting to compare Rosalba's likeness of Louis XV with the one La Tour made of the King more than twenty years later. Something of the child still remains.

Location: Zwinger Museum, Dresden.

Actual size: 19⅞in x 15⅛in (0,50½ x 0,38½)

22

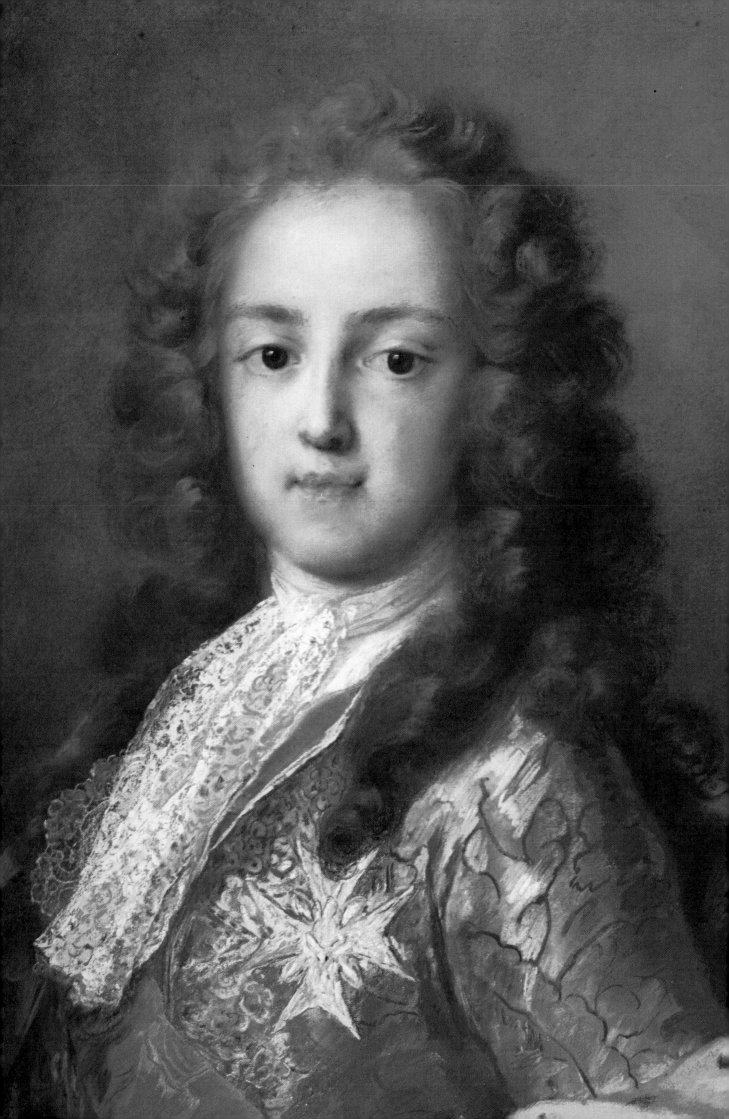

"RITRATTO DI PRELATO"
Rosalba Carriera
This distinguished dignitary of the cloth is identified as the Abbot Le Blond. Rosalba mentioned him in her diary of 1727 in connection with a visit she paid to the eminent Cardinal Polignac.

The excellent modeling of the features, and the dramatic use of light and shadow make it an extremely arresting portrait.

Location: Accademia Museum, Venice.

Actual size: 22in x 17in (0,56 x 0,44)

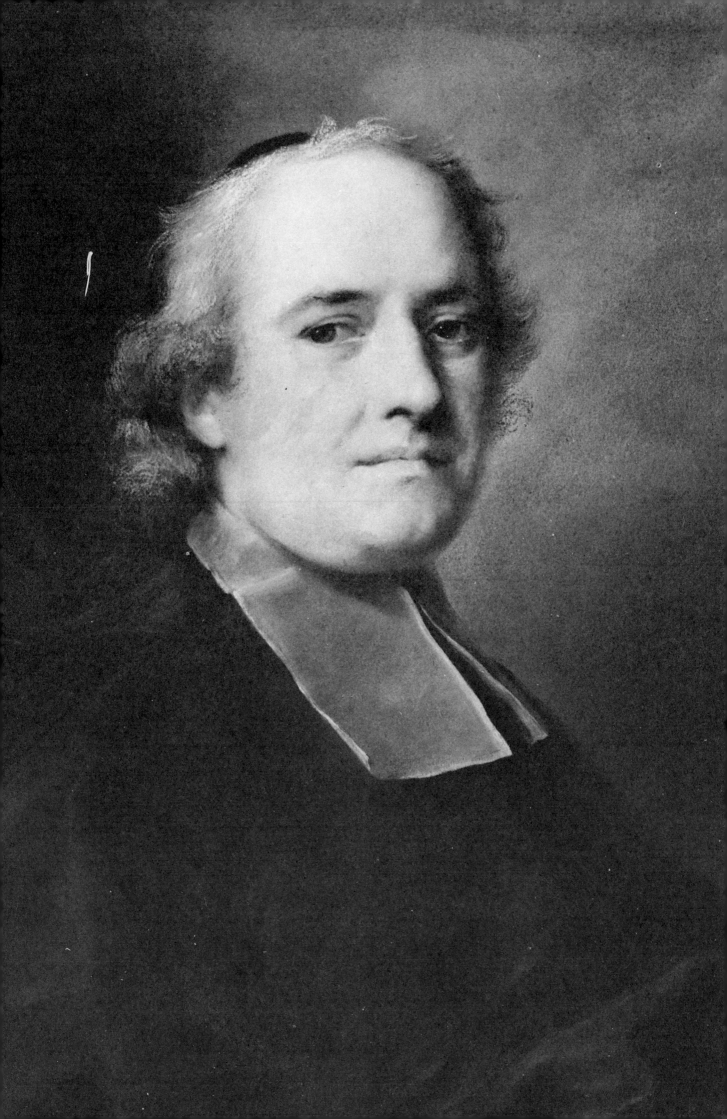

"ENRICHETTA ANNA SOFIA D'ESTE, PRINCIPESSA di MODENA"

Rosalba Carriera

Enrichetta was the youngest and fairest daughter of the powerful ruler of Modena, Duke Renaldo D'Este. According to Vittorio Malamani, this portrait and several others of her and her sisters were part of a matchmaking plot—cleverly devised by her father's ambassador to Paris, with Rosalba as accomplice.

The Princesses, innocent of the intrigue, grew tired of posing; Rosalba, homesick for Venice, found the whole assignment long and tedious; and, in the end, even the plot failed to go according to plans. Be that as it may— the world gained several exquisite pastels as a result.

Location: Uffizi Gallery, Florence.
Actual size: 21⅝in x 16½in (0,55 x 0,42)

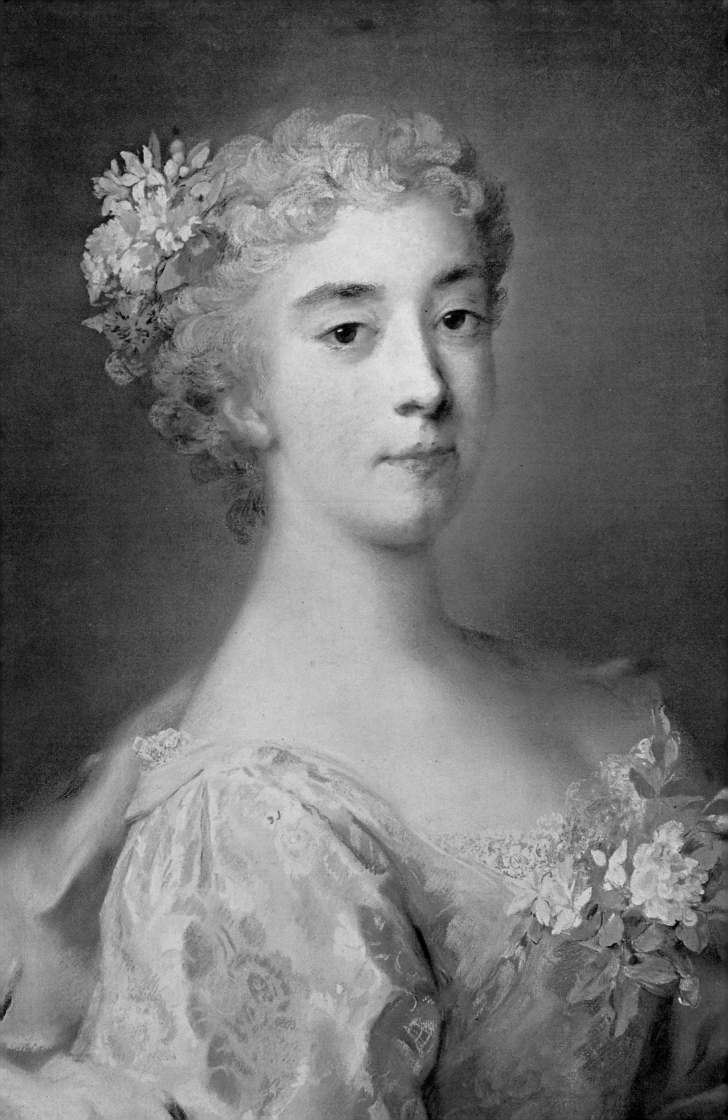

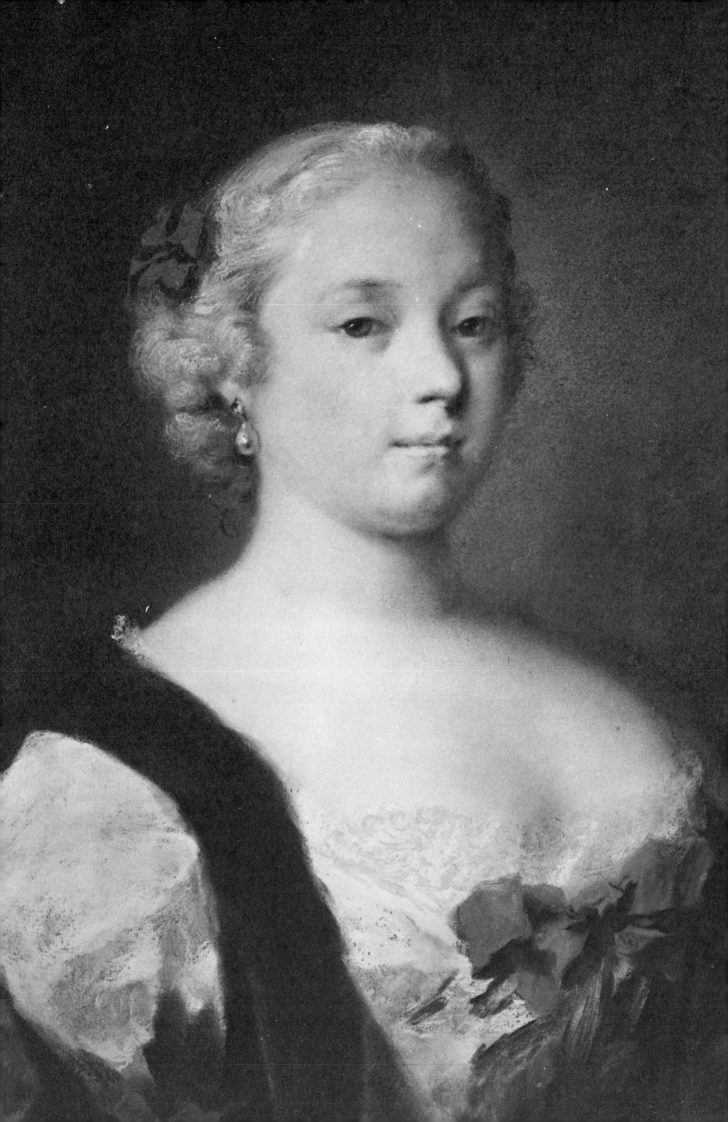

"RITRATTO DI DAMA"

Rosalba Carriera

Though Rosalba made many portraits of the various feminine members of
the French family, Le Blond, this one is considered the most remarkable.
Here we see her sensitive treatment of textures—the taffeta ribbon is crisp
and fragile, the little fur collar is deep and soft— and the skin of the sub-
ject has a 'lymphatic' glow for which the artist was famous.

 Location: Accademia Museum, Venice.

 Actual size: 21½in x 16in (0,55 x 0,41)

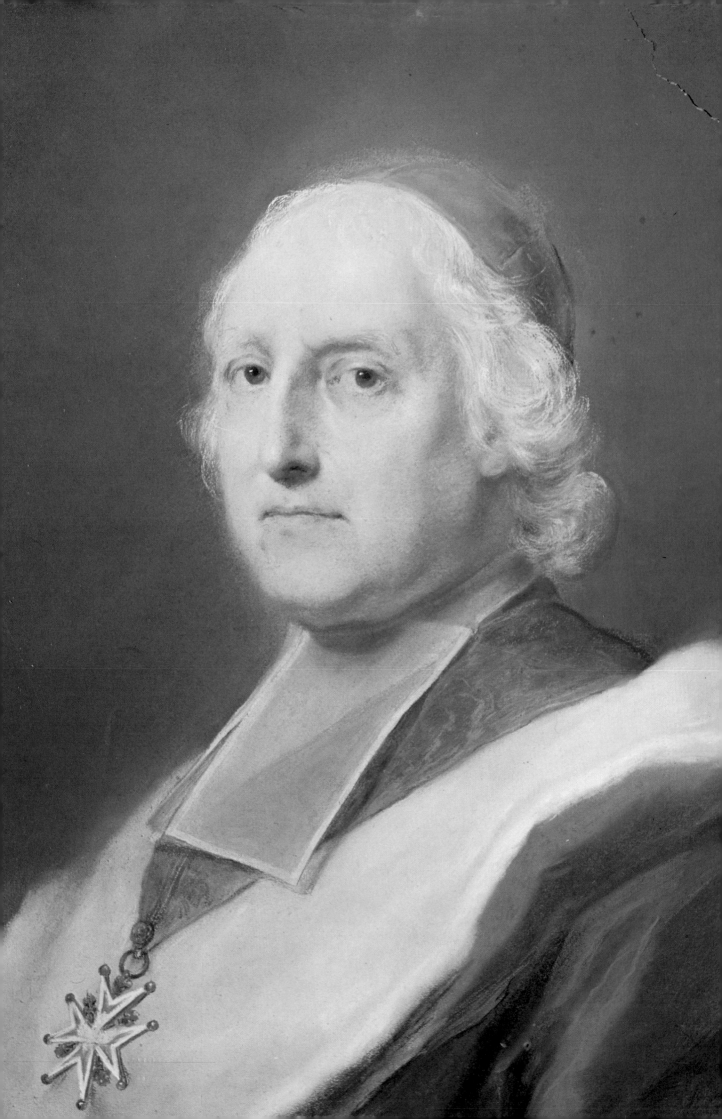

"IL CARDINALE POLIGNAC"

Rosalba Carriera

Melchior de Polignac, cardinal, writer and diplomat, was the descendant of three noble French families. Having entered the priesthood, he assisted at the elections of Pope Alexander VIII and Innocent XII. In his diplomatic capacity, he was sent to Poland as ambassador, and later served as pleni-potentiary in Holland, taking an active part in the writing of important political treaties. Polignac received his cardinal's cap in 1713.

Sixteen years later, as Louis XV's emissary to Rome, Polignac organized in Piazza Navonna one of the most elaborate fetes ever witnessed in the Eternal City, to celebrate the birth of the Dauphin. It was while making one of his official trips from Paris to Rome that he passed through Venice and sat for this penetrating portrait. Rosalba Carriera has recorded it all— the spiritual man, the aristocrat, the scholar. Many critics consider it one of her finest works.

Location: Accademia Museum, Venice.

Actual size: $22\frac{3}{4}$in x $18\frac{1}{8}$in (0,58 x 0,46)

31

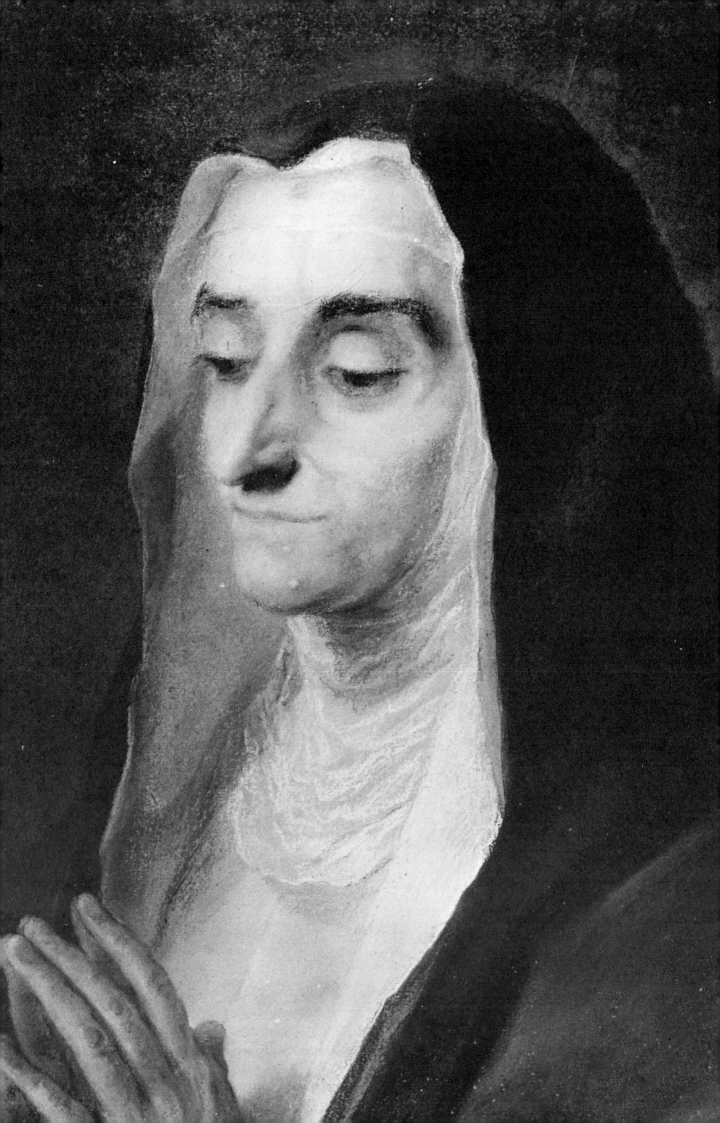

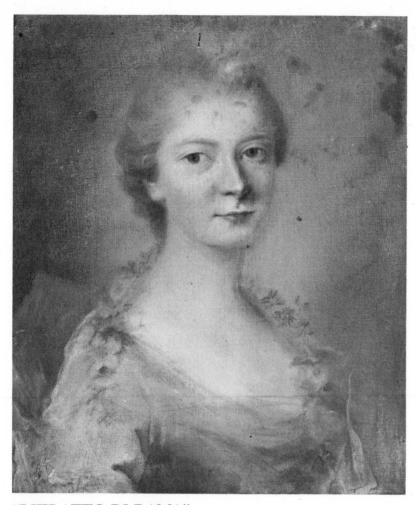

"RITRATTO DI DAMA"
Rosalba Carriera

We have included this once lovely pastel to show the disastrous effects of dampness on pastels. Spots of mildew form to eat away the chalk and discolor the paper beneath.

Fortunately, in this work, the face of the subject has not been too badly damaged.

The portrait belongs to the Galleria Estense in Modena.

"SUOR MARIA CATERINA"
Rosalba Carriera

This sensitive pastel portrays a famous religious figure of eighteenth century Venice. Sister Mary Catherine is said to have lived a saintly life and to have died in "holy fame". Isabelle Piccini, herself a nun and possessing great artistic ability, made an engraving of Rosalba's pastel which appeared in various religious publications of the day.

Location: Ca' Rezzonico Palace, Venice.

Actual size: 17¼in x 13¾in (0,44 x 0,35)

33

"FRIEDRICH CHRISTIAN VON SACHSEN ALS KRONPRINZ"

Rosalba Carriera

Despite the storms that raged around the throne of Poland, no one could look more poised or sure of himself than the little Crown Prince, Frederick Christian, as he sat for this elegant portrait. His father, Augustus III, had long admired Rosalba Carriera, and sent the boy to Venice to select even more of her lovely pastels to hang in his gallery at Dresden.

Typical of many of Rosalba's portraits, the position of the hand is used to give a three-dimensional quality to the composition; and in this particular work, the wide variety of textures shows the amazing versatility of pastel.

Location: Zwinger Museum, Dresden.

Actual size: 25in x 20¼in (0,63½ x 0,51½)

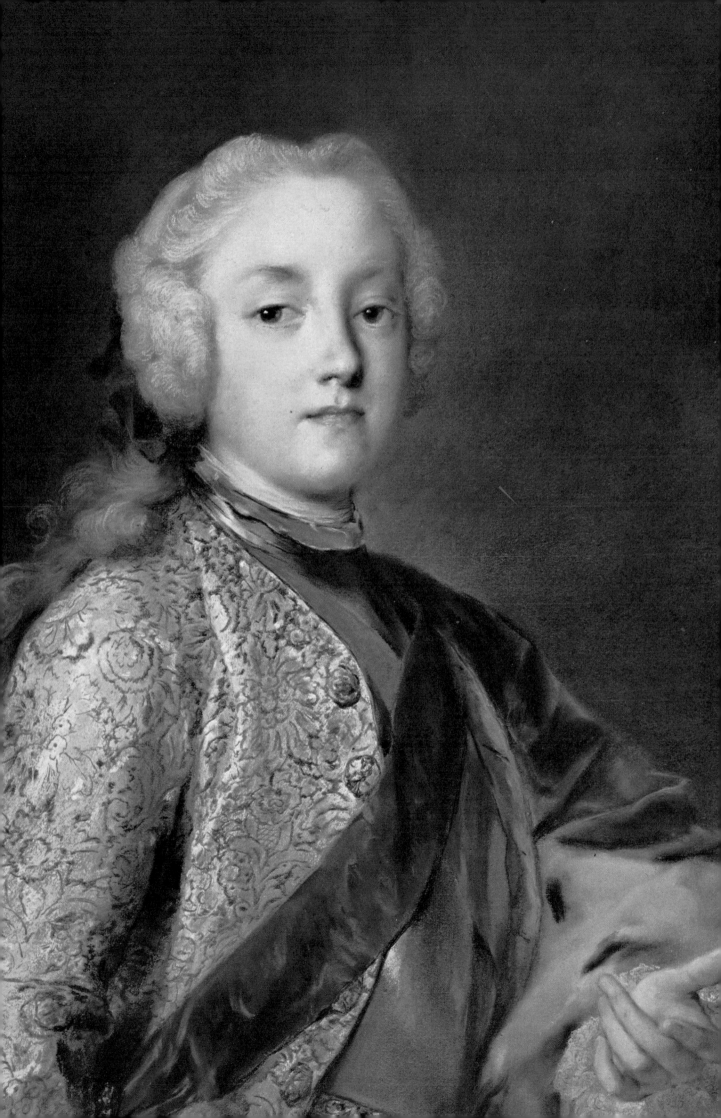

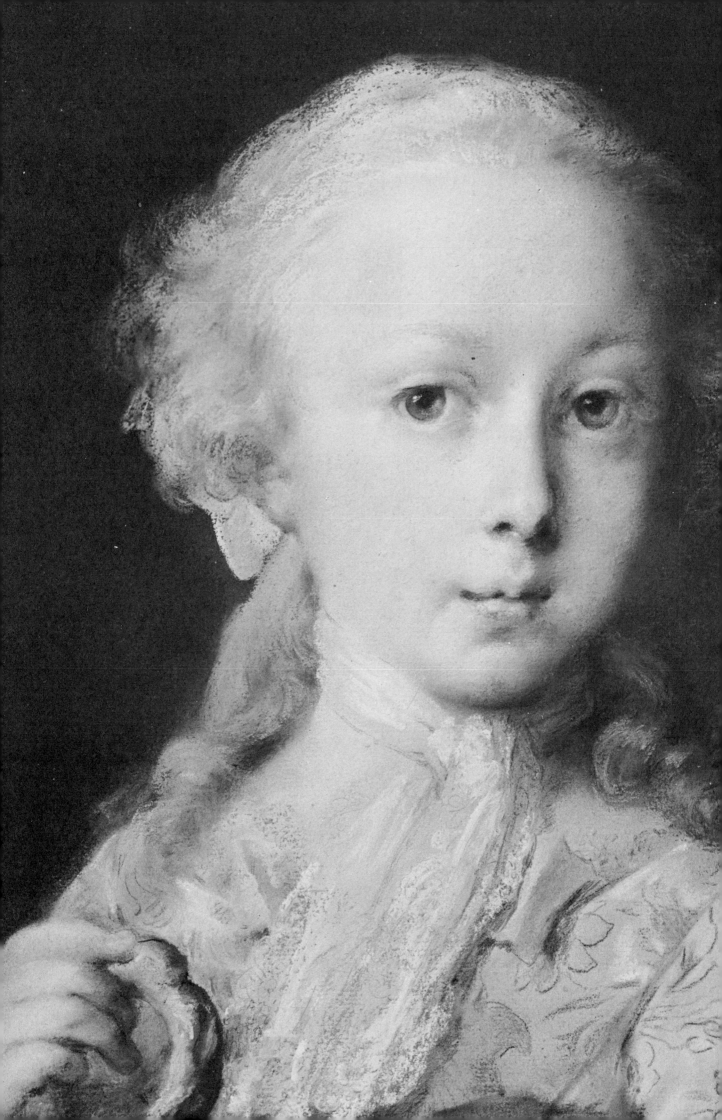

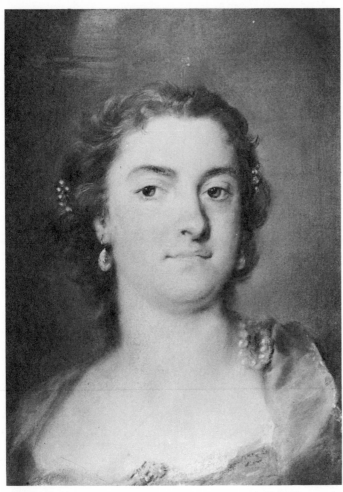

"RITRATTO DI FAUSTINA BORDINI"
Rosalba Carriera

Faustina Bordini was one of the great contraltos of eighteenth century opera, and as handsome and self-contained as Rosalba has portrayed her. At the age of thirty-eight she moved to Dresden where her splendid voice won her great favor at court. Faustina remained there until quite an old woman, finally returning to her native Venice to die in 1787.

Rosalba made several portraits of the singer, and perhaps due to the strong face of her subject, they are considered among her finest.

Location: Ca' Rezzonico Palace, Venice.
Actual size: 18½in x 13¾in (0,47 x 0,35)

"GIOVENETTO CON CIAMBELLA"
Rosalba Carriera

A child of the French Consul, Le Blond, this pastel has long been catalogued "Young Boy with a Ring Shaped Bun". Recent authorities, however, suggest that the little dear might in actual fact have been a girl! They cite by way of argument the flowered suit, the low-cut collar, the pale pink bow, and the long curls caught behind with ribbons. In the light of certain teen-age apparitions one meets today, the gender of the portrait can perhaps be left undisturbed.

Location: Accademia Museum, Venice.
Actual size: 13½in x 11in (0,34 x 0,28)

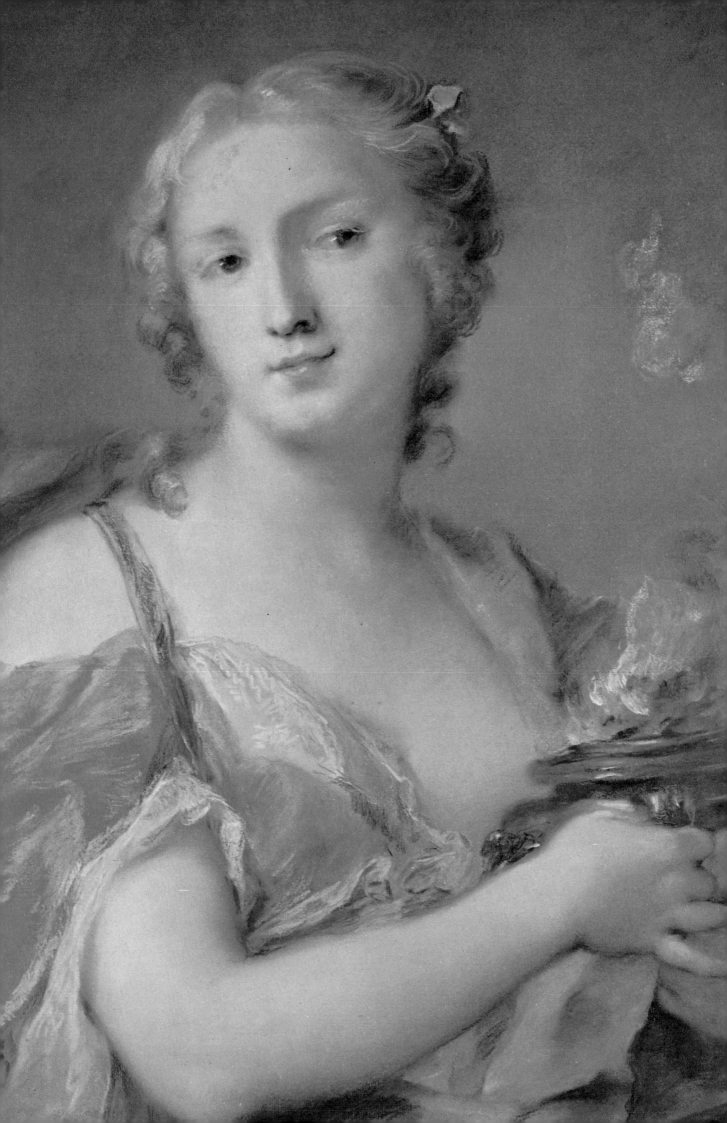

"DAS FEUER"

Rosalba Carriera

Here we see the work of a woman, half blind with cataracts, wondering if, for herself, the flame would go out before she could complete this lovely fantasy.

"Fire", one of a series entitled "The Four Elements", was indeed among the last works from the hand of Rosalba Carriera—commissioned by the King of Poland, and destined for the Royal Gallery at Dresden. Despite the fact that the artist was fighting against time, and in a state of deep anxiety, one still finds the same deft touch of genius, which is the certain signature of all her art.

Location: Zwinger Museum, Dresden.

Actual size: 22in x 18⅛in (0,56 x 0,46)

"MADONNA"

Rosalba Carriera

Little is known about this madonna, and for years it received little or no study from art scholars. The hands are particularly to be noted, as well as the balanced composition and dramatic lighting. When or why it was sketched remains undiscovered.

 Location: Ca' Rezzonico Palace, Venice.

 Actual size: 22¾in x 18¾in (0,58 x 0,48)

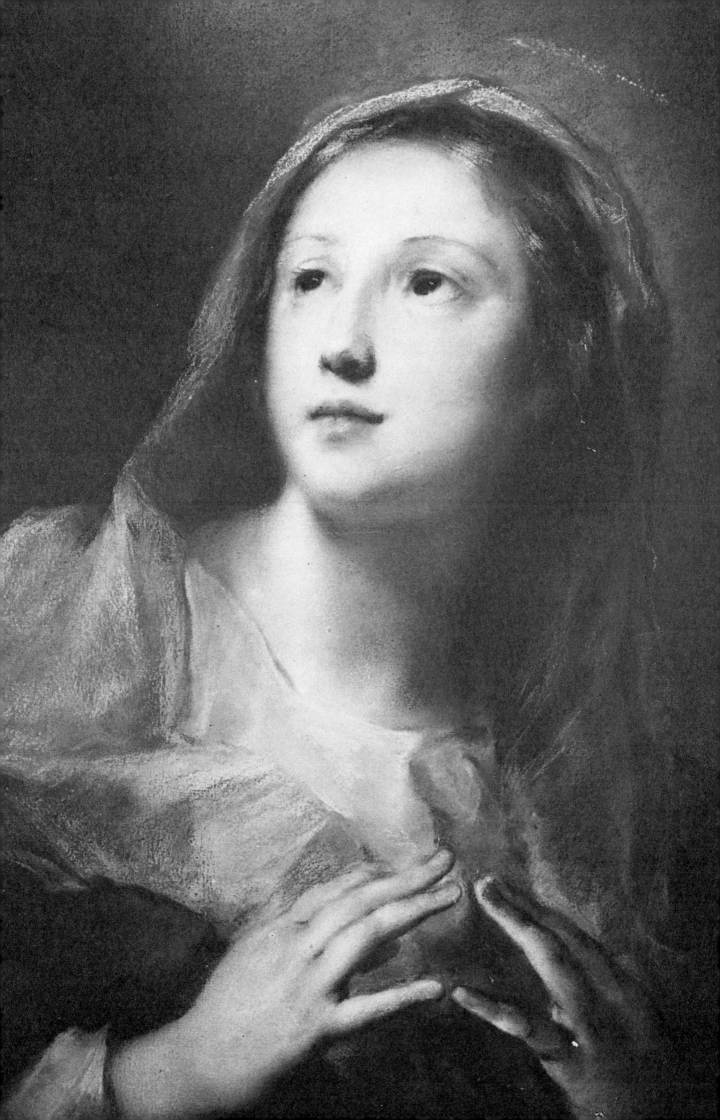

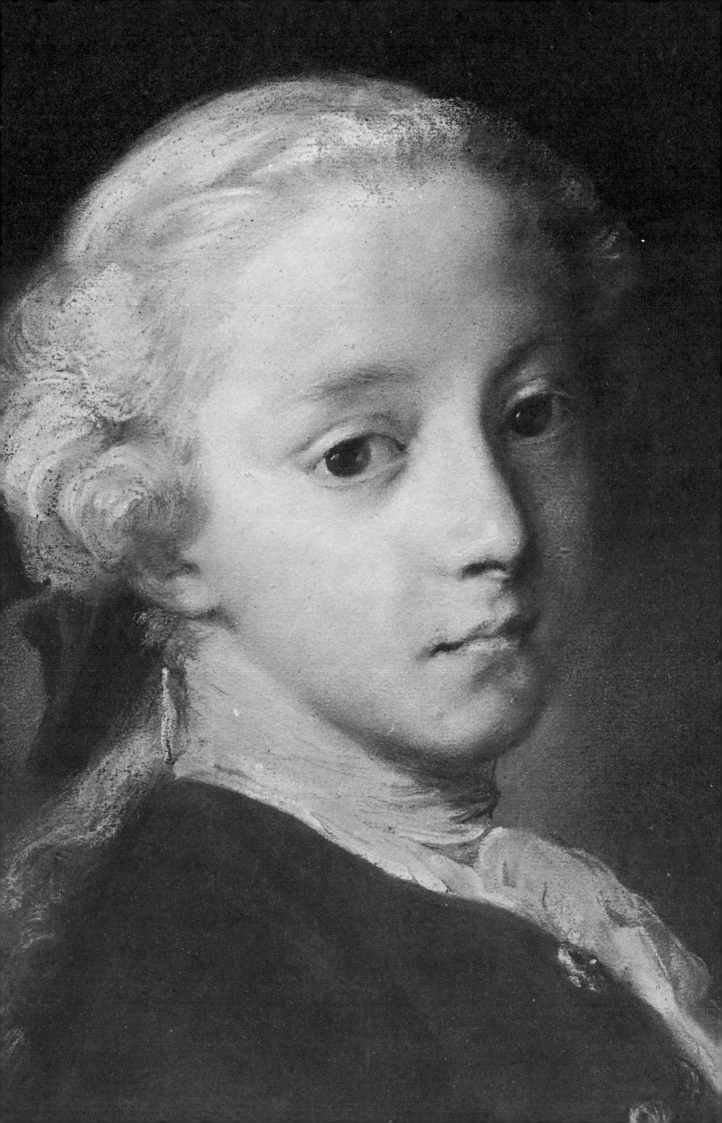

"RITRATTO DI GIOVENETTO"
Rosalba Carriera
This rather pensive looking youngster is believed to be a son of the Consul, Le Blond, France's envoy to Milan. Though another pastel of a child of Le Blond, entitled "Giovinetto con Ciambella", is far better known, this small portrait deserves our careful study and appreciation.
 Location: Accademia Museum, Venice.
 Actual size: 13½in x 10½in (0,34 x 0,27)

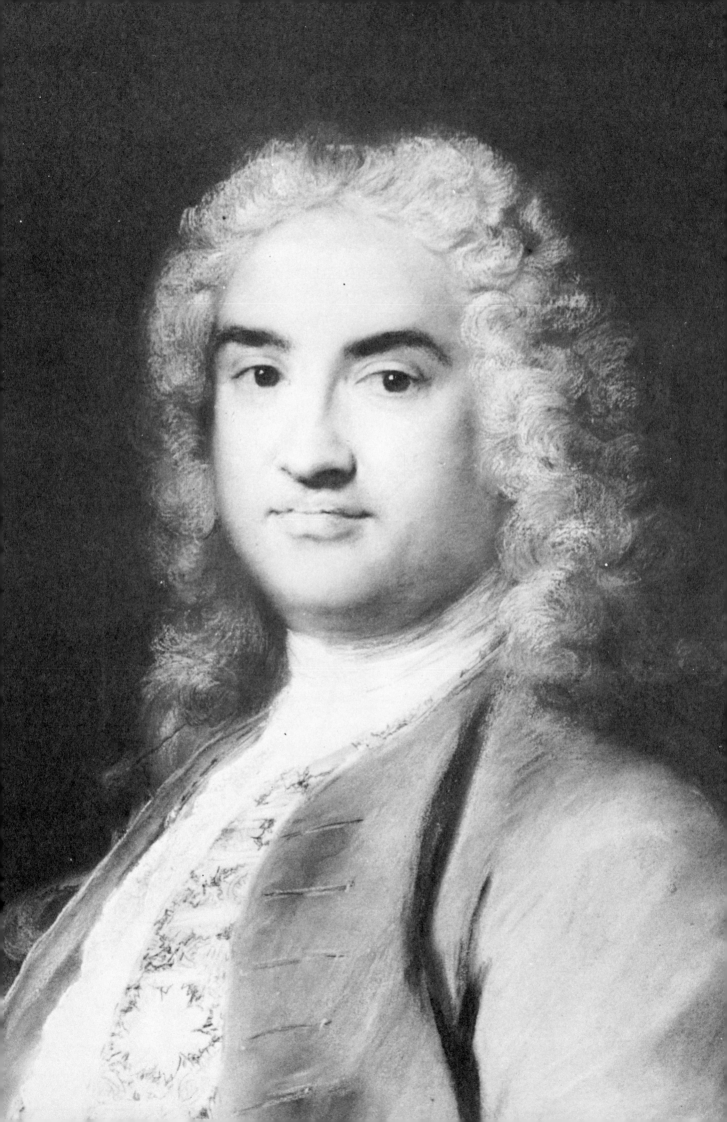

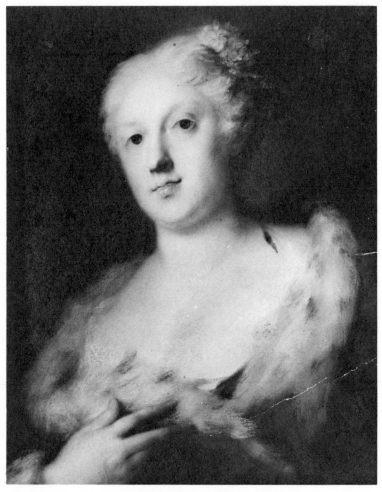

"RITRATTO DI SORELLA GIOVANNA"
Rosalba Carriera

"Naneta", as Giovanna was affectionately known, was the frailest of the three Carriera sisters. She never married, and was the constant companion and confidante of Rosalba. She was said to possess a child-like candor and a gentle disposition, which we see reflected in the tranquil face of this portrait. "Naneta" shared Rosalba's love of art and music, and she, herself, possessed a splendid lyrical voice. Her death cast Rosalba into a dark melancholy from which the artist never completely emerged.

 Location: Sabaudia Gallery, Turin.
 Actual size: $22\frac{1}{2}$in x $17\frac{2}{3}$in (0,57 x 0,45)

"RITRATTO DI GENTILUOMO"
Rosalba Carriera

Just who the "gentleman" is we have no idea, but this handsome portrait is one of the strongest and most imposing of Rosalba's works. The depth and richness of color is reminiscent of that used in the artist's famous likeness of Cardinal Polignac, executed at about the same period.

 Location: Ca' Rezzonico Palace, Venice.
 Actual size: $26\frac{1}{2}$in x 20in (0,67 x 0,51)

"RITRATTO DI DAMA ANZIANA"

Rosalba Carriera

This portrait of an "elderly woman" is thought to be a likeness of the wife of Jacques André Joseph Aved, himself a French portrait painter of note. Comparing it with other portraits of Madame Aved, authorities find a strong resemblance.

The lace in this pastel invites particular study and shows Rosalba's superb mastery of the difficult medium.

Location: Accademia Museum, Venice.

Actual size: 16in x 20in (0,40 x 0,50)

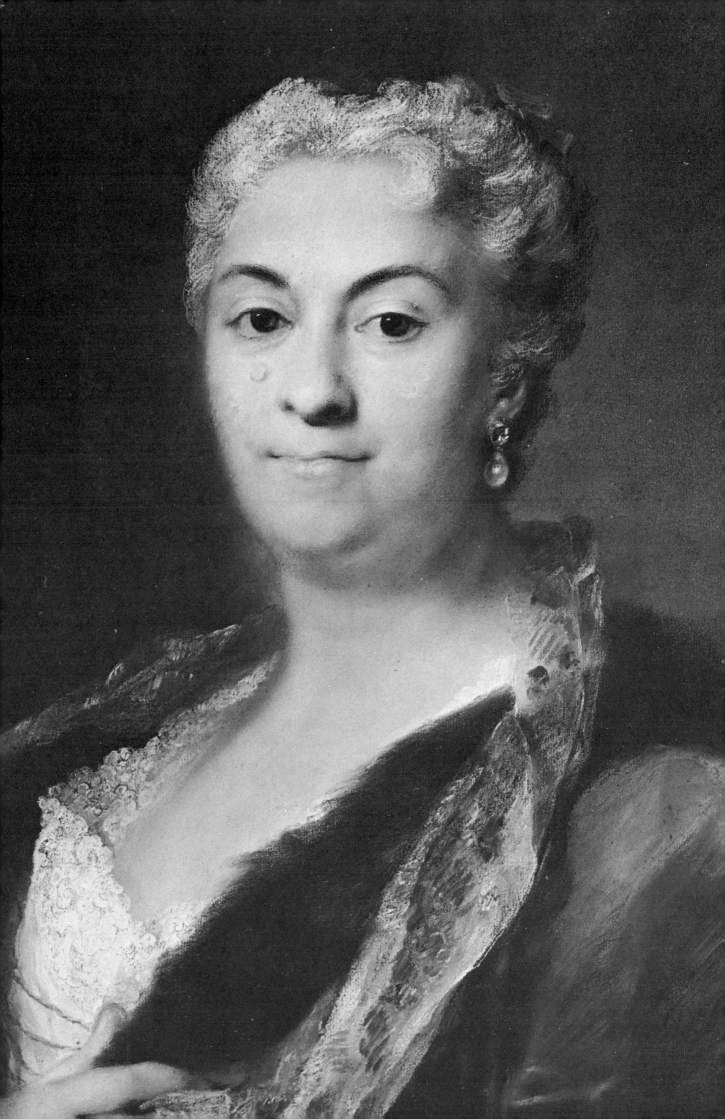

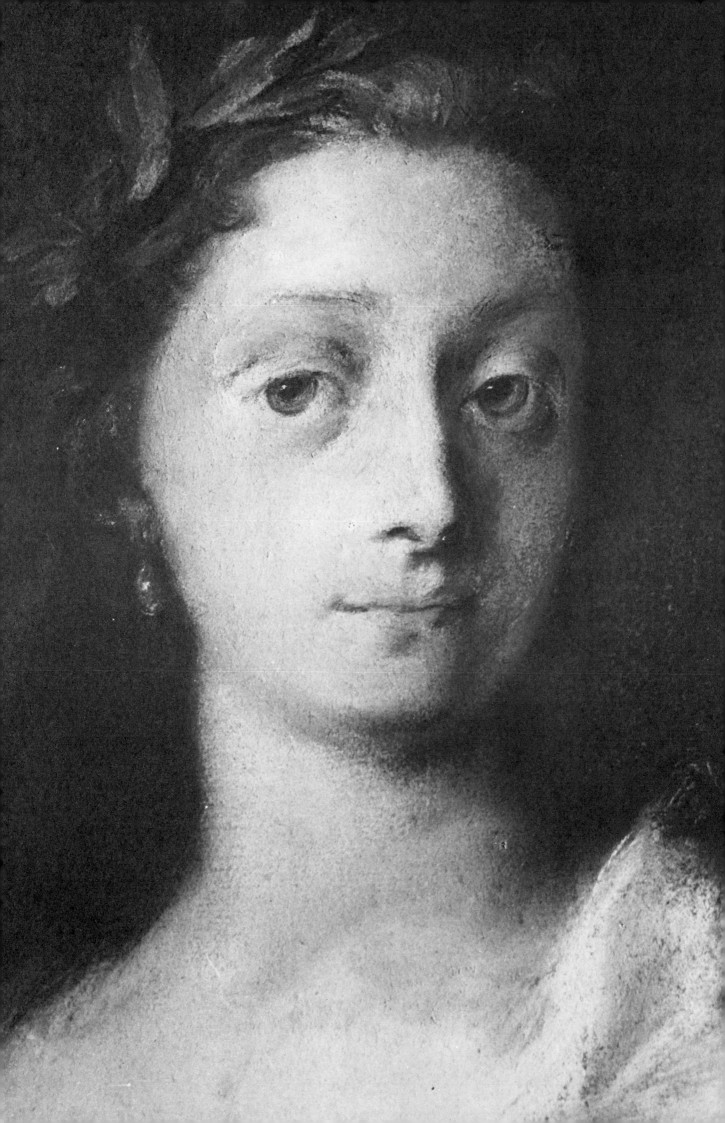

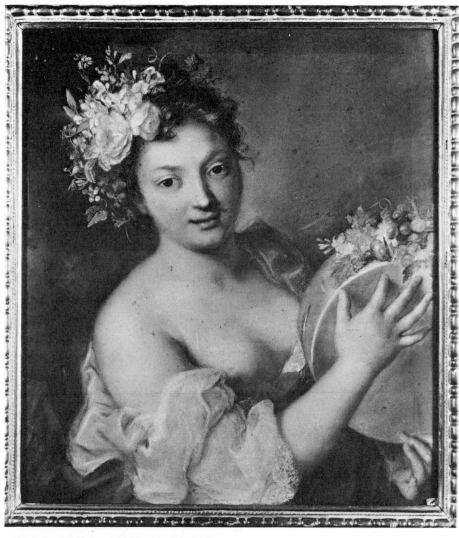

"ALLEGORIE DER MUSIK"

Rosalba Carriera

Rosalba was fond of creating fanciful and allegorical compositions. Some of her loveliest pastels romanticize the Elements, the Arts, the Seasons.

Rosalba's flower-decked maiden recalls the words of Sydney Smith—"All musical people seem to be happy; it is to them the engrossing pursuit; almost the only innocent and unpunished passion".

Location: Bayerisches Nationalmuseum, Munich.

Actual size: 23½in x 21in (0,59 7/10 x 0,53 3/10)

"AUTORITRATTO"

Rosalba Carriera

Of the many self portraits of Rosalba Carriera this is one of the more interesting, and certainly the kindest. It is believed to have been a gift to her friend, Giambattista Sartori, brother of her beloved pupil, Felicita—and shows the artist wearing the costume of the classical Greek theater, complete with bay leaf garland.

Another self portrait in this same "veste di Tragedia" was made many years later, shortly before the onset of her blindness.

Location: Ca' Rezzonico Palace, Venice.

Actual size: 11½in x 9in (0,29 x 0,23)

49

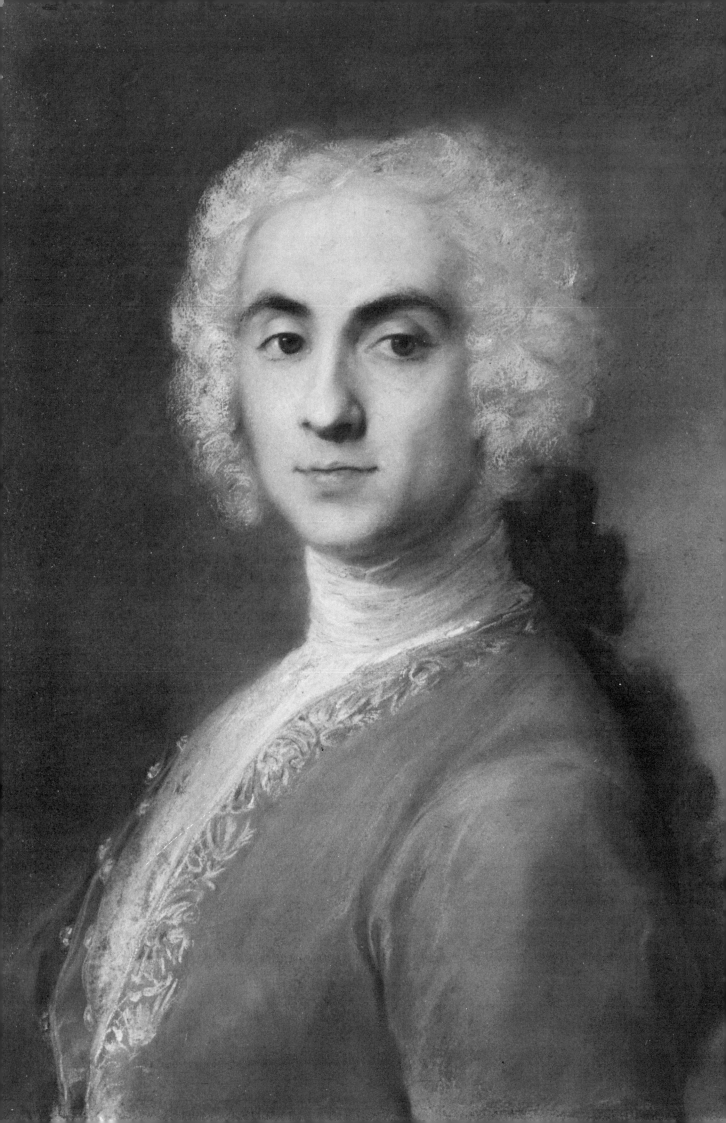

"PORTRAIT OF A GENTLEMAN"

Rosalba Carriera

Rosalba's pastels are generally characterized by a special quality of luminosity, well illustrated in this handsome study. Over two hundred years after their execution, her portraits retain a startling vitality and freshness. Of the many pastellists who followed, none ever excelled the Venetian in her sensitivity to the subtleties of color.

Location: National Gallery, London.

Actual size: 22¾in x 18½in (0,57⅛ x 0,47)

51

MAURICE QUENTIN DE LA TOUR
(1704-1788)

The eighteenth century was rightly named France's "Golden Age". With the death of Louis XIV, her stilted grandeur gave way to gallantry and grace. The stiff brocades were exchanged for rustling silks and flowing velvets; the formal, measured, pompous speech quickened to witty epigrams and subtle flatteries. France had been solemn and majestic for over half a century, and now she wished only to be elegant and gay; the courtier, the man of fashion, the coquette became the idols of the hour. What better medium than pastel to portray this new and frivolous mood? Once pastel had found its way to France—with an impressive introduction from the talented Venetian—pastel was to reach its greatest heights, and to meet its greatest master, Maurice Quentin De La Tour.

Saint-Quentin lies in the north of France, and in the early 1700's was a happy, bustling town, unaware that one of the noisy children playing in its streets would one day bring it lasting fame. Had they known, François La Tour and his wife would probably have been the most surprised of all! Their nervous little Maurice was a hopeless student, always sketching instead of studying, and hardly the sort of son a member of the church choir could point to with proper fatherly pride.

Holdane Macfall, the art historian, gives us a colorful description of the years that followed. At fifteen according to Macfall, Maurice ran away from home. At the bottom of a Tardieu print, he had found the address of the famous engraver and boldly written to him. On the strength of an encouraging reply, he headed straight for Paris; but when Tardieu discovered that young Monsieur La Tour had no interest whatsoever in engraving, but wanted only to paint, he gave up all ideas of taking him as a new apprentice. Perhaps amused by the boy's ingenuity, Tardieu sent him instead to the studio of Spoede, where he

quickly learned the techniques of painting—meanwhile sampling the varied delights of Paris.

After several years La Tour returned to Saint-Quentin, but involvement in an unsavory escapade soon sent him dashing off to Cambrai, to the bewilderment of his long-suffering parents. The next year found him in London, mercifully by now a more sober and mature young man. While in England, he was greatly impressed by the works of Van Dyke, in great vogue there, and by the time he returned to Paris had set his heart on portraiture. He entered the Studio of Dupouch, and it was not long before he had decided on the new, much talked of medium of pastel— a perfect choice for La Tour! Pastels were inexpensive, quick and easy to handle, and spared him the smell of paint and varnish which had always so annoyed him.

La Tour's first pastel to be engraved was a portrait of Voltaire, and already one sees him to be a finished master. How our gay young blade from Saint Quentin and the erudite man of letters ever met is hard to imagine, but in any event their friendship had a profound influence on the artist's life.

By the time La Tour had reached his early thirties, it was clear that he had undoubtedly 'arrived'. An elder brother, Charles, somewhere along the way, had amassed a fortune, so the two shared quarters near the Rue St. Honoré, and a life of ease and luxury seemed now assured.

La Tour's rise in the gilded society of Paris was swift and heady. He found himself constantly in the company of the rich and celebrated, and soon began to take on their attitudes and mannerisms. He was rapidly becoming 'one of them'. Luckily, for the new role, he looked the part—a pale handsome face, piercing blue eyes, a well shaped head, an erect carriage. Always flawlessly groomed and polished, he resembled nothing more than those fastidious gentlemen of fashion his pastels would one day immortalize.

At the same time, La Tour's personality was beginning to take on a strong and definite pattern. Though he could be curt and caustic with his late found companions, toward old friends and poor relations, he was all gentleness and affection. His uncontrolled display of nerves and temper were reserved solely for his spoiled, rich patrons. Members of fashionable literary circles were likely to be the recipients of his long philosophical ramblings, which, it must be added, they found far less brilliant than his art. Nevertheless, his great personal fascination saved him from ever boring them, even while his ideas were often banal, or hopelessly involved.

So much for La Tour's presence among the high and mighty.

54

We would have had to look behind the scenes of the opera and the theatre if we had really wished to see our genius at his happiest. The singers, the actors, the little known musicians were all his adored friends; with them he laughed and relaxed and sketched their portraits as they gossiped in the wings, awaiting their next cues. Many owe him their only immortality, for he alone recorded their brief moment of glory. It was here that La Tour found the only love of his entire life, an exquisite delicate creature with a lovely lyrical voice, Madmoiselle Marie Fell. She returned his sensitive affection and remained with him almost until the end, inspiring, soothing and encouraging.

La Tour was surely a man of enormous versatility and appeal, for we find him to have been a great favorite among the clergy as well. Granted, the priests of eighteenth century France themselves enjoyed a cultural ambience, and were clever observers of life and art—perhaps more concerned with "humanizing" ideas than with religious rotes and dogmas. La Tour sketched many of these worldly gentlemen of the cloth with his practiced skill and a searching eye. Though the portrait of Abbé Huber is certainly the best known, all of their likenesses invite serious observation, for as Holdane Macfall describes them, they were the "supreme paradox of the day".

In planning most of his masterpieces La Tour made quick preliminary sketches, catching the first impression of the sitter. He seemed to probe beneath the surface into the very souls of men. The gay manner, the pious attitude—whatever the superficial façade—it could never hide from him the true person beneath. In these hurried sketches La Tour purposely recorded only the subjects' features, ignoring completely their adornments. Here are examples of portraiture at its purest, and they hang today in the museum at Saint Quentin, a reminder of the heights to which pastel once aspired.

In May of 1737 La Tour was made an Associate of the Royal Academy. In that same year the first Salon of Louis XV was opened to the public—a glorious moment for France, and a tribute to La Tour, Boucher, Chardin, and all the other Academicians.

La Tour immediately seized upon his right to exhibit, and sent off that first year a portrait of himself and one of Boucher's pretty young wife, Jeanne Marie. The portraits were received with overwhelming praise and were the first pastels La Tour had ever exhibited to the public. In one swift moment he had 'arrived' as the master of the medium, and was hailed as the greatest pastellist in France! The qualities of force and vitality so brilliantly displayed in these works showed the world new possibilities for the medium.

A whole school now sprang up around La Tour, and even painters of such lofty reputation as Boucher, Fragonade, and Chardin were encouraged by the success of their friend to try pastel. Ducreux, Drouvais, Roshin—all came to La Tour asking for instruction, and even Madame Vignée Le Brun put her skilled hand to the new medium at his encouragement.

The Frenchman, Joseph Vivien, had made some noteworthy portraits in pastel even before the fated arrival in Paris of Rosalba and the start of the new vogue, but had removed himself from the artistic center to go to live in Bonn; the adopted Swede, Gustaf Lundberg, though still in great demand, was no longer a threat. Maurice La Tour was now the unchallenged leader of the French School.

A pastel by La Tour became an absolute "must" for the celebrities of the day. So in demand was the dapper young artist that it required the most involved intrigue to be placed on his waiting-list of commissions. From the bright young dancer at the opera to the King, himself, La Tour limned the various faces that peopled the stage of eighteenth century France—and these probing character studies in colored chalk tell us more of the times than a thousand words. The honesty of La Tour's vision, the sympathy and frankness with which he saw those whom he portrayed forever place him among the world's artistic geniuses.

Well, by now certainly everyone knows that Louis XV and his Queen were not on the best of terms, to say the least—and that the King entertained a series of 'consolations' in his royal plaisances in and around Paris, without even the slightest gesture toward an exercise of discretion. All of which brings us to one Marquise de Pompadour, by far the most consoling of all. A beautiful, ruthless woman, she ruled Louis and France with a steely will, and fortunately for our pastellists, was possessed of great intelligence and taste. It was she who promoted the arts and protected the artists. Without her, their careers might never have been so brilliant. Our friends La Tour, Boucher, and others met together in her drawing rooms and were a part of the stimulating, talented group she encouraged. Pompadour tirelessly surrounded herself with a galaxy of genius and wit, for Louis the "Well Beloved" had to be kept amused at any cost. She organised theater in her apartments, and filled her palaces with painting and sculpture. Even the looms at Gobelin and the porcelain factories at Sevres were all under her watchful aegis. Scheming, unscrupulous, grasping—all of these described the royal mistress, but to her credit it must be said, her love of art was sincere.

Adored by the court of Louis and Pompadour, La Tour exhibited in 1741 his first really large pastel—more than six feet in

height, and courtiers and critics alike gave it extravagant praise. The next year his portrait of Madame la Presidente de Rieux, mask in hand, dressed for the ball, was a sensation. His entries at the Salons in the years that followed included portraits of Louis XV, the Dauphin, the Duc de Villars, the Comte de Vignarry; the critics hailed La Tour the "King of Pastels".

La Tour could well afford now his famous temper tantrums and the outrageous demands he made upon his sitters. He soon began to insist they pay according to their station, and seemed to enjoy forcing lofty personages to beg for the privilege of sitting for him. He was frank and outspoken, reproaching the Dauphin for his gullibility, and informing the Prince that his children were miserably behaved and needed discipline. Once, however, while making a portrait of Marie Joséphe, Louis XV's daughter-in-law, he found his presumptuousness met with such courtesy and forbearance that finally, in embarrassment, he begged the dear lady's forgiveness. He even ended by presenting her with a decorated snuff box in apology—the supreme token of capitulation!

Though ensconced in a Louvre apartment and enjoying the gilded life, La Tour sought with increasing frequency the companionship of intellectuals above the society of the Court, and would brief himself from Boyle's Dictionary before going into their company, in order to sound properly knowledgeable. The beliefs of the great philosophers struck a harmonizing cord within his soul, as he came to share their passion for liberty and their contempt for mediocrity. He held a simple faith in a Supreme Being, along with noble ideals for the betterment of mankind. Though brilliantly articulate with brush and chalk, La Tour somehow never seemed able to express the profound in words— in spite of help from Boyle. His thoughts would always pour out in an erratic and confused fashion, and were poorly tolerated by his associates.

By 1746, La Tour had advanced to the rank of full Academician and soon the list of his portraits in the Salon's Catalogue read like a roll-call at Court. He used the strength of his position there to argue for higher prices for himself and other artists, feeling that the State should protect and encourage its geniuses. Unfortunately, at about this moment in his career, he began to experiment with fixatives, thereby damaging some of his finest works. We are told that one of his 'secrets' was to cover the back of his paper with spirits of wine, and to follow this with a coat of white varnish. The results were a complete disaster.

It was only a few years later that La Tour left the apartments in the Louvre and moved to Pigalle, the first of a long series of aimless changes of lodgings.

He was already forty-seven when he was finally accorded the title of 'councillor' in the Academy, the crowning recognition for one whose field was limited solely to portraiture. This honor would have doubtlessly come to him sooner had he not fought constantly with the State over the fees it paid to its artists.

La Tour must have thoroughly enjoyed making the controversial pastel of Jean Jacques Rousseau. In the presence of the gentle philosopher he was never provoked to his usual fits of temper or vitriolic outbursts; here was a sensitive, poetic soul with whom La Tour could communicate while he worked. Rousseau, himself, was pleased with the portrait, and La Tour —seldom satisfied with his own work—felt he had done his best. The critics, however, charged it with being a "pretty affair instead of the masterpiece he could have made it".* One imagines they resented so free a soul as Rousseau being placed in a rush bottomed chair, wearing the velvet trappings of the life he decried.

*Macfall, H.: "The French Pastellists of the Eighteenth Century" pp. 120

A portrait La Tour did not relish making was that of his patron, la Pompadour. In fact, he studiously avoided it as long as he safely could, partly out of caprice, and partly, as he wrote her envoy, because he did not wish to paint "before the whole town".* Finally, after two years he consented to make some sketches, but no sooner were these begun than La Tour wrote that he was a "prey to despondency, to a depression"* that he feared would "bring on a fever"*—and who knows what other vague ills and ailments. It is an eloquent tribute to La Tour that, instead of arousing murderous visions of his head upon the block, these delays brought forth only more pleading and flattering letters from the omnipotent Pompadour herself. Ultimately, like a victor in battle, La Tour laid down the terms—no interruptions from anyone whomsoever, during the sittings—and Pompadour humbly agreed.

*Macfall, H.: "The French Pastellists of the Eighteenth Century" pp. 138, 139

The Goncourts describe for us the scene of the first sitting. The artist had taken off his shoe buckles, his garters and neckerchief, and sat his powdered wig upon a candelabrum. He had just pulled a cap over his head and begun to sketch when the King burst through the door—registering obvious astonishment at his state of disabile. La Pompadour laughed! That was too much! La Tour quietly folded his easel, took off his cap, replaced his wig, assembled his items of wardrobe, and then, despite pleas from Louis and the willful beauty, flatly stated, "I will come back when Madame is alone".* He did indeed keep his promise, but during the subsequent sittings poor Pompadour's health began to break, and it was only with the aid of the apothecaries and perfumers that she was able to hold on a little longer to her fading beauty.

*Goncourt, E. and J., "French Eighteenth Century Painters" pp. 177

After three years his hard fought portrait was finally completed—La Tour's largest and most ambitious pastel, and destined to be the sensation of Paris. He caught Pompadour's cultivation and charm, as well as her shrewdness and calculation. The critics found this the epitomy of his accomplishments. La Tour had not long to wait, however, to discover the sting in the tail of his success. Pompadour refused to pay his price, and he was finally forced to settle for only half of it—a wound both to pocket book and pride.

In the years 1761 and 1762, La Tour sent to the Salons many pastels of the royal family, among them the Comte de Provence, afterwards Louis XVIII. Each of his entries added laurels to his reputation. For the next five years he exhibited nothing, and at the age of sixty-two suddenly decided to go to Holland. He did a few portraits there, but in them one sees that La Tour was now beginning to show his age. When three years later he sent four pastels to the Salons, he was to hear for the last time the sweet soothing music of the critics' praises. The following years his entries were greeted with a sepulchral silence. La Tour in a night became old.

It was only a matter of time before his brilliant mind began to weaken, and the bright flame of his genius to burn low. He worked steadily on, becoming obsessed now with finding the ideal method of 'fixing' his earlier pastels. Diderot laments that the old man seems to have used the "last of his life to spoil the masterpieces that he created in the vigor of his days". The artist, himself, was aware that the sand in the hourglass was running out.

La Tour made his will, and set up scholarships to educate young artists, establishing three student prizes at the Royal Academy. At the same time, he endowed a foundation in his native Saint Quentin for old and infirm artesans, as well as a school to give free classes in drawing to children.

For all his farsighted charitable plans, his poor brain was beginning to lose its clarity. Always fascinated with the occult, La Tour now took to concocting the most nauseous nostrums with which he proposed to regenerate his thinking faculties and bodily functions. Some terrible arguments resulted from his efforts to force reluctant friends to join him in sampling them. His favorite was a particularly loathsome brew called "fasting water".* He is said to have choked down several pints a day, with who knows what pathological unheavals as a result. In any event, it certainly does not appear to have helped him any.

*Macfall, H.: "The French Pastellists of the Eighteenth Century" pp. 193

Having already moved La Tour's belongings to a house the artist owned at Chaillot, his devoted step-brother—with the help

of Marie Fell—gently persuaded him to return at last to Saint Quentin. Those two, who loved him most, could not bear to see the pity and embarrassment in the eyes of the old Parisian friends who had known him when his genius burned the brightest.

La Tour's homecoming was celebrated with cheers and church bells, and even a holiday was declared. He went to live near his step-brother, and for the first time since their fateful meeting years ago, he was parted from his adored Marie. The lovely singer realized that such an informal relationship as theirs would be poorly tolerated in the provincial town of Saint Quentin, and so reluctantly stayed behind. La Tour left her everything he possessed at Chaillot for her lifetime—except his treasured telescope. Why this last should have been withheld from the dear lady we shall never know, along with why such a devoted and faithful couple never married.

His intellect gone, poor La Tour could be seen wandering the streets of Saint Quentin embracing trees and assuring them that soon they would be used for fire to warm the poor. Mercifully, at eight-four, the old man quietly died, and was buried by his townsmen in Saint Andrews churchyard, their most illustrious son.

This was in 1788. In the deluge that followed, the name of La Tour with all the rest was, for a time, lost in abysmal silence. But he who gave back to portraiture its reality was not forever to be forgotten. As long as art endures and the memory of eighteenth century France lives on, Maurice Quentin de La Tour will stand pre-eminent, his pastels a tribute to the wondrous talents of mankind.

JEAN BAPTISTE PERRONNEAU
(1715-1783)

Poor benighted genius—what unlucky star presided at his birth? The life of Jean Baptiste Perronneau was a kaleidoscope of disappointments, one tumbling atop another—with only brief flashes of happiness, doomed to vanish as soon as they appeared.

Little is known of Perronneau's childhood, save that his father, Henri, was a burgess of Paris, and that at an early age little Jean Baptiste was apprenticed to an engraver. The child showed an early interest in drawing, and on his own initiative studied art in what few spare hours he could steal from his work. Even at this age, the restless, unstable temperament that was forever to haunt his days kept him in an uneasy, anxious state of mind.

Having launched on his career well after pastels were the established vogue, it is not surprising that he came to them

almost from the beginning. They were easier to handle than oils, and well suited to his nervous impatient nature. His first efforts were awkward and unskilled, but within six months—despite his nomadic wanderings and erratic habits—Perronneau managed to bring his talents under complete control. Soon his exquisite pastels began to receive their deserved acclaim—and were to be described years after his death as the "most brilliant chapter in the history of pastel in the eighteenth century".*

*Vaillat, L. et Ratouis De Limay, P.: "Perronneau" pp. 72

Just at the moment of his big success, however, a sudden reaction against the medium revealed itself at the Academy. Pastel was too facile, too short lived. Alex Loir, the most recent pastellist to be elected to the Academy, had been cited not for his pastels, but for his "talent in modeling".* The point was obvious. It would be poor Perronneau's luck to 'arrive' at just the wrong moment!

*Macfall, H.: "The French Pastellists of the Eighteenth Century" pp. 111

Unable to ignore his rare genius, however, the Academy did finally elect him to membership, but insisted that his two portraits of acceptance be done in oils, and not pastels, his great forte. Characteristic of Perronneau's disorganised mode de vie, it was seven long years before he got around to presenting the required oils. Meantime he exercised his privilege to exhibit his work at the Salons, sending on one occasion a portrait of the Most Reverend Abbot of Saint Genevier, along with that of a dancer. The unlikely combination of subjects almost overshadowed the critics' praises of their execution.

Of all the superb pastels Perronneau sent to the Academy through the years, to his sad misfortune, the most talked of was his portrait of La Tour. And here fate struck again. La Tour, so goes the story, also made a portrait of himself that same year in much the same pose as the one by Perronneau. The pastels were both sent to the Academy to the same exhibition, and through an unhappy set of circumstances were even hung side by side! Perronneau's portrait, excellent though it was, suffered by comparison; and was not only denied its just acclaim but received, instead, unflattering notoriety.

We learn that Perronneau never painted for the court. His sitters came from the "well-to-do" middle classes, so we have very scant records of who they were or what they did. His portraits had great qualities of sensitivity and truth, but despite his many admirers, he could never seem to attain to the heights of praise enjoyed by La Tour.

After his long delayed paintings for the Academy were finally presented, commissions began to come his way in vast numbers. Perronneau felt sufficiency established to propose marriage to

the pretty daughter of Louis Francois Aubert, himself an Academician and pastellist. The girl accepted, and here, at last, seemed a chance for stability and happiness. His work in the years that followed was prolific.

As luck would have it, just when things were going well for him, Perronneau's old vagabond restlessness suddenly returned to plague him, and he was soon off again on his gipsy-like wanderings.

In Bordeaux, Perronneau found many sitters, and left behind some of his finest pastels; but his erratic, demanding behavior won him few friends. The poet, Robbé de Beauveset found him impossible to sit for, complaining that the artist wouldn't even allow him "to blow his nose".*

*Macfall, H.: "The French Pastellists of the Eighteenth Century" pp. 135

These nervous wanderings sent him next to Lyons, then down to Italy, then up to Holland. In each city he found work and instant acclaim, but never peace. He wrote back to old friends describing his dilemma. According to his distraught letters, he had to be alone in order to paint . . . the children's constant whining drove him wild . . . the family was in dire need of money . . . he had no choice but to continue his work. In what arid soil does genius sometimes flourish!

A second sojourn to Holland only added to the misery of the dismal little family. Perronneau's wife became ill in his absence, and for the first time he found a lack of sitters, just when he most needed them. The barbs of the critics at home were only an added abrasive to his discouraged spirit, as Perronneau's own health began to break under the strain. He returned to Paris to discover that his once great vogue there had passed. He thought then to travel back to Lyon, the scene of former triumphs, but the trip proved a complete disaster when he found his delicate pastels no longer in demand.

Another child arrived in the Perronneau household, and his poor young wife sank into a deep melancholy following the birth. Perronneau continued to send portraits to the Salons, but was becoming increasingly distracted and discouraged. More and more he was plagued by comparison with La Tour. In 1777 his entries were treated with harsh comments from the critics, and in 1779, his last appearance at the Academy, his work received no notice whatsoever—the most feared denouncement of all!

In that same year, however, he created one of his greatest masterpieces, the portrait of the Comte Goyonde Vandurant. It was indeed so well executed that for a long time it was falsely attributed to La Tour. Perronneau seemed doomed to lose at every turn of the wheel.

In 1783 he made one last trip to Holland, where he ignominiously died at the age of forty-two. His death notice read, "—Jean Baptiste Perronneau, of no particular profession—".

With the Revolution, his once great reputation was swept into oblivion, but for those who treasure truth and delicacy in portraiture, the name Jean Baptiste Perronneau will ever hold a hallowed place.

FRANÇOIS BOUCHER
(1703-1770)

François Boucher—the very name, and before our eyes float rosy cherubs on plump pink clouds, their glossy curls wreathed in garlands! But when our vision clears, we must take a long, hard look at a dedicated genius who, at the height of his fame, was hailed "the glory of France".

Born a year before La Tour, the infant François was the son of a young Parisian couple who greeted his arrival with wild enthusiasm. His father, a humble designer of embroideries and chair covers, became so carried away at the baptism that he signed the certificate "Master Painter"! But then this was the age of extravagant conceits and gay pretentions; so why not?

The little François grew up in a happy, haphazard household —a laughing, light-hearted child, loved for his charm. His one absorbing interest was drawing. When he was seventeen, he gained entrance into the studio of the revered Academician, Lemoyne, where he eagerly absorbed all he could learn from the old master. So successful were his efforts that he won the coveted student's prize given each year by the Academy, and on the day his name was announced, his raucous fellow students rode him in triumph on their brawny shoulders around the courtyard of the old Louvre palace. Boucher's career had been clearly decided.

The young artist soon came to know the great Watteau, and under his guidance developed a harmony of taste and a rich color sense which he never lost. Through Watteau he became aware of the true spirit of France.

Eager to see the treasures of Rome and Venice, Boucher saved enough money by his twenty-fifth birthday to make an extended tour of Italy. Dazzled by what he saw, he still wrote back courageous and sincere opinions of the Italian artists. Corregio he found "gloomy", Raphael "insipid" and Michelangelo "contorted". Deserved or not, these criticisms, boldly expressed, proved him to be a free-thinking Frenchman, unhampered by artistic pedantry. He wandered about for three years, finally returning to his native Paris with a definite style

and fresh ideas of his own. This was the era of powdered wigs, rouge pots, and fans—and our handsome Boucher was a living symbol of it. He had wearied of the pale Italian Madonnas with their patient, beatific smiles, and chose instead to romanticize a rosy, glazed-eyed Venus—and Paris cheered. François Boucher was elected to the Royal Academy the following November, to the surprise of no one.

Two years later, a Mademoiselle Marie Jeanne Busseau, with shining blond hair and a roguish smile, pirouetted gracefully into Boucher's life and completely obsessed his every thought. Theirs was an idyll of bliss from the beginning, as Marie Jeanne was herself an artist, with an absorbing interest in Boucher's career. After their marriage Boucher began to use her as the model for his famous Pyche pieces—she posed for nymphs and goddesses until her lovely face was well known to all of France. Maurice de La Tour thought the little bride so charming he made a pastel of her to send as his entry that year to the Salon. Everyone found the child a pure delight.

Boucher was soon happily at work on his painting "Renaude et Armide", destined for the Royal Academy. Its acceptance would enable him to claim his seat there, a moment he had long looked forward to with pride. The magnificent work brought him to the King's attention, and led to his becoming the new court painter. It was indeed an eventful year for the young Boucher.

Soon on his canvases cherubs began to descend, in winged and dimpled profusion—and his famous shepherdesses to loll about in dreamy somnolence. The milk-maids he glorified were coquettish and charming, and even his coal heavers appeared groomed and dandified. Boucher refused to see the realities of life behind the make-believe, and Paris loved him for it. The favored few, who could afford his art, wished life to be one long minuet—danced with half closed eyes, lest the miseries outside their enchanted circle offend the sight. France was at an "airy moment in history".*

*Goncourt, Edmund and Jules: "French Eighteenth Century Painters" pp. 55

In 1755, to his great delight, Boucher was summoned to France's tapestry works, and there he created those exquisite designs for which "Gobelin" is famous. His pastel sketches were now in great demand, and bore the same mark of diffused light and airy ambience which characterized his paintings. He had been introduced to pastel by his friend La Tour, and the delicate medium proved ideally suited to Boucher's touch.

Back in Paris again, our smiling, gay, debonair artist spent all his days at his easel, working for the sheer joy it brought him, as well as for the fame and wealth. His nights were spent in care-

free carousals, and the firm conviction that tomorrow would never come. The critics, even while praising him, began to notice that the heads of his women seemed always more "coy" than "noble", but Boucher was unconcerned. The amount of work he was producing during those years was enormous, and despite the critics innuendoes, he knew that his art clearly spoke the language of the day.

Pompadour's brother, whom the King had made his Minister of Art, wrangled a pension for Boucher and even secured for him an apartment at the Louvre, which for an artist was the ultimate accolade. Boucher was now so busy he refused to take the time to draw from life. He began to rely solely on his memory, until the quality of his work showed a gradual, irreversible decline. His vision became less clear and his hand less sure. The critics began to label him as "the painter of fans" and to ridicule his "exasperating rose tints".* Even Diderot voiced his contempt that such a talent should be "debouched" to gain the praises of shallow men. He regretted Boucher's influence over younger painters, less they, too, strive for prettiness and vapidity in their work.

*Macfall, H.: "The French Pastellists of the Eighteenth Century" pp. 129

Boucher, himself, could not completely ignore the changes that were in the air, as the ideas of the great philosophers penetrated the public's taste. His old magic was gone, and he was now approaching a premature old age. Though spent in body, his great love for work held him to the easel till the very end. On a soft May morning in 1770, a knock on his studio door brought no reply. He was later found seated before a picture of Venus, his brush fallen from his hand, and that joyous spirit gone somewhere far away to join the cherubs in their endless frolic.

JEAN BAPTISTE SIMÉON CHARDIN
(1699-1779)

Simple, honest old Chardin, of all people, was to end by giving eighteenth century France, one of its greatest achievements—the purification of its art.

But let us go back into his life and map the turning points that finally led to this remarkable contribution. Chardin's beginnings were certainly inauspicious enough. His father was a maker of billiard tables to the Court of Versailles, who, when young Siméon evinced an interest in drawing, reacted with a show of horror. He deemed any form of art detrimental to the earning of a livelihood, so poor little Siméon was quickly shunted off to his father's work shops in an effort to erase all such 'foolishness' from his mind. Instead, he developed a lasting distaste for billiard tables and a firm determination to follow his own star. He always spoke with regret of those wasted years.

Finally the elder Chardin was persuaded to send his son to study with a painter of sorts named Cazes, whose sole form of instruction was to give his students his own uninspired works to copy. Needless to say, Siméon learned little from this dubious source of study, and grew restless and increasingly anxious to work from models. On his own initiative, he transferred to the studio of a young artist, Nicole Coypel, and to him he was to owe a lifelong debt of gratitude. It was Coypel who taught him to give studious attention always to his models, and to observe even the smallest details of their structure.

It was likely through Coypel that Chardin's first real commission came. He was asked to assist in restoring the paintings at Fontainebleau, a distinct honor for one so young. The boy must have remembered that journey, for it was the only one he ever made outside Paris. His reputation was greatly enhanced by the glamorous sojourn, and the name, "Chardin", was soon to be bandied about the studios in warmly flattering terms.

Among the commissions which now began to come his way was one for a small, swinging sign to hang above a surgeon's office—a routine job at best, but Chardin turned it into an epic making event. On a simple, oblong board he painted a scene, entitled "The Duel"—and soon wide-eyed crowds were literally gaping in the streets before the surgeon's door, many members of the Royal Academy among them. We never learned whether or not the surgeon's career prospered as a result of all the excitement, but we certainly know that Chardin's did. That little swinging sign contained the same elements of honesty which in his later works were to give the art of France a new feeling of reality and truth, and Paris sensed the touch of a genius.

Chardin was unimpressive in appearance—short and muscular, with a pleasant round face and kind, genial eyes. He was a conventional person in unconventional times—loyal, trustworthy, and for his friends, a living symbol of stability. He was unassuming and reserved in manner, without the slightest trace of jealousy. In every altercation involving fellow artists it was "good old Chardin" who had to act as arbiter and peacemaker, and it was always to his door that struggling students came for criticism and advice. How fortunate for the world that this same honesty and sincerity found its greatest expression in his art.

History records only one incident in which Chardin lost control of his temper, and this, interestingly enough, involved an insult received from Baron Thiers, a sort of "lackey" of Rosalba's friend, Pietro Crozat. According to Holdane Macfall, the husky artist quietly picked up the offending gentleman, hurled him headlong down the stairs, and never once referred to the matter again.

For years Chardin lived with his wife and son in a house on the Rue Princess, painting steadily night and day. He was fascinated by still-life and adored sketching animals, always working from careful observation of a model. What an odd sight this gentle, homely fellow must have been, wandering through the streets of Paris in search of dead cats, dogs, and squirrels to take to his studio.

In his extreme modesty, Chardin charged very little for his paintings and soon became pathetically overworked. By the time he was forty-four he was a sick man—but unable to alter his pace, he drove himself relentlessly. After the tragic death of his wife and new-born daughter he was completely desolate, and only his growing reputation and the insatiable drive to paint brought any comfort to the lonely days that followed.

A second marriage to a practical "managing" type of woman seemed to bring his life again into focus, and it must have been at this moment that he decided to try pastels. The result was a surprise to his contemporaries and a boon to the world of art. Chardin's handling of the medium was a startling innovation. The British art scholars, Richmond and Littlejohns, have best described his technique: "Chardin broke up light and shadow into touches of pure color, the juxtaposition of which gave the appearance of things seen in an ambient atmosphere".* Chardin was indeed setting the stage for one phase of Impressionism.
*Richmond, L. and Littlejohns, J.: "The Art of Painting in Pastel" pp. V

Pleased with the acceptance of his work, the artist began to make numerous portraits in pastel, realizing in these the greatest possibilities of the medium. History always notes that through Chardin pastel attained new dignity and statue.

Despite Madame Chardin's business-like approach to life, the family always seemed short of funds, and constantly harassed by bill collectors and creditors. Things came to such a pass that members of the Royal Academy appealed to the King to grant their beloved genius a pension of 500 livres. The sum was immediately approved, and eighteen months later Chardin was given one of the coveted Louvre apartments as well. He must have had mixed emotions about leaving the little house on the Rue Princess, where he had doubtless known his happiest hours, but soon we see him packing the shabby old trunks and starting out for his new, impressive residence.

It surprised no one when tried and trustworthy Siméon Chardin was appointed treasurer of the Royal Academy, as well as arranger of pictures at the exhibitions. With his particular character, this latter honor of course meant his own entries would always be hung in the least conspicuous spots, and seldom to their best advantage.

Life now followed a monotonous pattern of work; the only interruptions were unpleasant ones, caused by his reckless, erratic son for whom he had earlier held such brilliant hopes. The boy's untimely death, believed to be suicide, was almost more than the tired old man could bear. Where had he failed as a father? He, who had always tried to encourage the young, had been powerless to help his own son.

His spirit broken, Chardin's health grew steadily worse. By now money had become such an urgent problem he was forced to sell the beloved house on the Rue Princess, a part of himself going with it. On a bleak Christmas day that same year he resigned from the office of treasurer of the Royal Academy, needing to spend all of his time now at his easel.

Chardin's last years were spent working in pastels, the medium he discovered so late and to which he gave such importance. Though his eyes were growing weak and his hand less steady, he seemed in these pastels to have recaptured the vigor of his youth and the superb technique of his finest years.

In 1779, he died at the age of eighty-eight, meeting death with the same courage and simple faith with which he had lived —and in his great humility, completely unaware of the wondrous heritage he left behind.

GUSTAF LUNDBERG
(1695-1786)

Lundberg, the gifted Swede, was a member of the French school of pastellists, but according to his own words was inspired to his career by a meeting with Rosalba Carriera.

Born in Stockholm in the last years of the sixteenth century, young Gustaf, on his mother's side, came from a family of noted artists. An uncle, David Richer, had established himself in Vienna as a fashionable portraitist, and several cousins were painters by profession in Sweden.

Though Gustaf's grandfather sent him to the University of Uppsala with a carefully chosen tutor to supervise his education, the boy's stay at school there was brief. He was far too embued with an inherited love of art to pursue a normal course of studies. His dear old grandfather understood the boy's frustration. He allowed Gustaf to leave Uppsala, and took him, himself, to the studio of David Krafft, the court painter, for training in drawing. Though Krafft's talents at this period were somewhat in decline, and his involvement in an unpleasant divorce procedure took his concentration from his pupils, still young Gustaf benefited greatly from a stay in his studio. After the first few lessons he was helping to prepare portraits for Krafft—sketching in the backgrounds and costumes of the sitters.

With an excellent groundwork laid, Gustaf Lundberg, like so many fledgling artists of his day, longed to go to Paris. So it was, in his twenty-second year, he packed his bags and set out on the long journey down from Sweden. Fortunately, he was not just another aspiring 'foreigner' with only his talent to recommend him—Erik Sparre, the Swedish Ambassador to France, had given him letters of introduction, addressed to such established names as Rigaud, Largillierre and Francois de Troy. Thanks to these artists he was allowed to attend the coveted classes given by Cazes at the Academy, and his first years in Paris were spent perfecting his technique.

His truly big moment came, however, when a friend presented him to Rosalba Carriera. In no time he was converted from oils to pastels, partly out of admiration for the Venetian woman's great talent, and partly from a sudden infatuation with the new medium—"light and diaphanous as the wings of a butterfly".* Though Rosalba gave lessons to the young Swede, we find no mention of him in her diary.

By the time he was thirty years old, Lundberg had gained flattering recognition in the highly competitive artistic world of eighteenth century Paris; and important commissions were now beginning to come his way. He had the honor of making one of the first portraits of Marie Leczinska, the gentle wife of Louis XV. It must be admitted, however, that Lundberg's talents were not the only consideration involved in his receiving this coveted commission. The King of Sweden was greatly attached to Stanislas, Marie's father, and had staunchly supported his claim to the Polish throne—and Lundberg was a Swede. Added to this political nuance, the artist's portrait of Louis XV had just been reproduced in enamel and was causing something of a sensation in the sophisticated circles of the court.

Lundberg's pastel of Marie Leczinska was executed at Fontainebleau. Upon its completion the artist decided to follow Stanislas down to Chambord, where the deposed monarch had settled himself into a highly pleasant and comfortable life of exile. Lundberg made several portraits of him, and even gave him lessons in pastel. During these same years he made portraits of the Prussian Ambassador, Le Chambrier, Elizabeth de Condé and Alexandrine de Bourbon. Only when Stanislas regained the throne and returned to Poland did Lundberg finally move back to Paris.

In 1733 the talented Swede made two more portraits of Marie Leczinska—one for Versailles and one for Marly—which naturally inspired still more commissions from members of the royal family. By 1735, according to Ratouis De Limay, Lundberg's reputation was established as a pastellist with perhaps

*Lespinasse, P.: "Les Artistes Suedois en France" pp 58

only one possible rival—La Tour. Even the great La Tour had not yet been accepted by the Acadamy, and Perronneau was at that time still little known.

By luck, one Carl-Gustaf Tessin was named Swedish Ambassador to Paris, a gentleman of great taste and cultural interests. The eminent diplomat's father was superintendent of the beaux-arts in Sweden and had built the royal chateaux of Stockholm. In Tessin, Lundberg was to find a patron and a sincere friend. Tessin immediately asked the artist to make replicas of his lovely pastels of Elizabeth de Condé and Alexandrine de Bourbon, as well as commissioning several new works to hang on his walls.

These were busy days for Lundberg, for not only were his Paris clients impressive in name and large in number, but every important Swede who visited the fashionable capital wanted a portrait by their famous native son.

In 1740, he was voted to membership in the Royal Academy, but, being a Protestant, his admission was automatically withheld. Fortunately, the old precedent which barred all but the followers of the "faith" came under serious scrutiny the following year. The rules were subsequently altered, and the Academy agreed to receive Gustaf Lundberg as a "foreigner".

His two portraits of acceptance at the Academy were pastels of Boucher and Natoire, both works of outstanding beauty. To the Salon of 1743, he sent a portrait of Boucher's little wife, Marie, which proved a great success as well. It was at this same period in his life that he executed his excellent pastel of Etienne Massé.

Lundberg, like La Tour, took pupils into his studio, and it is to his credit that several of these later became known in the field of portraiture. It was always Lundberg's special talent to impart a lifelike animation to his subjects. His models "live". This gift was combined with a sure knowledge of design, warmth of color, and an elegance of proportion.

After Tessin's departure from Paris, Lundberg remained at the Swedish Embassy until 1743—when, to be more free, he moved to the house of a certain M. Le Maitre in the rue Vieux Colombier. There he became swept into a whirlwind romance with the landlord's daughter, which ended in such grievous disappointment that the poor artist is said to have developed a miserable case of jaundice!

Now, with no bonds of love to hold him and his work at the Academy no longer a challenge, Lundberg, for the first time, considered leaving Paris. The art scholar, Lespinasse, suggests another reason: La Tour and Perronneau had arrived—with their "vigorous naturalism" and "clear and precise observation".

Perhaps the Swede sensed their superiority and the public's swing to their favor. In any event, Gustaf Lundberg began to negotiate with an intermediary of Tessin for an official post in Stockholm.

After twenty-eight years in France he said a sad good-bye to his Parisian friends, and set out on a voyage to Spain and Portugal which would eventually take him home.

The Sweden to which Lundberg returned was greatly changed. A new aesthetic awareness had developed in his absence; the Academy of Beaux Arts had been founded in 1735 and a great artistic awakening followed. Upon his arrival, he was overwhelmed with commissions, and in 1760 was elected to the Academy of Art of Stockholm. The ascension of Gustaf III to the throne brought royal favor and commands for several portraits of the new monarch—always in pastel.

Lundberg revisited Paris only once, but meantime sent entries to the Salons and filled his days making portraits of such Swedish notables as Count and Countess Fersen, the great military commander, Count Swerin, Senator Ribbing, the Baroness Gyllencrone and Countess Ebba Margaretha Bonde. His portrait of Juliana Henck was his last masterpiece, containing all the best elements of his talent.

But Lundberg and his medium were gradually slipping in popularity. Portraitists such as Roslin and Pasch, working in oils, were now the rage. In 1780, Lundberg became ill and discouraged. His clientele was disappearing, his studio was no longer a brilliant center—in a final effort to hold on to his fading vogue, he once again took up his brushes and began to work in oils.

Lundberg died in Stockholm at the age of ninety-one, having executed more than five hundred portraits in his long lifetime. Alas, many of these will forever be labeled "artist unknown", and others have been falsely attributed to rivals—for Gustaf Lundberg, for all his talent, rarely ever put his signature on any of his glorious pastels.

JEAN-ETIENNE LIOTARD
(1702-1790)

Born in Switzerland, a member of the French school of pastellists, and known as the "Turkish Painter", Jean-Etienne Liotard was a true cosmopolite with a vagabond heart. His father, a goldsmith of French origin, had angrily turned his back on France, as had so many other Protestants, when, without reason, Louis XIV revoked the Edict of Nantes. An avowed ex-patriot,

Antoine Liotard, established himself at Montelemar, and so it was that the little twins, Jean-Etienne and Jean-Michel, were born in Geneva and christened into the Calvanist faith.

Early in life both boys showed an aptitude for drawing. Jean-Etienne was sent to study in the studio of Gardelle, the elder, in Geneva, and soon began executing creditable portraits from life. By the time he was twenty-one, his father was sufficiently convinced of his talents to pack him off to Paris to "finsh" his education. All went smoothly for nearly three years. Jean-Etienne was safely ensconced in the revered studio of Massé, and seemingly dedicated to serious study. Suddenly, without cause and without a word to his bewildered family, he unceremoniously left—giving the first indication of the restless, unpredictable nature which was to dictate the pattern of his career.

Luckily, an attendant to the Comte de Lauzun became interested in Liotard's work, and through his intermediation the young artist was introduced to the brilliant inner-circle of Parisian society. Louis XV's reign had just begun, and life at court was at a dazzling height. Here Liotard became a friend of the Marquis de Puysieux, France's ambassador to Italy, and to his great delight was invited to accompany the eminent envoy down to Rome. Many highly flattering commissions followed upon his arrival in the Eternal City—even a command for a portrait of Pope Clement XII, himself. Another nature would have found contentment in so rewarding a situation, but Liotard complained that life in Rome was dull and monotonous, and began quietly to cast about for any excuse to leave. Such an excuse came in the person of a young English friend, the Cavalier Ponsomby, future Count of Besborough, who generously invited Liotard to join him on a trip to the Middle East. The trip lasted seven years!

Upon arriving at Constantinople Liotard set up his easel, and was soon at work on portraits of various Turkish notables, among them the celebrated Achmed Pasha, Comte de Bonneval —considered to be quite a plum for visiting artists. Enamored of Turkish customs, manners and dress, Liotard began to adopt them for himself, and remained in the exotic capital for five exciting years. Finally becoming restless, he set out for Moldavia, where the long abundant beards worn by the Moldavian men so intrigued him that he grew one in a similar style. This distinguishing detail greatly contributed to his fame, and when, two years later, he arrived in Vienna the "Turkish Painter" became the rage. The emperor himself consented to pose for his portrait and members of the court immediately followed his lead.

It was while in Vienna that Liotard made his famous pastel, "The Chocolate Girl", which received instant acclaim. No amount of success, however, could hold him long in one spot. He

was soon off to Venice, Darmstadt, Lyons—and finally to Paris, where he enjoyed a breathtaking vogue in the year of 1748. The royal princesses, the ladies of the court, generals and noblemen became his models. Ever eager to move on, Liotard was soon seen heading hastily back to Lyons, and on this visit he executed his beloved works, "The Family Breakfast" and "The Lunch of the Young Ladies, Lavergnes", using his nieces as models for the latter.

Next in his travels was a sojourn to London, and here he enjoyed a triumph equal to that of Paris. His old friend, Ponsomby secured him the patronage of the Prince of Wales and Princess Louise-Anne, commissions which could only assure him immediate success.

Liotard abruptly decided to leave for Le Haye, where our hero paused long enough to fall in love with the pretty daughter of a French merchant and—in order to marry her—to sacrifice his exuberant beard. One imagines the young lady gave him a firm ultimatum—and won!

After a brief journey to Paris, Liotard arrived again in Geneva, this time determined to settle down to a stable, organized existence. The resolution began well enough. He made beautiful pastels of many important Genovese, the Thélussons, the Tronchins, Professor de la Rive, but no amount of self persuasion could hold his vagabond temperament in check. While commissions went unfinished, Liotard headed once more for Vienna. The Queen, Maria Theresa, posed for him a second time, and perhaps it was on this particular visit that he gave lessons in pastel to her husband. So successful was the artist as a teacher, and so apt was the "coregent of the Hapsburg dominions" as a pupil that the latter's work bears a strong resemblance to the pastels of Liotard.

Upon returning to Geneva, Liotard acquired an attractive property, but had no sooner moved into his new dwelling than he packed his trunks for Paris, this time to execute a lovely portrait of Marie Antoinette at the behest of her mother, Maria Theresa.

After a quick dash to London, he returned once more to Geneva, seriously believing he would remain forever. He did manage to remain for three restless years, then at the age of sixty-five could keep still no longer and set out, for the last time, for Vienna. Though he still enjoyed the favor of the Royal family, he no longer found in Vienna his great acceptance of former years. Serious historians have suggested that the loss of his beard contributed to his popularity's disappointing demise. Liotard was now just another portraitist and no longer the dashing "Turk".

Be that as it may, it was a discouraged and bitter old man who finally returned to his native Geneva, this time never again to leave. Liotard's last years were spent in writing a technical treatise on the principles and rules of painting, and in experimenting with various methods of painting on glass and porcelain. His restless spirit at last found peace in June of 1790—only a month before the Revolution which would forever change the world he knew and painted.

JOSEPH BOZE
(1744-1826)

Joseph Boze arrived late on the eighteenth century artistic scene, but well in time to carve his own special niche in its memory. He was born at Martigues (Bouches-du-Rhone) in 1744, and almost from infancy showed a passion for drawing. Even the walls of his parents' house were not safe from his fits of decorating—childish sketches were everywhere.

Sent away to school at an early age, Boze was next heard from upon his arrival in Paris—excited, uncertain and eager to test his talents in the great wide world. Acceptance came almost immediately, for the bright young man from Martigues possessed the most important requisite of a portrait painter—the unfailing ability to capture likeness.

His growing reputation led to a royal court summons, and Joseph Boze could soon boast of Louis XVI and Marie Antoinnette as his sitters. Their portraits and those of other members of the royal family were so enthusiastically received that in the years that followed the most glittering names in Paris appeared at his studio for sittings.

Despite such flattering successes, Boze's inherent modesty never allowed the favor of the great to turn his head, nor did he ever use his position at court to press an advantage. He was generous, self-denying, and so abstemious in his habits that he allowed himself no stronger drink than water!

Boze studied the technique of pastels under La Tour, and the grand old master considered him his most promising pupil. This faith was to prove more than justified, for it was Joseph Boze, as well as Du Creux, who prolonged the practice of pastel—in its highest tradition—on past the Revolution. Luckily Boze discovered a thoroughly effective fixing method, which has preserved his works in all their pristine clarity—as fresh and glowing as the moment he added the last brilliant highlight.

Boze had the genius to record for posterity the historic confrontation between Mirabeau and the Marquis de Dreux-Brézé. So great was the painting's impact on the public that a guard had to be stationed at his studio door.

But the days of 1889 were far from easy ones. Boze's devotion to the royal family had caused his very life to be in jeopardy. Narrowly escaping the guillotine, he was nevertheless for a while imprisoned.

Though known as the "King's Painter", Boze sent to the open Salon of 1791 a portrait of Rebespierre, which unfortunately the critics labelled "sallow"* and "pallid"*, though always conceding his talent for "resemblance".*
*Maze-Sencier, A.: "Le Livre des Collectionneurs"

Boze left France, in disguise, in the year 1794, going first to Holland, then to England, where he remained quietly until the Restoration made feasible his return to Paris. He lived on well into the nineteenth century, to accomplish some of his most important work in the later years of his life. It was he who portrayed the "First Consul" in his hour of triumph at the battle of Marengo, and it was Boze who depicted Louis XVIII's history-making return to France. The latter painting inspired a visit from no less than the Emperor of Austria to his studio.

Not all of Boze's time was spent among paint pots, chalks and ermine. The successful artist was also an ingenious inventor, and a respected member of the Society of Inventions and Discoveries. He devised a means of unharnessing horses who seize the bit in their teeth, and also invented a brake to stop runaway carriages, even in the steepest descents. Though approved by the eminent society, these interesting inventions were never put to use. Boze also invented a music-stand, which automatically turned the sheets of music without any help from the musician's hand. He was a friend of the great Vancanson, and presented a portrait of him to the Academy of Arts and Science, which hangs there today in silent tribute to both their genius.

The wealth of art Boze left behind bear witness to his outstanding talent, but one small vignette tells us as much about Boze, the man. According to legend, a struggling young architect died, leaving a small son. When the child's own mother deserted him, Boze immediately adopted the boy and took him into his own large family of children. When praised for the deed, he lightly replied, "Where there's enough for six, there's enough for seven".

Joseph Boze lived until the venerable age of eighty-two, with no record of infirmity in mind or body—a testimony perhaps to the efficacious benefits of talent, charity and plain water.

The illustrations

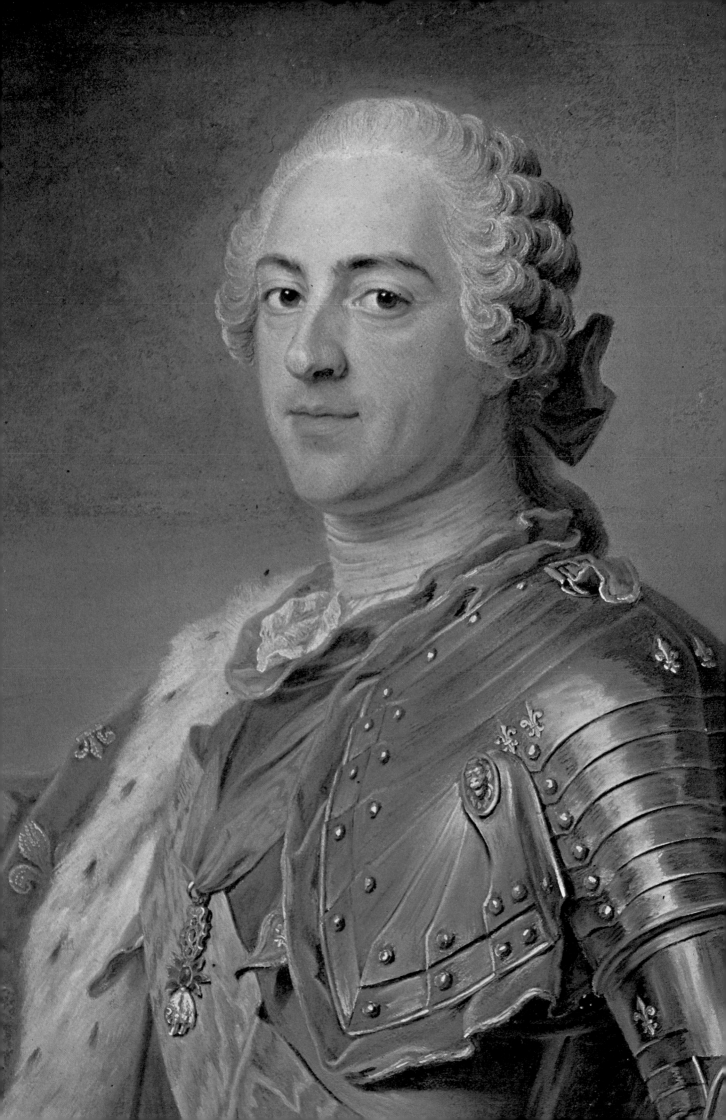

"LOUIS XV"

Maurice Quentin de La Tour

Volumes have been written about the complete misrule of Louis XV of France, the misery he inadvertently brought to his country, and the vain pleasure-seeking in which he indulged. But one thing we must admit of him, the Well-Beloved certainly made a handsome subject for a portrait! Look carefully and you will also see that La Tour records something finer in his face than the history of his life would affirm. Perhaps cast in another role, at another time, Louis XV might have demonstrated more lofty qualities of manhood.

A wise old Frenchman once observed, " It is the misfortune of kings that they scarcely ever do the good they have a mind to do; and through surprise and the insinuations of flatterers they often do mischief they never intended".

Location: Pavillon de Flore, Louvre Museum, Paris.

Actual size: 22¼in x 21 3/16in (0,64 x 0,54)

Cabinet des Dessins, Louvre Museum.

"ABBÉ HUBER"
Maurice Quentin de La Tour

The portrait of Abbé Huber is among La Tour's best known works. Wily, mundane, with a rare understanding of commerce and industry, the Abbé Huber presented a fascinating contradiction of saint and cynic.

La Tour made two studies of his great friend in the same pose; the other likeness hangs in the Museum of Art and History in Geneva.

Location: Lécuyer Museum, Saint Quentin.
Actual size: 31in x 38½in (0,79 x 0,98)

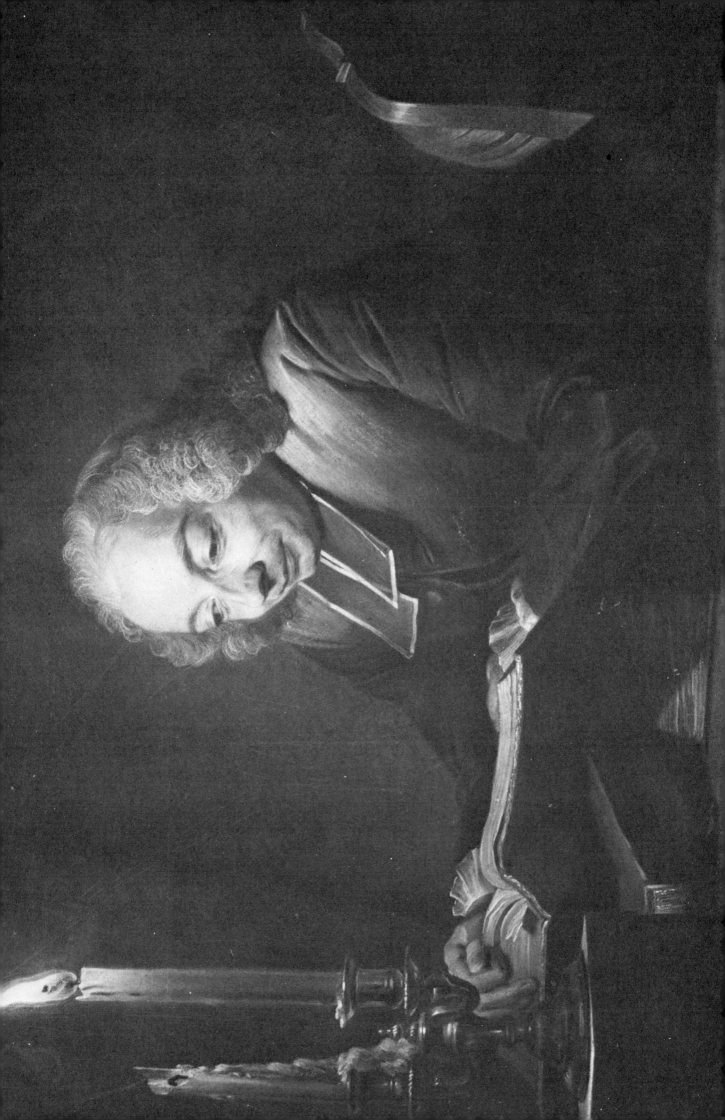

"D' ALEMBERT"
Maurice Quentin de La Tour

Here is the shrewd yet genial face of a freethinking "intellectual". Jean Le Rond d'Alembert was a farsighted philosopher, a friend of Voltaire, and a champion of the "people". A member of the French Academy and the Academy of Science, he was eloquently fearless in the expression of his ideas, and, with Diderot, was a director of the *Encyclopédie*.

La Tour exhibited this portrait in the Salon of 1753, and was delighted when the most censorous critics declared it an "outstanding likeness". A superb preliminary sketch hangs at the Lécuyer Museum in Saint Quentin.

Location: Pavillon de Flore, Louvre Museum, Paris.

Actual size: $21\frac{5}{8}$in x $17\frac{3}{4}$in (0,55 x 0,45)

Cabinet des Dessins, Louvre Museum.

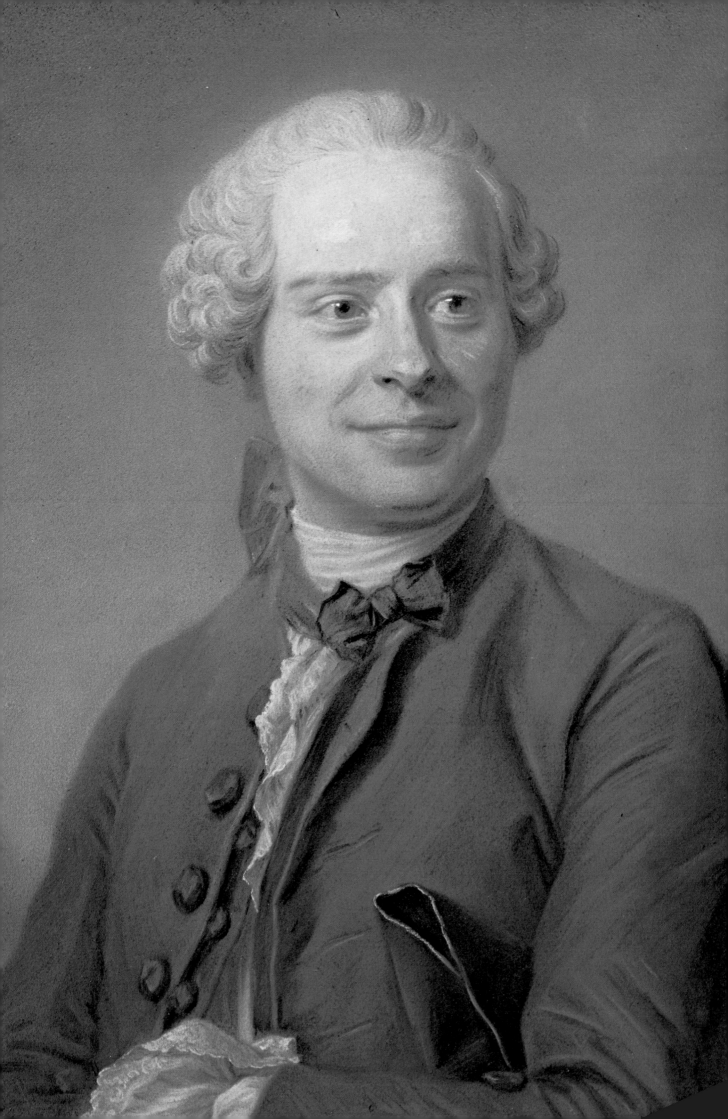

"HENRY DAWKINS"

Maurice Quentin de La Tour

The artist from Saint Quentin was fond of sketching men of rank and distinction. In time he began to copy their manner and their dress, and became, himself, one of them. The costume worn by Henry Dawkins in this portrait is similar to the one in which La Tour dressed himself for his own self-portrait.

Location: National Gallery, London.

Actual size: 26½in x 21in (0,66½ x 0,53)

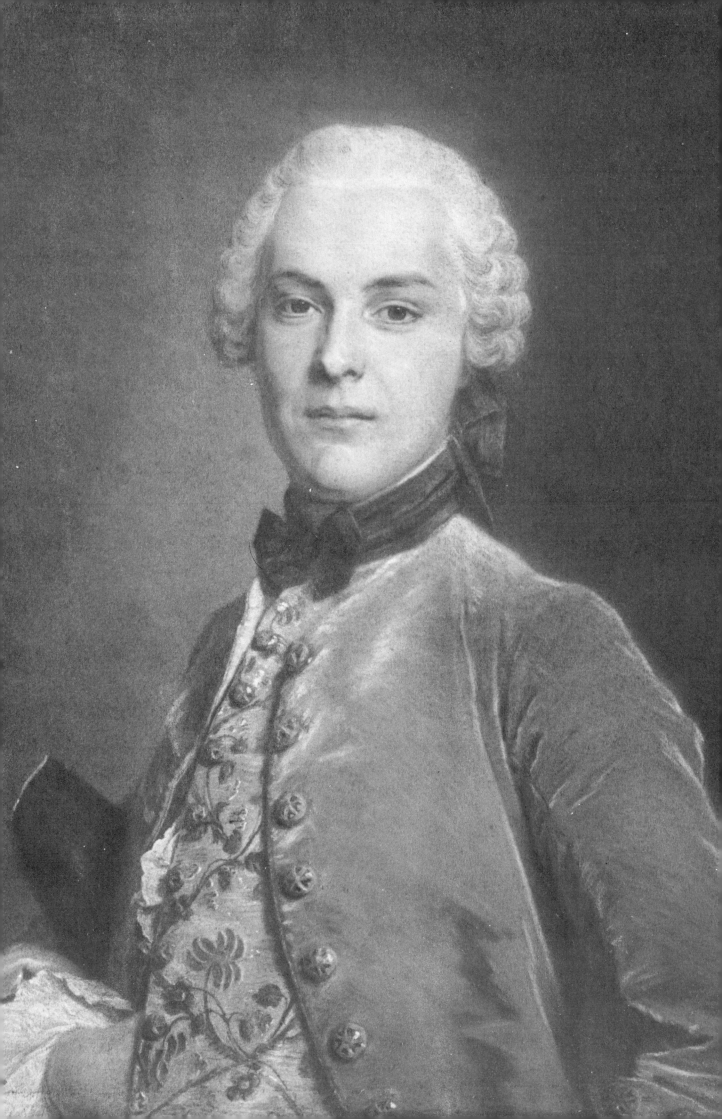

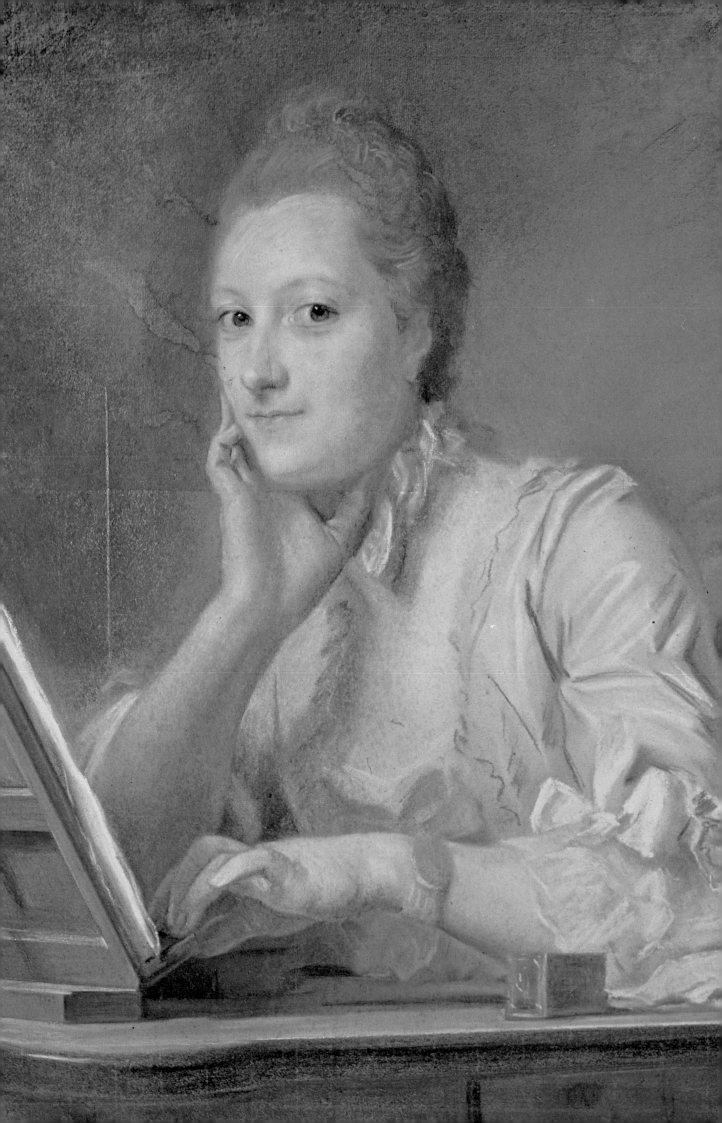

"MADAME DE LA POUPLINIÈRE"

Maurice Quentin de La Tour

This pleasant looking soul was born Françoise-Catherine-Thérèse Boutinon Des Hayes, and became in her youth a well-known singer at the Opera. If rumor is to be believed, she led rather a dissolute life—and, though ultimately married to a rich farmer-general, never really embraced the vows of fidelity with much enthusiasm.

Critics describe the head as "sweet" and "delicate", but without distinction. In the pose and in the eyes much of the character of the subject has been revealed.

Location: Lécuyer Museum, Saint Quentin.
Actual size: 26¾in x 20⅞in (0,68 x 0,53)

"MARQUISE DE POMPADOUR"

Maurice Quentin de La Tour

This carefully drawn head is a preliminary study for the large portrait of the royal mistress which hangs in the Louvre. Before the final portrait was completed, poor Pompadour had lost her health and much of her beauty, but La Tour has depicted her in all of her glory.

 Location: Lécuyer Mueseum, Saint Quentin.

 Size: 12½in x 9½in (0,32 x 0,24)

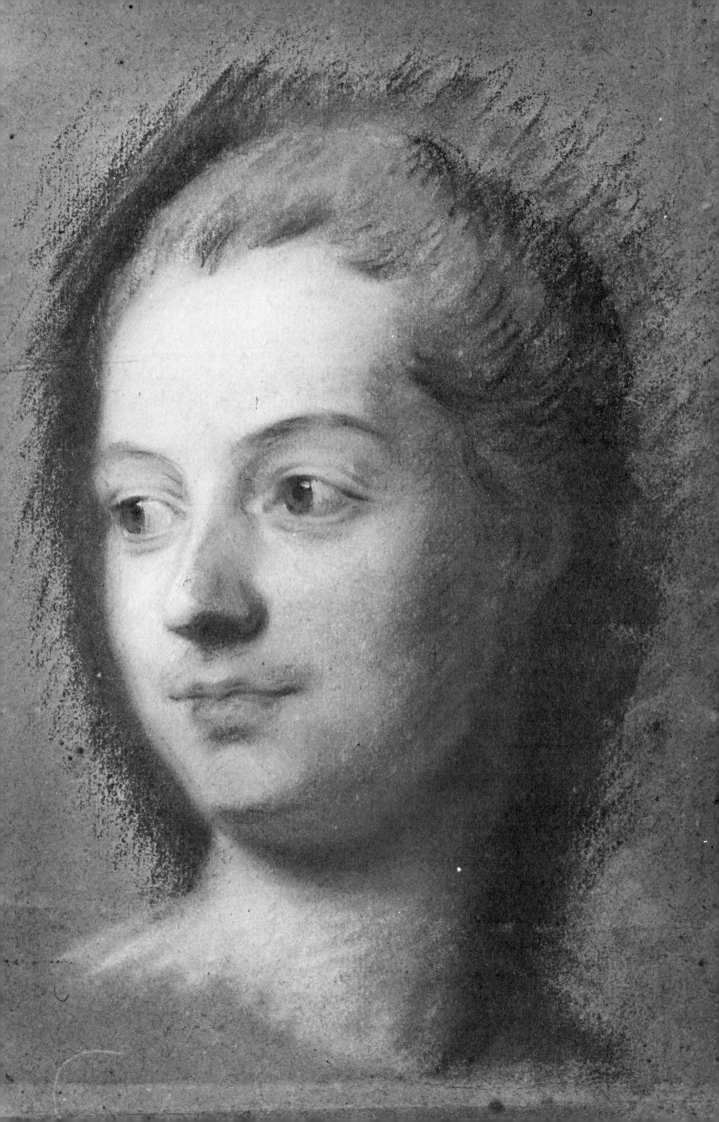

"MAURICE DE SAXE"
Maurice Quentin de La Tour

History describes Hermann Maurice, Maréchal Général de Saxe as moving from "victory to victory", playing a brilliant part for France in the wars of both Polish and Austrian Succession. La Tour tells the story best in the strength, intelligence and assurance he has recorded in the subject's face. Even the pose is that of a man secure in his own judgment and power.

This handsome portrait was first exhibited in the Salon of 1748, along with pastels of Louis XV, the Queen and the Dauphin. Maréchal de Saxe was himself a half brother of Augustus III, and died at the Château of Chambord at the age of fifty-four.

Location: Pavillon de Flore, Louvre Museum, Paris.
Actual size: 22⅞in x 18in (0,58 x 0,48)
Cabinet des Dessins, Louvre Museum

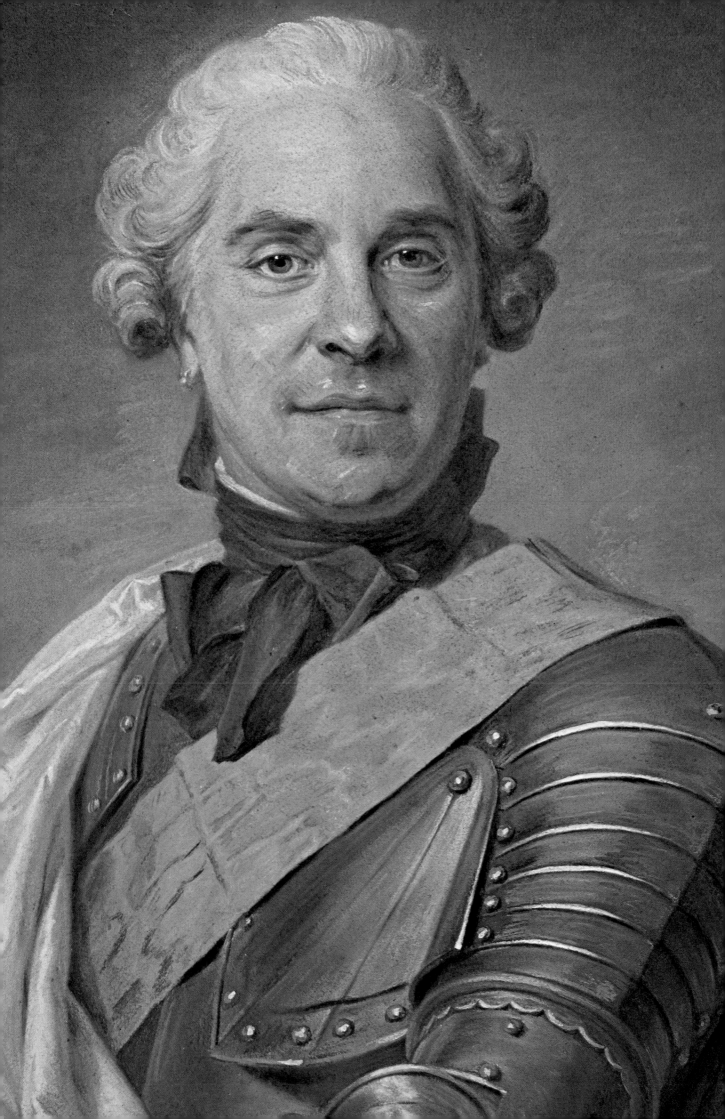

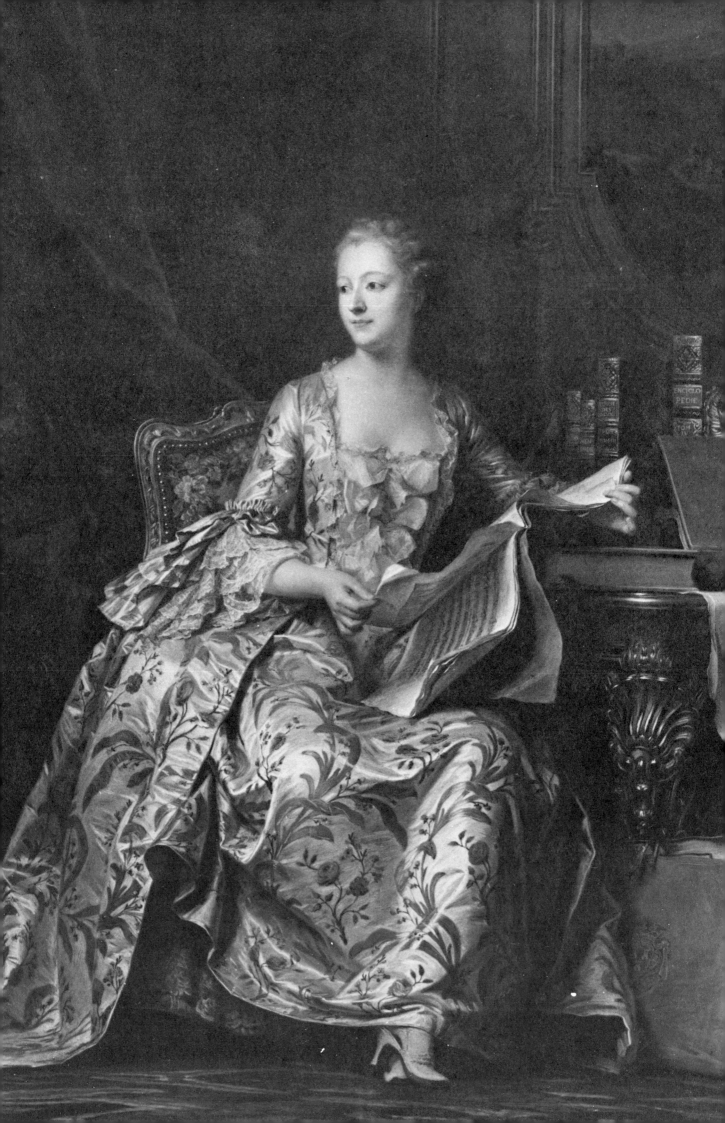

"LA MARQUISE DE POMPADOUR"

Maurice Quentin de La Tour

Here is La Tour's hard fought portrait of Madame Pompadour—perhaps his most famous, certainly his most ambitious. The shrewd, beautiful woman is portrayed here in all her facets.

This heroic pastel, which caused a sensation at the Salon of 1775, had been three strenuous years in the making. One can hardly imagine that in the end Pompadour quarrelled bitterly over the fee, and La Tour settled for only a half!

Location: Pavillon de Flore, Louvre Museum, Paris.
Actual size: 71in x 51¾in (1,77½ x 1,31)
Cabinet des Dessins, Louvre Museum

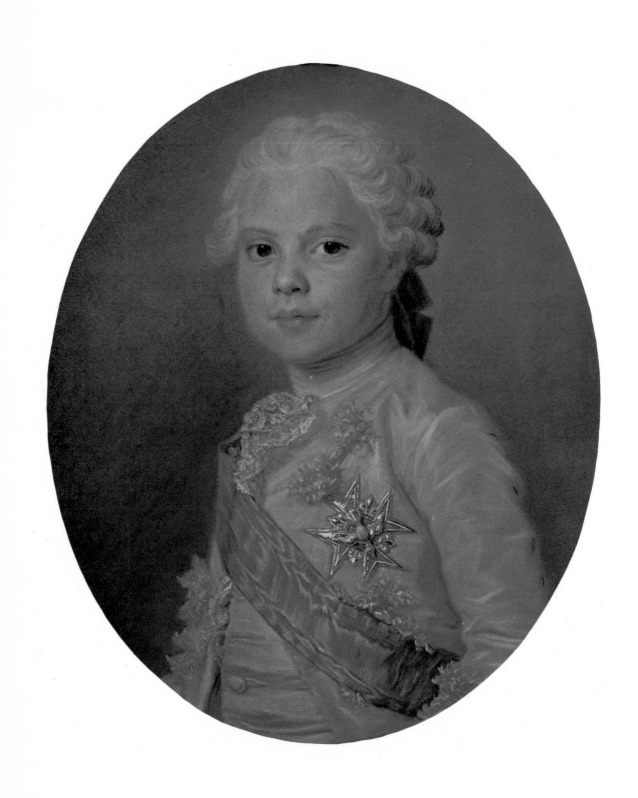

"LE COMTE DE PROVENCE"

Maurice Quentin de La Tour

This charming little fellow grew up to be Louis XVIII of France, but the crown was to sit uneasily upon his head. Described in history as a "weak king", beset by trials and opposition, his life was never a happy one.

Coleridge once said that every countenance contains a history or a prophesy; perhaps La Tour, in this portrait, caught a hint of what the future was to hold for this pretty brown-eyed boy in his pale pink taffeta waistcoat.

Location: Pavillon de Flore, Louvre Museum, Paris.

Actual size: 19⅝in x 17¾in (0,50 x 0,45)

Cabinet des Dessins, Louvre Museum

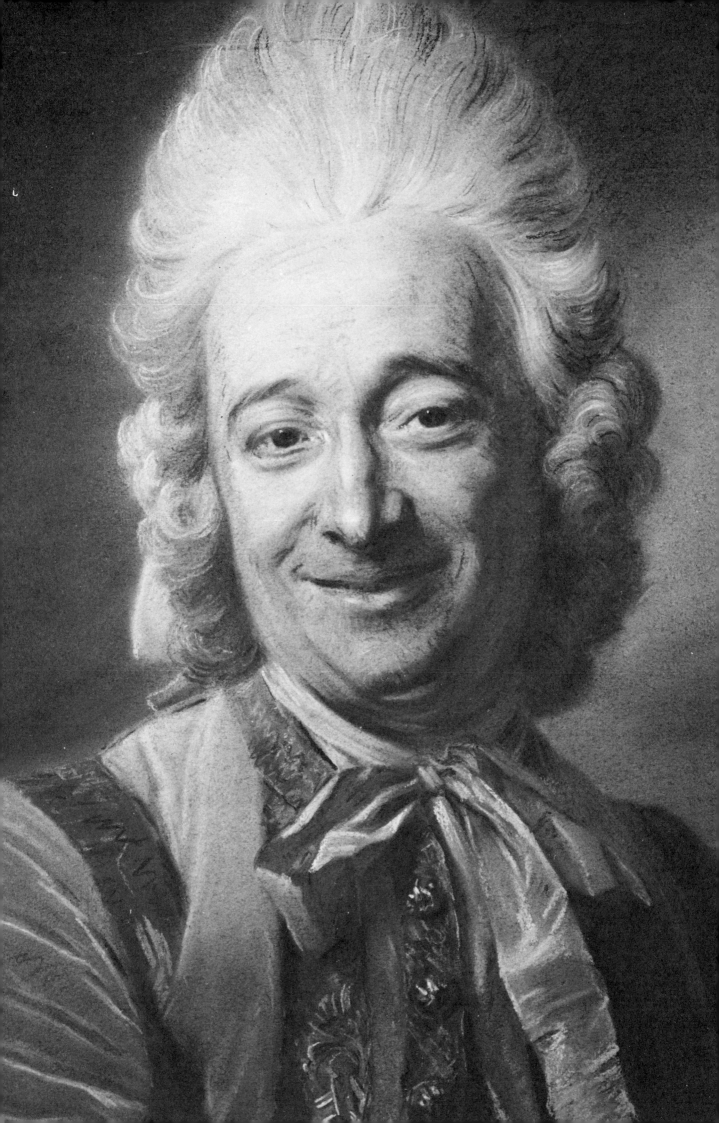

"MANELLI"

Maurice Quentin de La Tour

Manelli was an Italian comic singer who had the role of an impresario in a two act musical, entitled "The Music Master", which played to the discerning Paris audiences of 1752.

La Tour found great delight in sketching the actors and singers of his day, ensuring them a lasting record of their brief moment of glory.

Location: Lécuyer Museum, Saint Quentin.

Size: 17¾in x 14¼in (0,45 x 0,36)

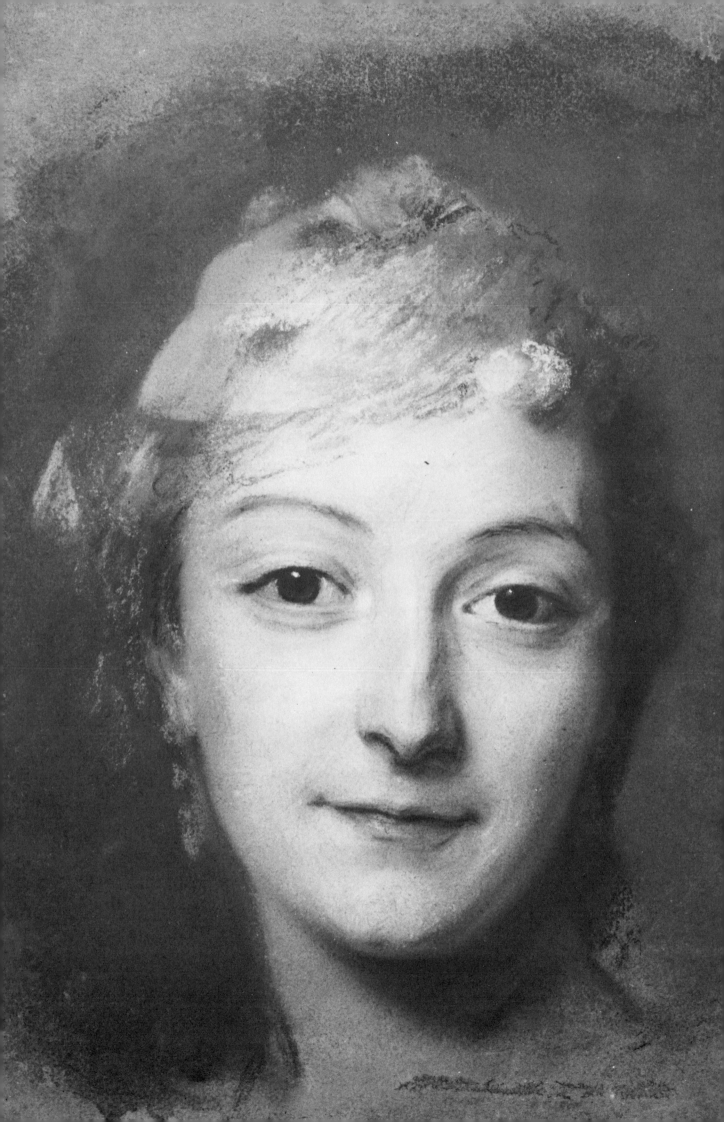

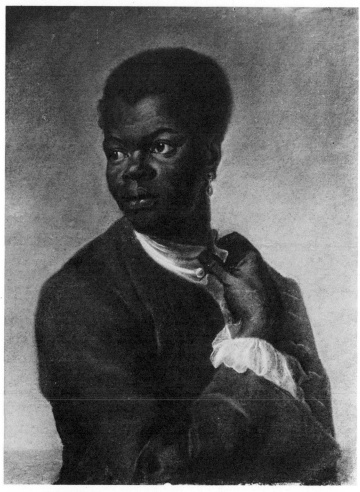

"LE NÈGRE"
Maurice Quentin de La Tour

Though less well-known than many of his other works, La Tour's "Le Nègre" is one of eighteenth century's finest portraits of a negro—of which there were very few, certainly in pastel. Here we see the strength and discipline La Tour brought to the medium.

Critics consider La Tour's art more solid than that of Perronneau, and in his technique closer to Chardin.

Location: Museum of Art and History, Geneva.
Actual size: 25½in x 21in (0,65 x 0,53½)

"MARIE FEL"
Maurice Quentin de La Tour

Here is gentle little Madmoiselle Marie Fel of the lovely lyrical voice. The daughter of an organist, she began her career with the Paris opera in 1734, and shortly afterwards met the great La Tour. The deep affection that grew between them lasted throughout their lives.

The Goncourts suggest that Marie Fel was something of a femme fatale. They tell us that before her romance with La Tour "the poet Cahusac died insane in a cell at Charenton mad with sorrow because he could not marry her"!

Location: Lécuyer Museum, Saint Quentin.
Size: 12½in x 9½in (0,32 x 0,24)

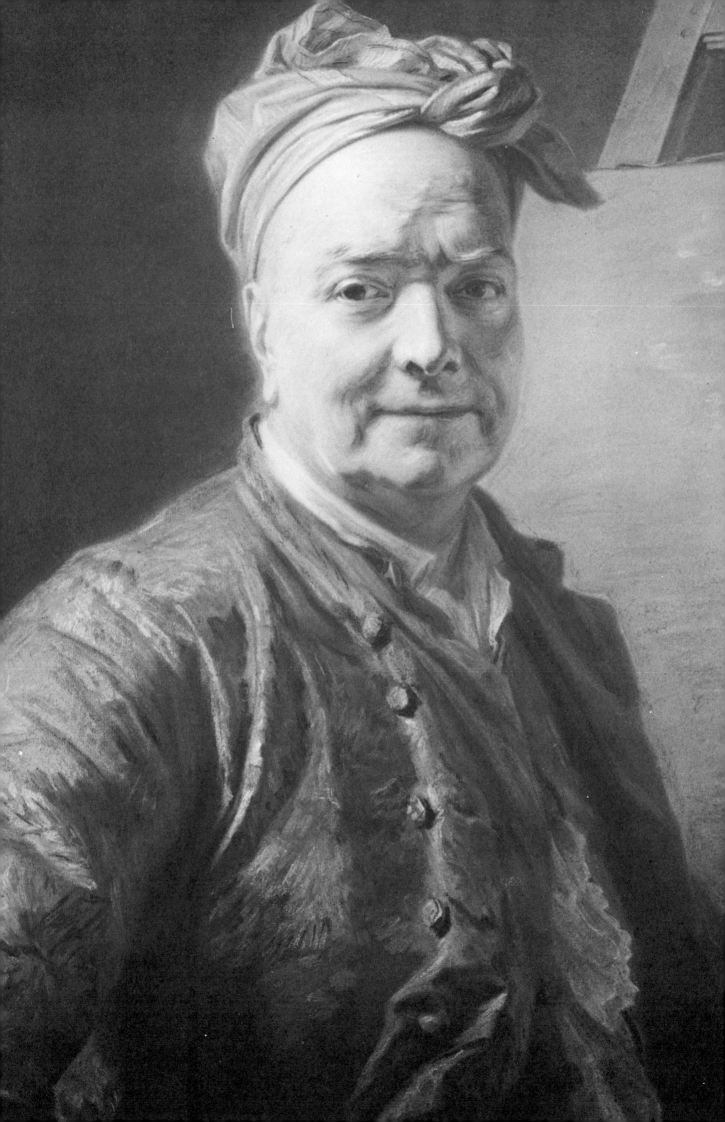

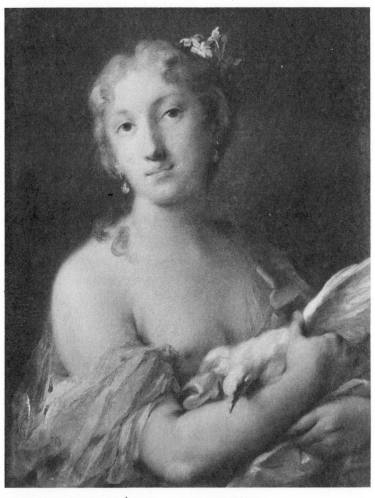

"JEUNE FILLE À LA COLOMBE"
Maurice Quentin de La Tour (copy of Rosalba Carriera)

It was not unusual for one artist to copy the work of another, particularly if he was studying the technique of a new medium. La Tour's copy of Rosalba Carriera's "Young Girl with a Dove" is particularly interesting for, in the copying, something of the luminous quality of Rosalba is lost, and something of La Tour's strength is added.

 Location: Lécuyer Museum, Saint Quentin.

 Actual size: 24½in x 16½in (0,54 x 0,42)

"LOUIS DE SYLVESTRE"
Maurice Quentin de La Tour

Louis de Sylvestre was himself a painter of note, and son of the engraver, Israel Sylvestre. Elected to the Royal Academy in 1702, Sylvestre became the first painter to the King of Poland, and was chosen by the monarch to be director of the academy of Dresden.

 This vibrant pastel is considered one of La Tour's finest.

 Location: Lécuyer Museum, Saint Quentin.

 Size: 24in x 20in (0,61 x 0,51)

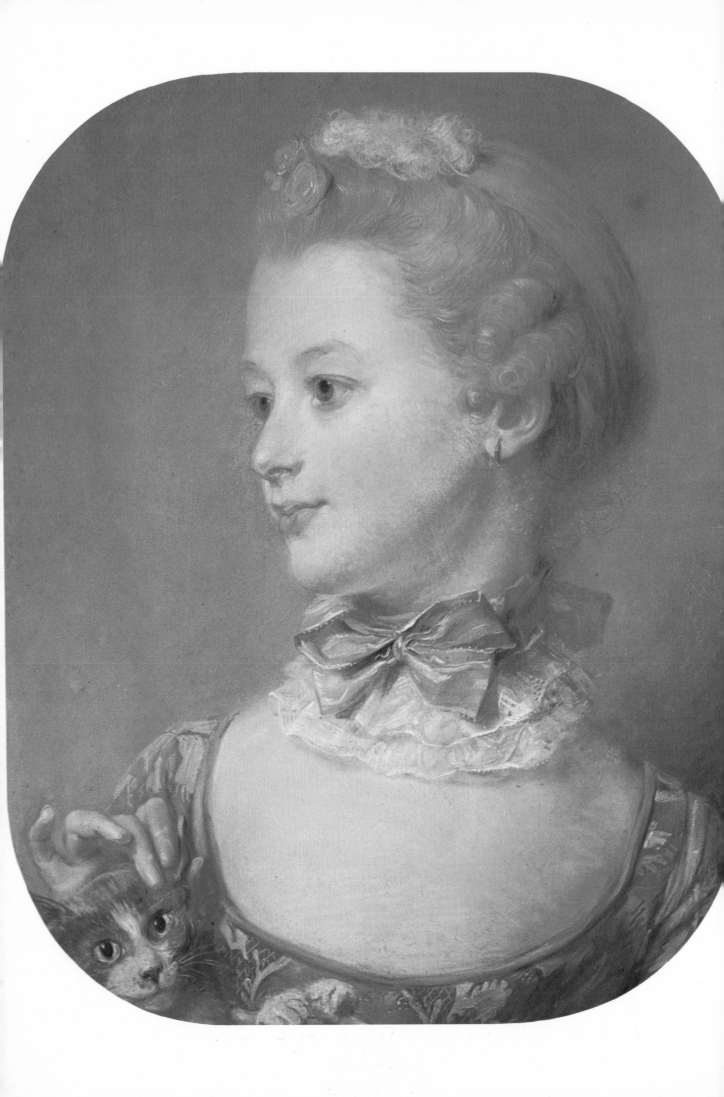

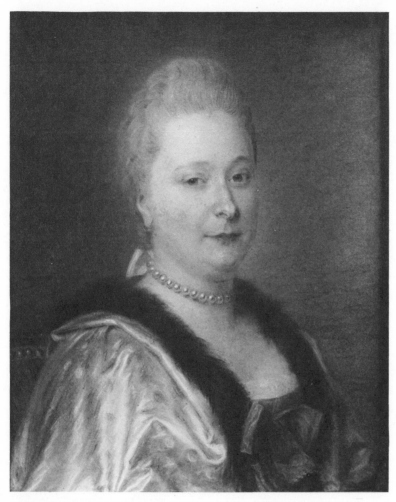

"PORTRAIT DE LA BABONNE D'HOGGUER"
Jean Baptiste Perronneau

Perronneau, not attached to the artificial life of the court, had far more experience with human beings in all walks of life than many of his contemporaries. Art historians feel this developed in him a greater honesty of vision.

Among the very "well-to-do" who commissioned his works were the Baroness d'Hogguer and her husband whose portraits are done in matching costumes, and designed to hang side by side.

Location: Museum of Art and History, Geneva.

Actual size: $21\frac{1}{4}$in x $17\frac{7}{8}$in (0,54 x 0,45$\frac{1}{2}$)

"JEUNE FILLE AU CHAT"
Jean Baptiste Perronneau

Perronneau's art held a very special place in eighteenth century portariture. France's bourgeosie, unable to partake in the frolics of the court, chose to fancy themselves "romantics". Perronneau was their artist, and skilfully abetted them in their harmless masquerades.

This very pretty young girl is Madmoiselle Huguier.

Location: Pavillon de Flore, Louvre Museum, Paris.

Actual size: $18\frac{1}{2}$in x 15in (0,47 x .0,38)

Cabinet des Dessins, Louvre Museum

103

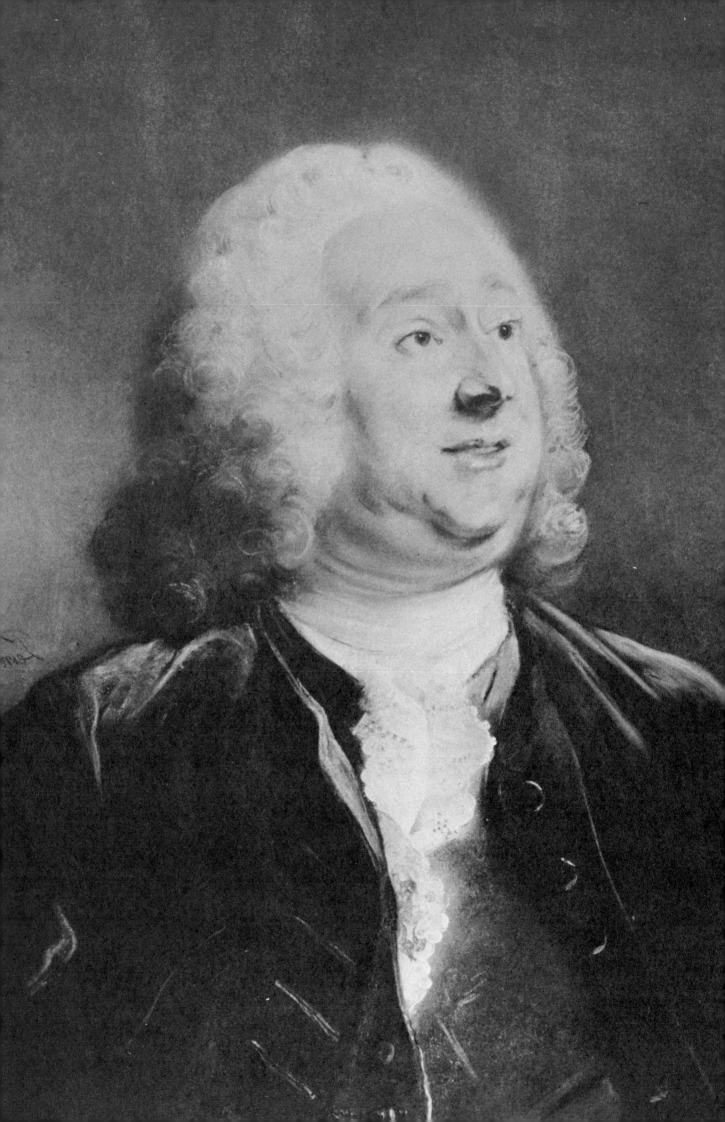

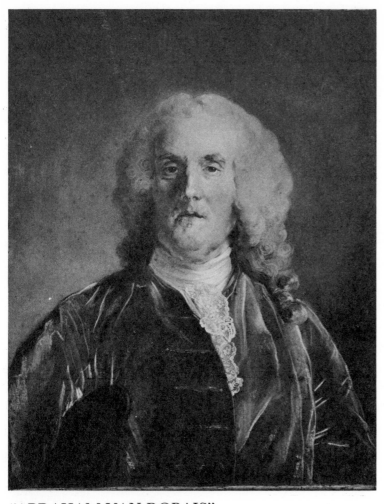

"ABRAHAM VAN ROBAIS"
Jean Baptiste Perronneau

Perronneau must have enjoyed making this impressive portrait of Abraham Van Robais, for he had a real affection for the old industrialist.

The Van Robáis family were makers of cloth, having been licenced by Louis XIV, and owned vast factories in the city of Abbeville.

This was one of Perronneau's many "out-of-town" commissions, which afforded him an escape from worries at home.

Location: Pavillon de Flore, Louvre Museum, Paris.
Actual size: 28¾in x 23¼in (0,73 x 0,59)
Cabinet des Dessins, Louvre Museum

"LE COMTE DE BASTARD"
Jean Baptiste Perronneau

Perronneau has created a highly dramatic portrait by using monochromatic tones in the background and dress of his sitter—only the face glows with color.

Bastard was the dean of the parliament of Toulouse, and is best remembered for his relentless prosecution of the Jesuits, his old masters.

Location: Pavillon de Flore, Louvre Museum, Paris.
Actual size: 26⅜in x 22in (0,67 x 0,56)
Cabinet des Dessins, Louvre Museum

105

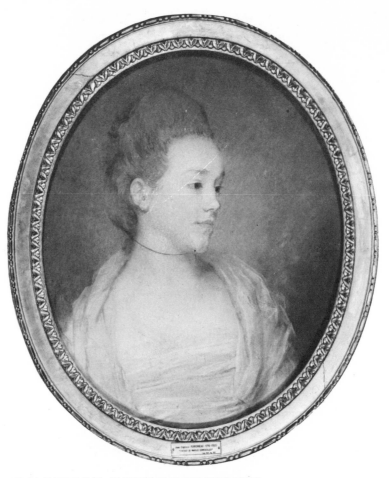

"MARTILLE COURREGEOLLES"
Jean Baptiste Perronneau

According to the inscription found on the back of his delicate pastel, Mademoiselle Courrégeolles posed for her portrait at Bordeaux in April of 1768, At this time Perronneau was still at the height of his fame—but in the years that followed the fickle public and unrelenting critics turned his life into a marathon of despair.

Location: Beaux Arts Museum, Bordeaux.
Actual size: 22¾in x 19⅛in (0,58 x 0,48½)
Photograph by A. Danvers, Bordeaux.

"GIRL WITH A KITTEN"
Jean Baptiste Perronneau

It would appear that Perronneau enjoyed portraying young girls and their cats—such are the subjects of two of his best known works.

Though critics have sometimes decried the inanity of his themes, Perronneau was a portraitist in need of commissions; if a patron wished his daughter posed prissily with her kitten, he was in no position to demur.

Location: National Gallery, London.
Actual size: 23¼in x 19⅝in (0,59 x 0,50)

106

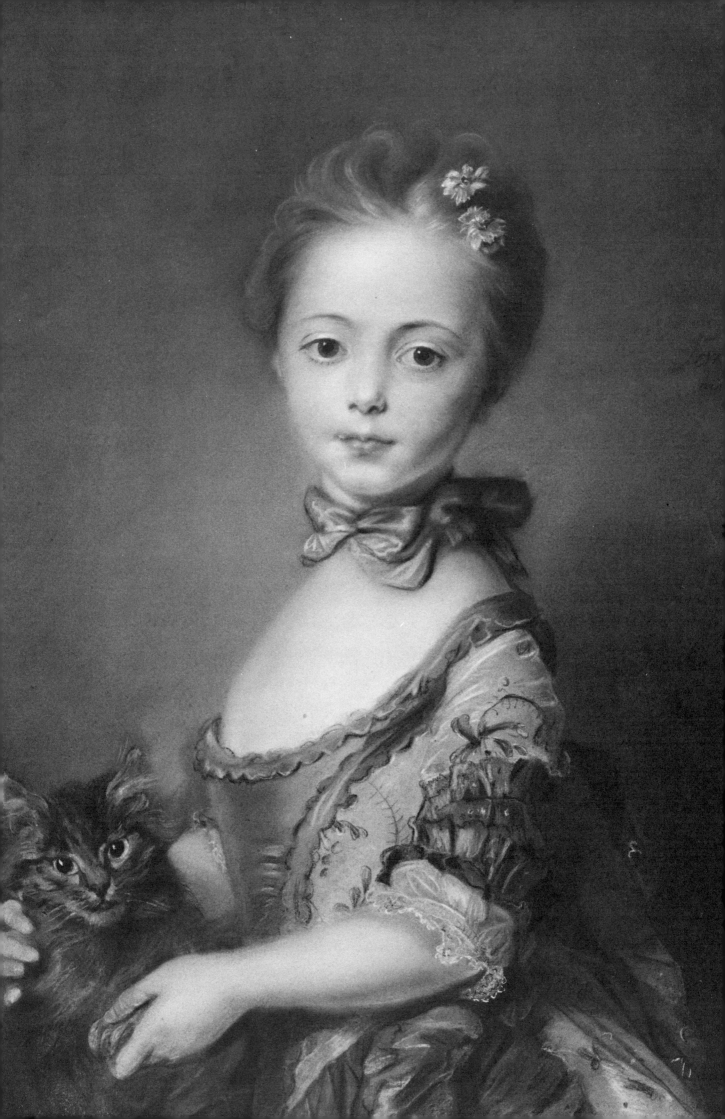

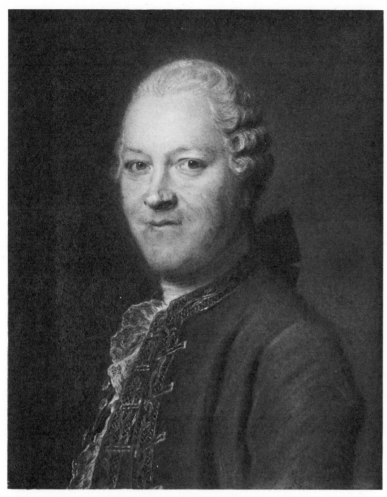

"PORTRAIT DU BARON D'HOGGUER"
Jean Baptiste Perronneau

Regrettably, the portrait of the Baron, as well as the one of his wife, seem to have lost their density—and few highlights remain. Equal to the scourge of mildew, a most dreadful threat to pastels is the gradual sifting off of chalk. Still surviving in these two portraits, is Perronneau's excellent drawing.

 Location: Museum of Art and History, Geneva.

 Actual size: 21¼in x 17⅞in (0,54 x 0,45½)

"AIR"
François Boucher

Boucher was a true embodiment of all that was light and lovely in eighteenth century France, and his bouyant spirit can be seen reflected in his work. Though his art was accused of "prettiness" and a certain "vapidity", he nevertheless reflected the mood of his era.

 Into pastels such as this one, he seems to have breathed his own joy of living.

 Location: Metropolitan Museum, New York.

 Actual size: 30in x 22¼in (0,75½ x 0,56¼)

The Metropolitan Museum of Art purchase, 1964. Louis V. Bell Fund.

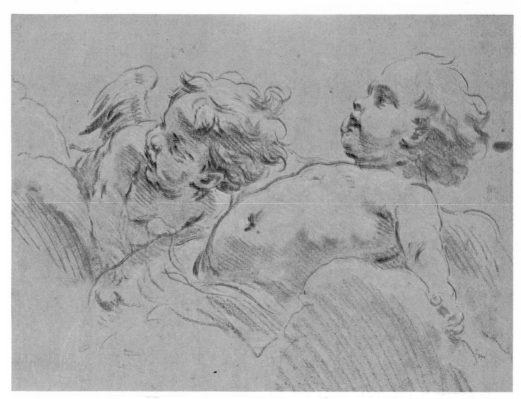

"STUDY OF TWO CUPIDS"

François Boucher

These chubby, winged babes can hardly be termed portraits in the true sense of the word, but we have included them to show one of Boucher's favorite methods of employing pastels. He often used white, grey and black chalks on a muted background, usually blue-grey or rose-tan. These monochromatic works might well be called "grisailles" in chalk.

Boucher was typical of many eighteenth century masters who, though best known for their oils, created exquisite studies in pastels, as well.

Location: Victoria and Albert Museum, London.

Actual size: 12¾in x 7½in (0,33 x 0,19)

Victoria and Albert Museum, Crown Copyright.

"ÉTUDE"

François Boucher

Boucher is said to have executed a thousand paintings and ten thousand designs during his busy life, working at his easel ten hours a day.

Though the influence of Watteau can be immediately seen in the younger man's work, what Watteau subtly suggested, Boucher clearly expressed.

Location: Louvre Museum, Paris.

Actual size: 10¾in x 8½in (0,27⅗ x 0,21⅗)

Cabinet des Dessins, Louvre Museum.

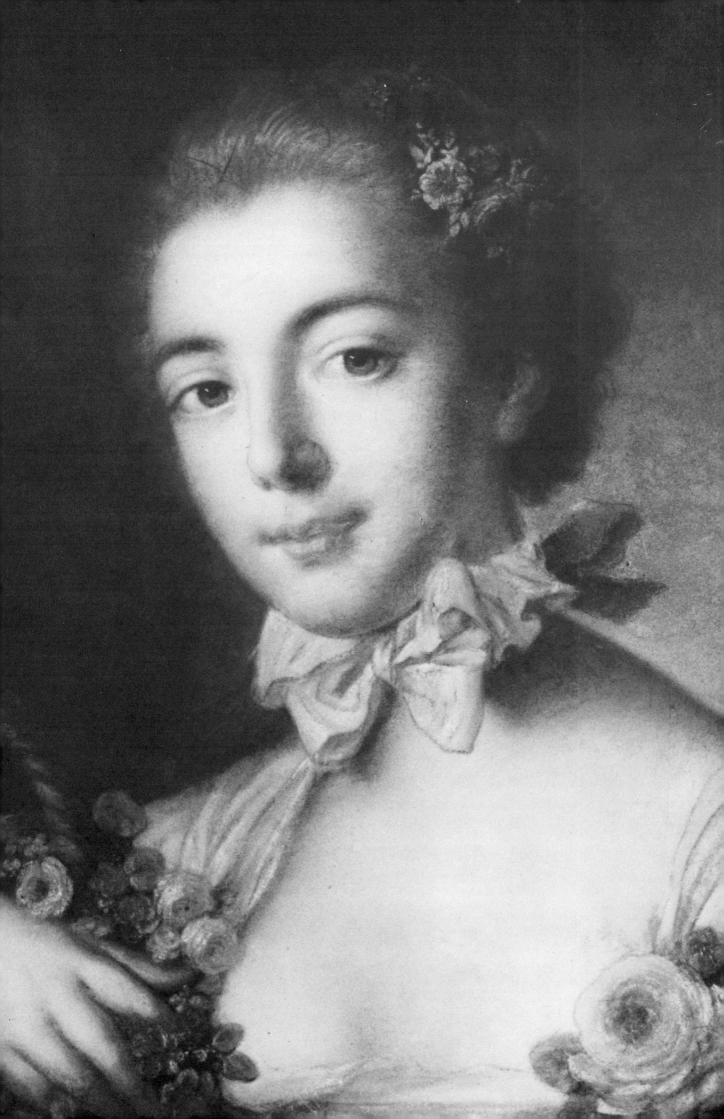

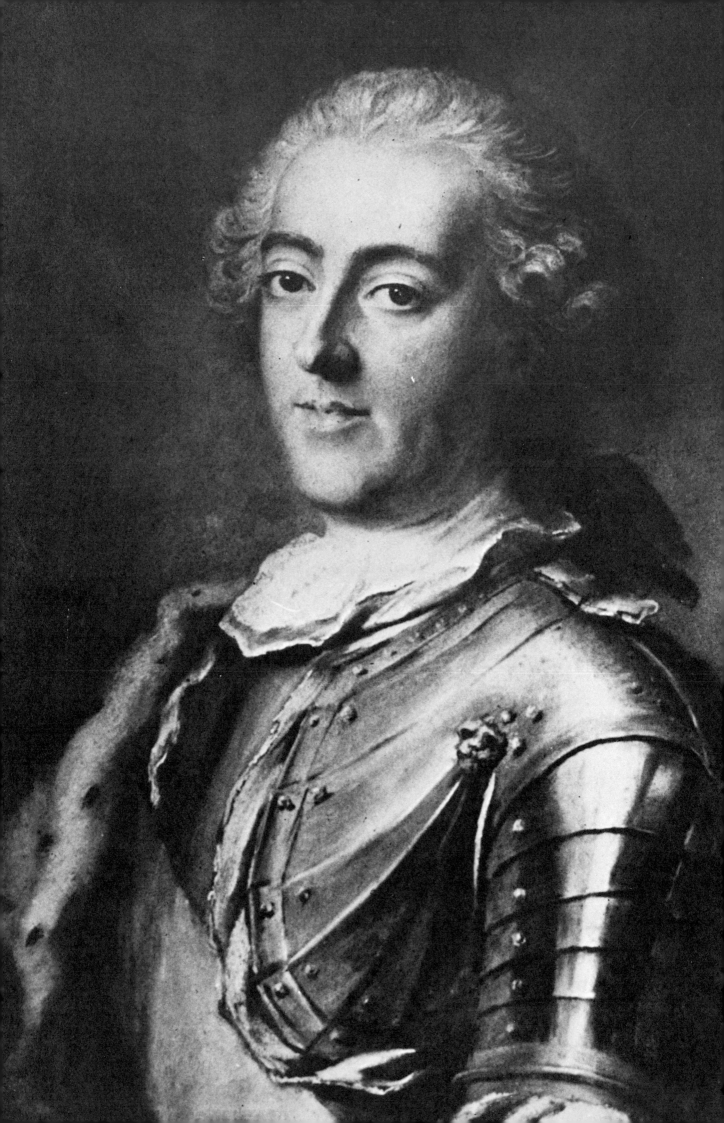

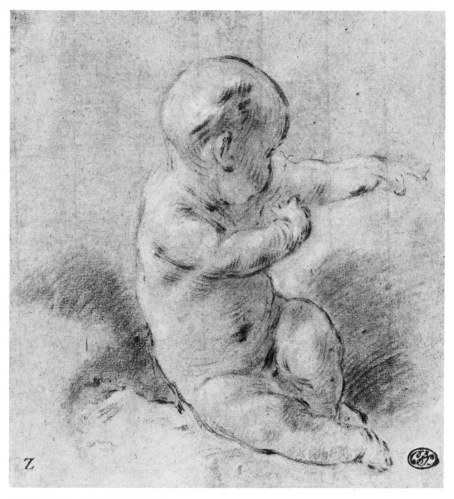

"ETUDE D'ENFANT"
François Boucher

Boucher had a rare gift for portraying the very young. Though often the addition of wings turned his tiny subjects into cupids or cherubs, still his knowledge of infant anatomy was complete.

Location: National Gallery of Ireland, Dublin.

Actual size: 6⅝in x 6⅛in (0,17 x 0,15⅞)

"LOUIS XV"
Gustaf Lundberg

Here is Lundberg's portrayal of Louis XV. Compare it with the pastel of the King made by La Tour. Though in technique Lundberg is perhaps closer to La Tour, he took much of his inspiration from Rosalba Carriera, and was converted to the medium of pastel by her example.

Location: Versailles Palace, Versailles.

Actual size: 21⅝in x 17¾in (0,55 x 0,45)

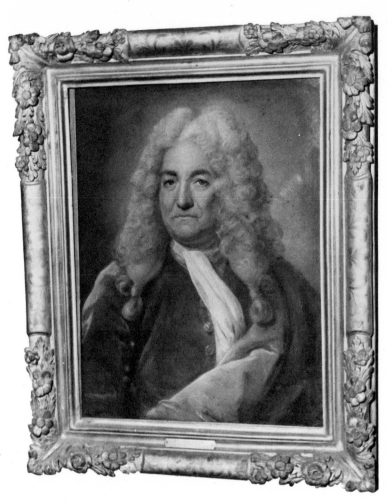

"HOCQUART DE TURTOT"
Gustaf Lundberg

The subject of this portrait was a son of Jean Hocquart, Commissioner General of the French marines. There is an intensity of expression in the face characteristic of Lundberg's best works, and a life-like animation in the eyes.

The portrait was made during Lundberg's long stay in Paris, where for twenty-eight years he enjoyed great popularity and acclaim.

Location: Institut Tessin, Paris.
Actual size: 27½in x 20½in (0,70 x 0,52)

"MARIE LECZINSKA"
Gustaf Lundberg

An earlier pastel which Lundberg made of Marie Leczinska was unfortunately lost. This later one, which still hangs in Versailles Palace, is considered to be less flattering to the Queen.

The match between Louis XV and the Polish Princess was arranged by the "incapable" Duke of Bourbon, when the young King was only fifteen years old. The royal couple had seven children, but the marriage could hardly have been considered "happy", and one always finds a certain sadness in the likenesses of Marie Leczinska.

Location: Versailles Palace, Versailles.
Actual size: 21⅝in x 17⅔in (0,55 x 0,45)

114

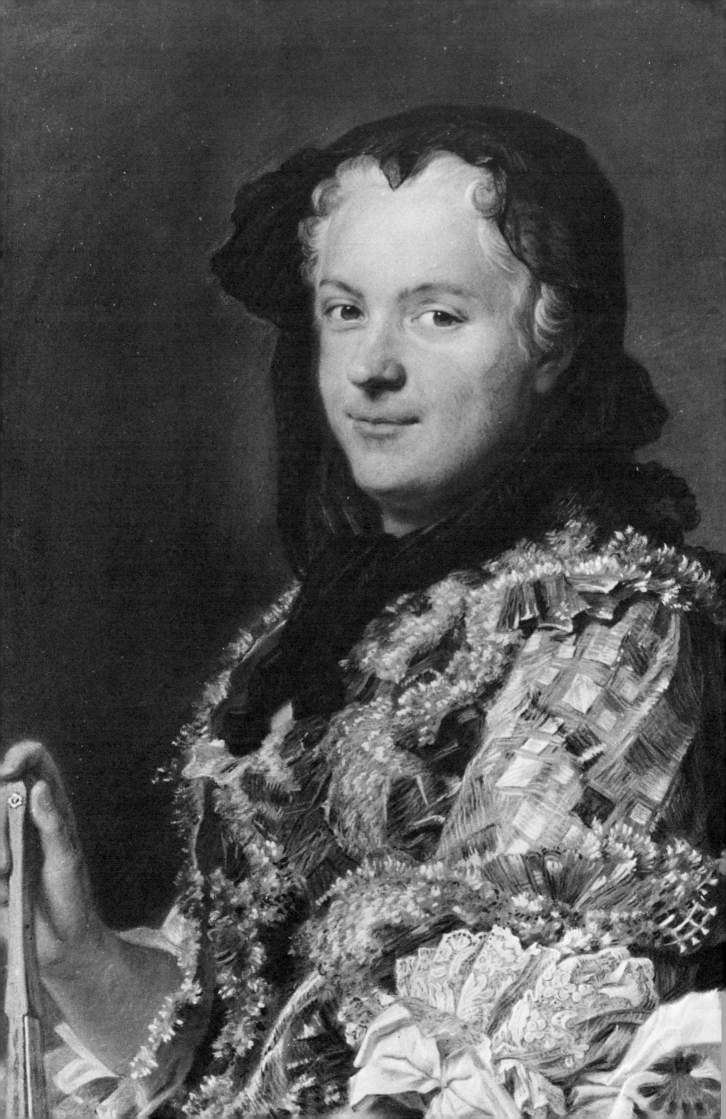

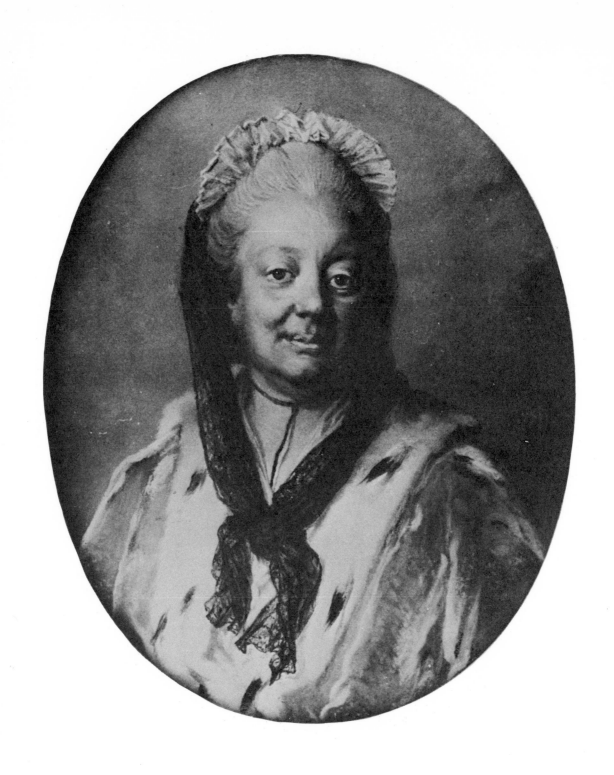

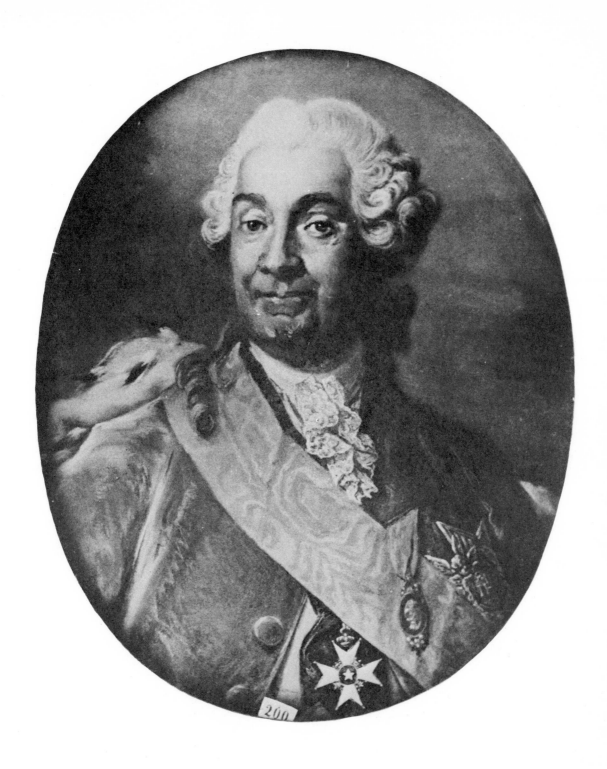

"COUNTESS GUSTAFA SABINA SCHEFFER"
"COUNT FREDRIK SCHEFFER"

Gustaf Lundberg

These portraits are a part of the famed Vibyholm collection of Count Carl Csson Bonde, and have been included to show the excellent pastels of which Lundberg was capable even in his eighties.

On the back of a still later work, the dear old artist wrote with obvious and justifiable pride, "painted by me without glasses and with a steady hand at eighty-five"!

Location: Hörningsholm Castle, Stockholm.

Actual size: 29in x 19in $(0.73\frac{3}{4}$ x $0.48\frac{1}{4})$

117

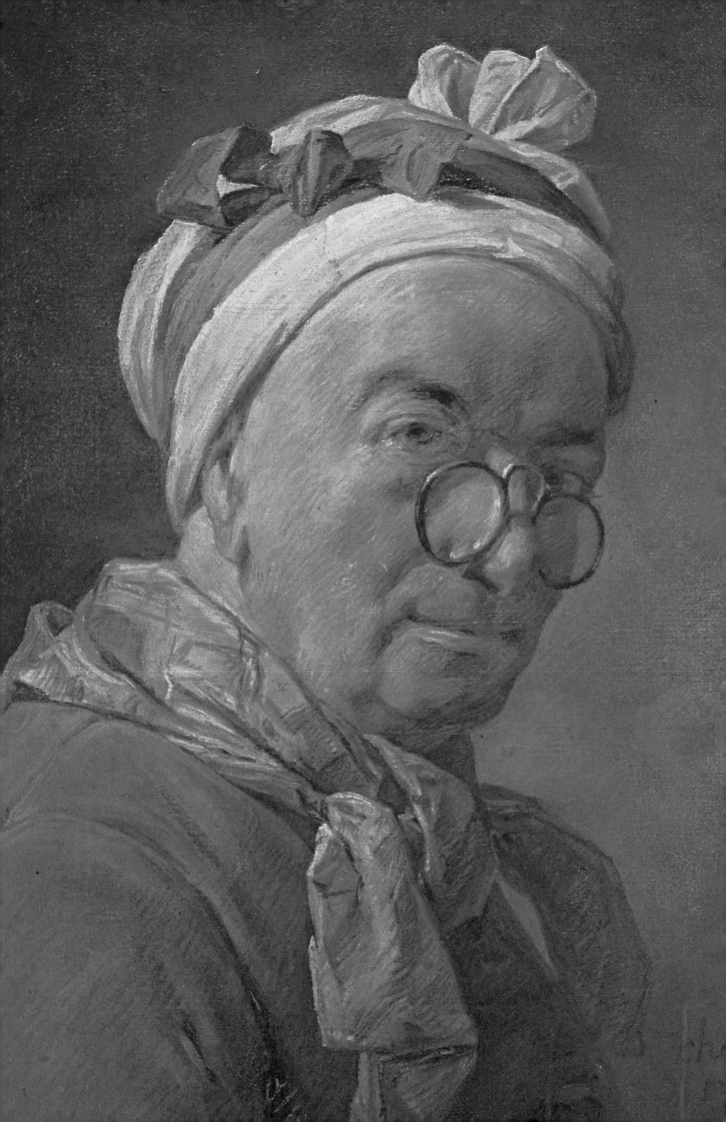

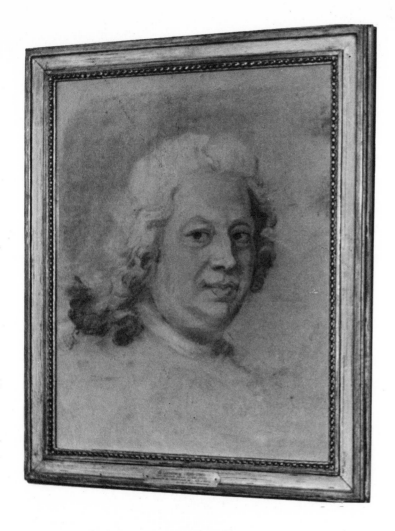

"CARL REINHOLD BERCH"
Gustaf Lundberg

This well-drawn head portrays the very cultured secretary of Count Carl-Gustaf Tessin, Swedish Ambassador to France. Berch, himself a collector and numismatist, was quite at home in the great artistic center.

Lundberg's excellent modelling of the features shows his early classical training and understanding of anatomy.

Location: Institut Tessin, Paris.

Actual size: 18½in x 14⅛in (0,47 x 0,36)

"AUTOPORTRAIT AUX BESICLES"
Jean Baptiste Siméon Chardin

Chardin's portrait of himself is an outstanding example of the finest achievement in the medium of pastel. His purity of color, the relation of light and shade, and the total effect of "ambience" makes this an unquestioned masterpiece.

One instinctively knows this is just how dear old Chardin must have looked—warm, honest, kind—a man of strength and genius. No velvet waistcoats or lace jabots—here was a man of the "people", living in quiet dignity a modest life of simplicity and integrity.

Location: Pavillon de Flore, Cabinet des Dessins, Louvre Museum Paris.

Actual size: 18⅛in x 13⅞in (0,46 x 0,38)

119

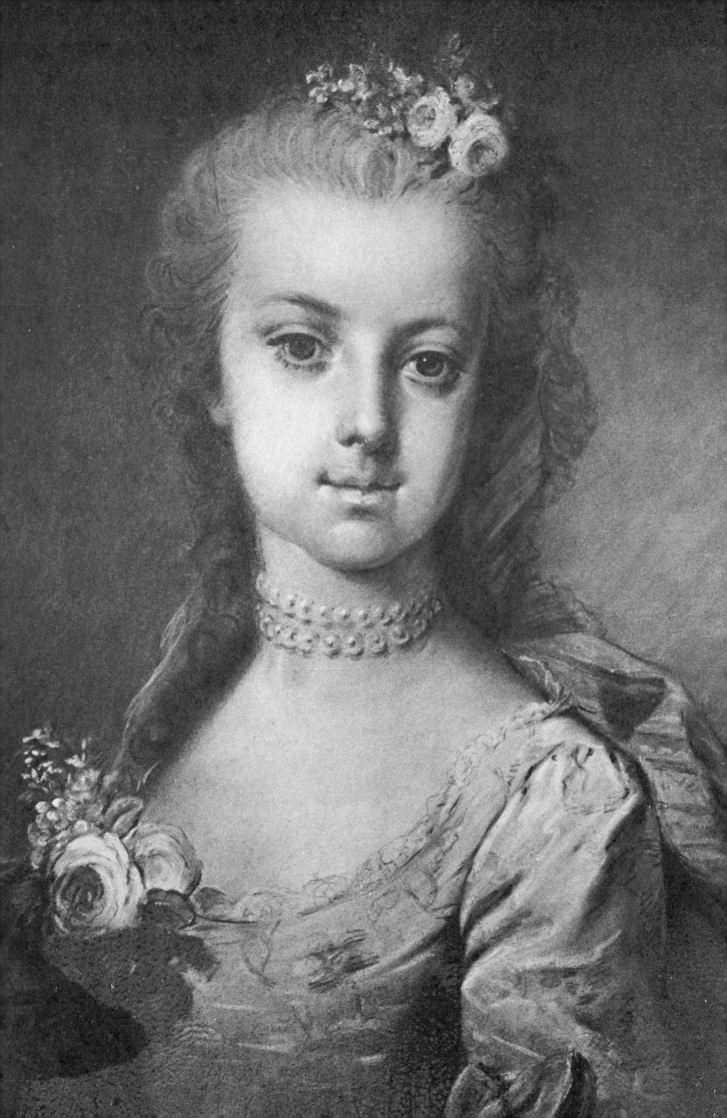

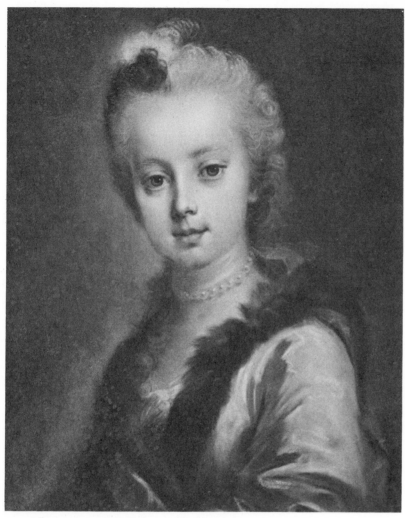

"ERZH. ELIZABETH ALS KIND"
Jean-Etienne Liotard

One of Liotard's most beloved pastels is that of Elizabeth of Austria. If the artist has not greatly flattered his subject, then this was surely Maria Therea's most beautiful child. The soft red velvet jacket is a perfect foil for her fair skin and bright blue eyes.

Location: Schönbrunn Palace, Vienna.
Actual size: 17in x 14½in (0,43 x 0,37)

"ERZH. M. CHRISTINA, TOCHTER M. THERESA"
Jean-Etienne Liotard

This portrait of Maria Christina of Austria is well balanced and pleasing. Liotard, "The Turk", made several visits to Vienna, and was a great favorite of Empress Maria Theresa and her husband. At their behest, he made many portraits of "the children", who were said to be fascinated by his flowing beard and exotic dress.

Location: Schönbrunn Palace, Vienna.
Actual size: 26in x 20in (0,66 x 0,50)

"MADAME CHARDIN"

Jean Baptiste Siméon Chardin

Historians describe the second Madame Chardin as a sensible, managing woman, a no-nonsense type—while his first wife had been of "charming aspect, but delicate, sickly, and valetudinarian".

In this portrait we see Chardin's particular method of applying pastels, in strokes of pure color, which gave an exciting new vigor to the medium.

Location: Pavillon de Flore, Louvre Museum, Paris. Cabinet des Dessins
Actual size: $18\frac{7}{8}$in x $15\frac{3}{8}$in (0,48 x 0,39)
Goncourt, E. and J., "French Eighteenth Century Painters" pp. 137, 138

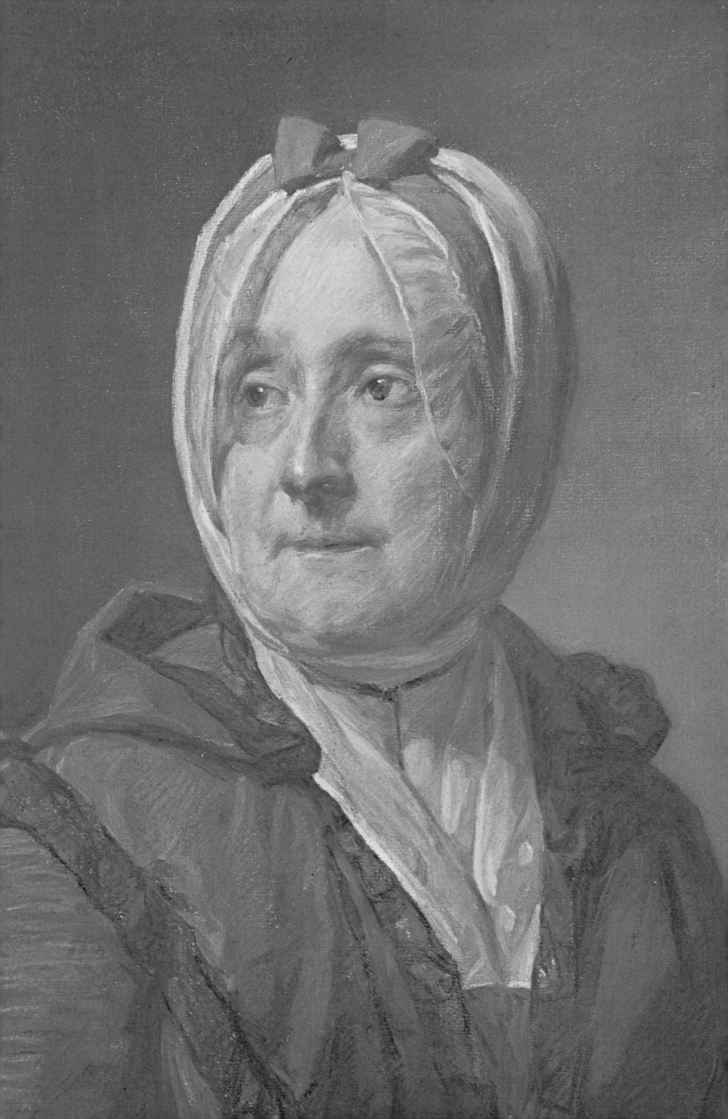

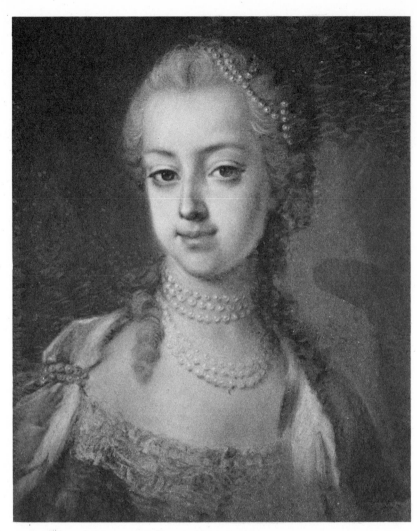

"ERZH. MARIANNE TOCHTER THERESA ALS KIND"
Jean-Etienne Liotard

What could be more evocative of an era long past than Liotard's exquisite little portrait of Marianne of Austria? This pale proud beauty was the daughter of Maria Theresa, and the sister of Marie Antoinette and Kaiser Joseph II.

Liotard was particularly adept at capturing the luxurious opulence of the courts of the eighteenth century, and forever recorded it in his portraits.

Location: Schönbrunn Palace, Vienna.
Actual size: 17in x 15in (0,43 x 0,38)

"MAXIMILIAN"
Jean-Etienne Liotard

Maximilian I, the able ruler of Bavaria, projected two distinct images. To the European powers of the early 1800's he appeared as a strong, dominating political force, the most important member of the confederation of the Rhine. In private life, however, he was all gentleness and simplicity, liking nothing more than to walk the streets unattended, conversing with his humblest subjects. Which side of his nature has Liotard portrayed?

Location: Rijksmuseum, Amsterdam.
Size: 26in x 19$\frac{7}{8}$in (0,66 x 0,48)

124

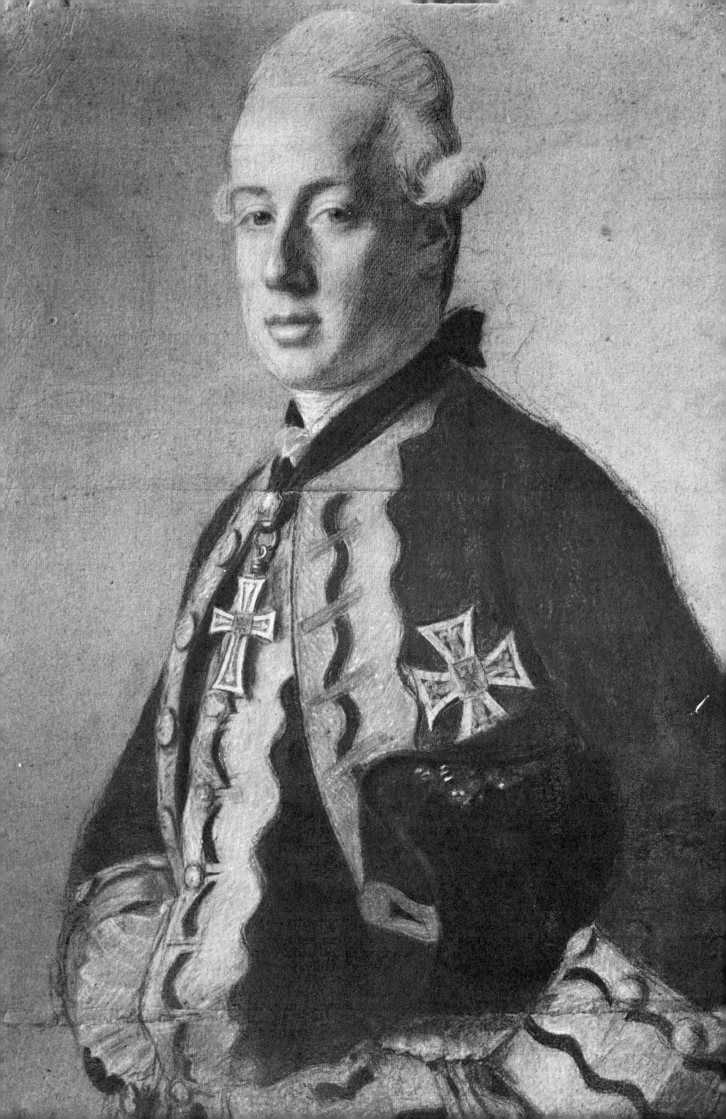

"LIOTARD À LA BARBE"

Jean-Etienne Liotard

This striking self-portrait explains the great fascination Liotard held for his patrons. The hypnotic eyes, the cascading beard, and the exotic dress all seem calculated to make the "Turkish painter" fairly irresistible. Unfortunately, however, he was barred from reception at the Academy because of his somewhat bizarre behavior.

At the insistence of his future bride, the famous beard was finally shorn. Is it merely a coincidence that his popularity diminished shortly after?

Location: Museum of Art and History, Geneva.

Actual size: 36¼in x 28in (0,92 x 0,71)

126

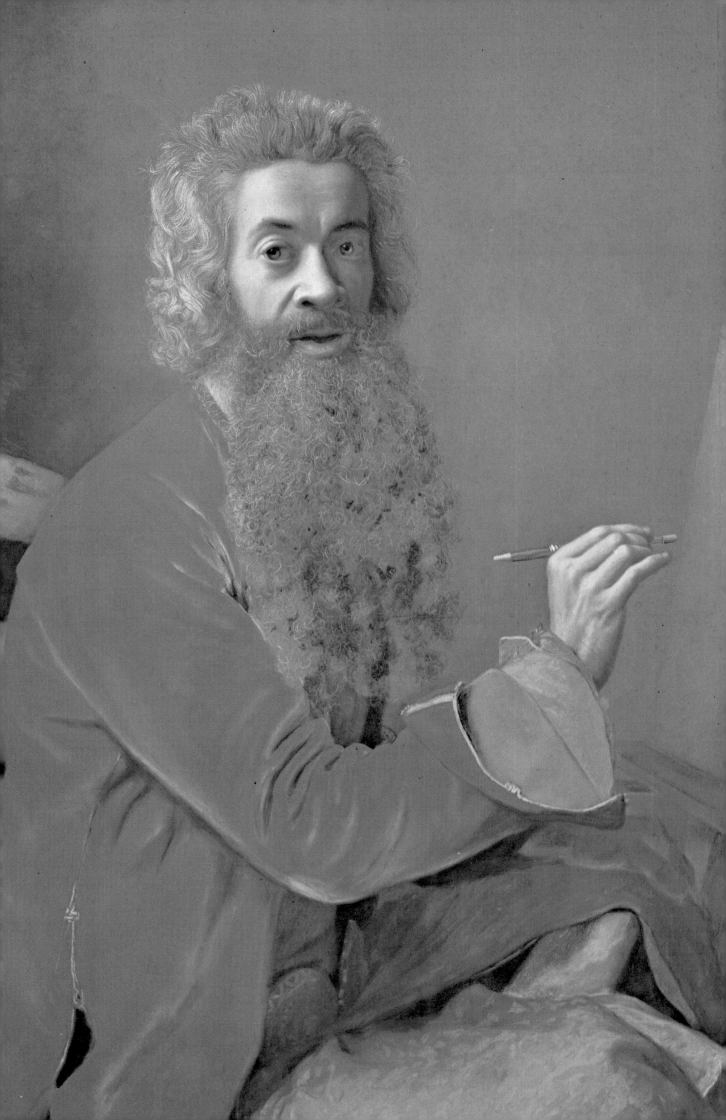

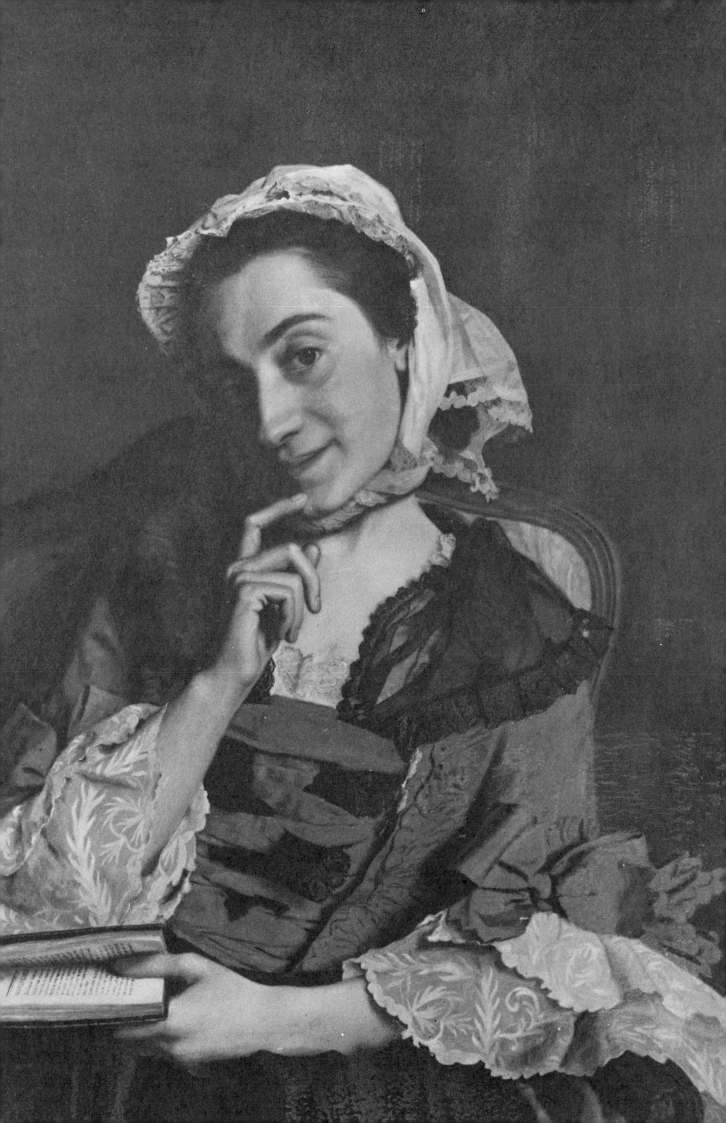

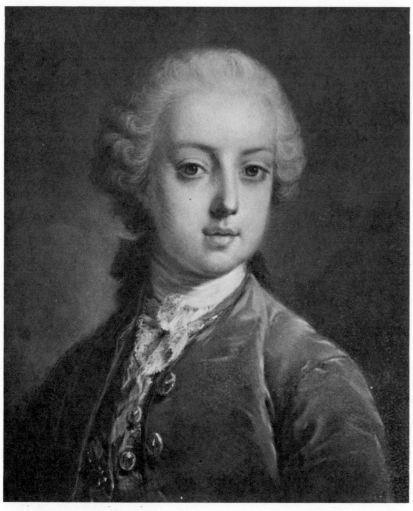

"KAISER JOSEF II"
Jean-Etienne Liotard

Certainly a busy future lay ahead for this handsome lad. As successor to his mother, Maria Theresa, he inherited the crown of Austria and was named Holy Roman Emperor at the age of twenty-three. Upon the death of his father, he also succeeded to the throne of Germany, and soon set about adding important territory to the powerful Austrian dominions.

Josef II was a born reformer. A strong proponent of religious independence with a genuine concern for his subjects, he reduced the power of the clergy, abolished serfdom, and reorganized the system of taxation. It can indeed be said of him, he played the role assigned to him in history with sincerity and courage.

Location: Schönbrunn Palace, Vienna.
Actual size: 17in x 14½in (0,43 x 0,37)

"LOUISE D' ESCLAVELLES, MARQUISE D' EPINAY"
Jean-Etienne Liotard

Liotard's portrait of the Marquise d' Epinay is one of his most captivating. The composition, the attention to detail, and the characterization of the sitter make it worthy of careful study.

Liotard was a great admirer of Watteau, and in the delicacy and finish of works such as this, Watteau's influence is clearly seen.

Location: Museum of Art and History, Geneva
Actual size: 26¾in x 21¼in (0,68 x 0,54)

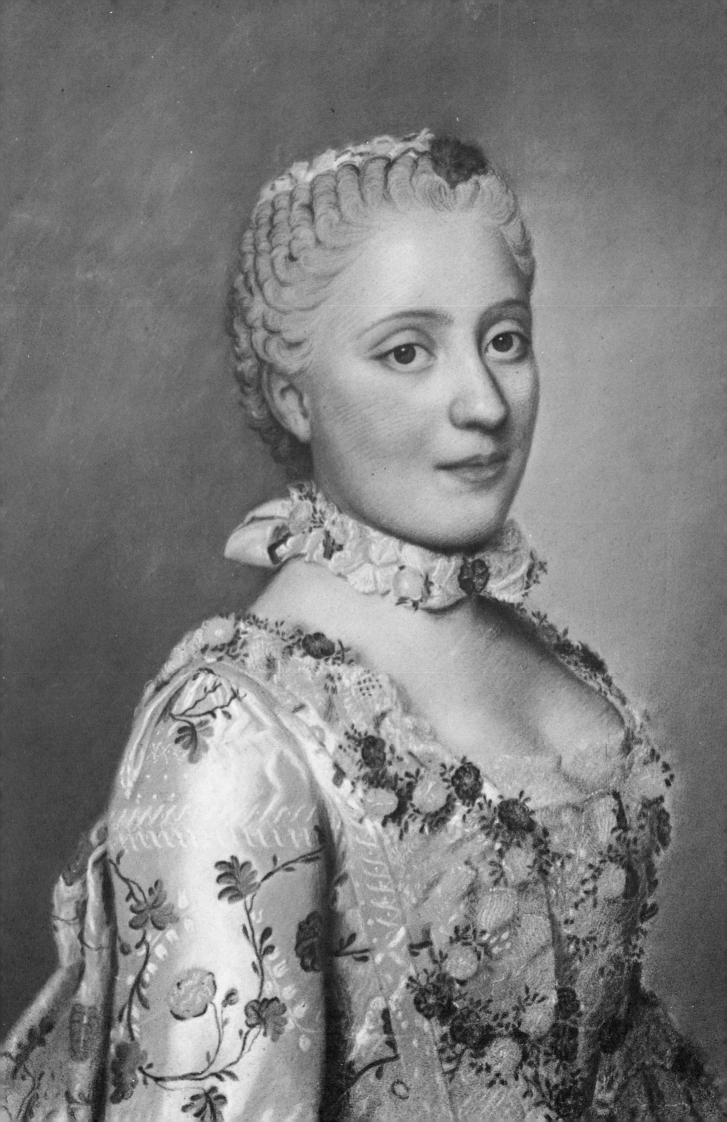

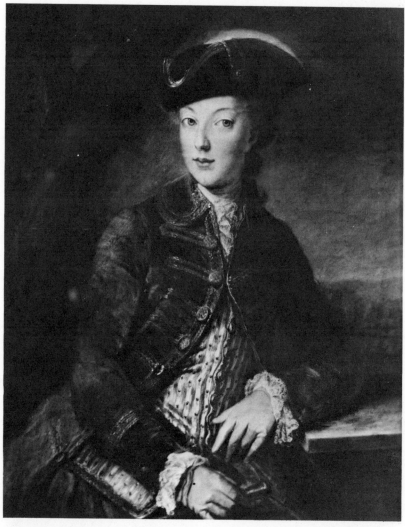

"ERZH. MARIA ANTOINETTE IM JAGD-COSTUM"

Jean-Etienne Liotard

This pastel of Marie Antoinette of Austria, future queen of France, is considered among Liotard's finest.

There is always a special poignancy about portraits of children, whom we know, in retrospect, to be marked by fate. This pretty, clear-eyed girl in her bright pink riding jacket could scarce have dreamed the nightmare that was to be her destiny.

Location: Schönbrunn Palace, Vienna.

Actual size: 31in x 25in (0,79 x 0,63)

"MARIE JOSEPHINE DE SAXE"

Jean-Etienne Liotard

This interesting portrait was executed on parchment instead of the conventional paper customarily used by pastellists.

Marie Josephine de Saxe was the daughter of the King of Poland, Rosalba's great friend and patron. She was married at Versailles to the son of Louis XV, and became the mother of the last three Bourbon Kings.

Known for her aristocracy of heart, Marie Josephine was held in highest esteem by the artists for whom she sat. It is said that even the capricious La Tour presented her with a snuff-box in apology for a curt remark.

Location: Rijksmuseum, Amsterdam.

Actual size: 16in x 12in (0,40 x 0,30)

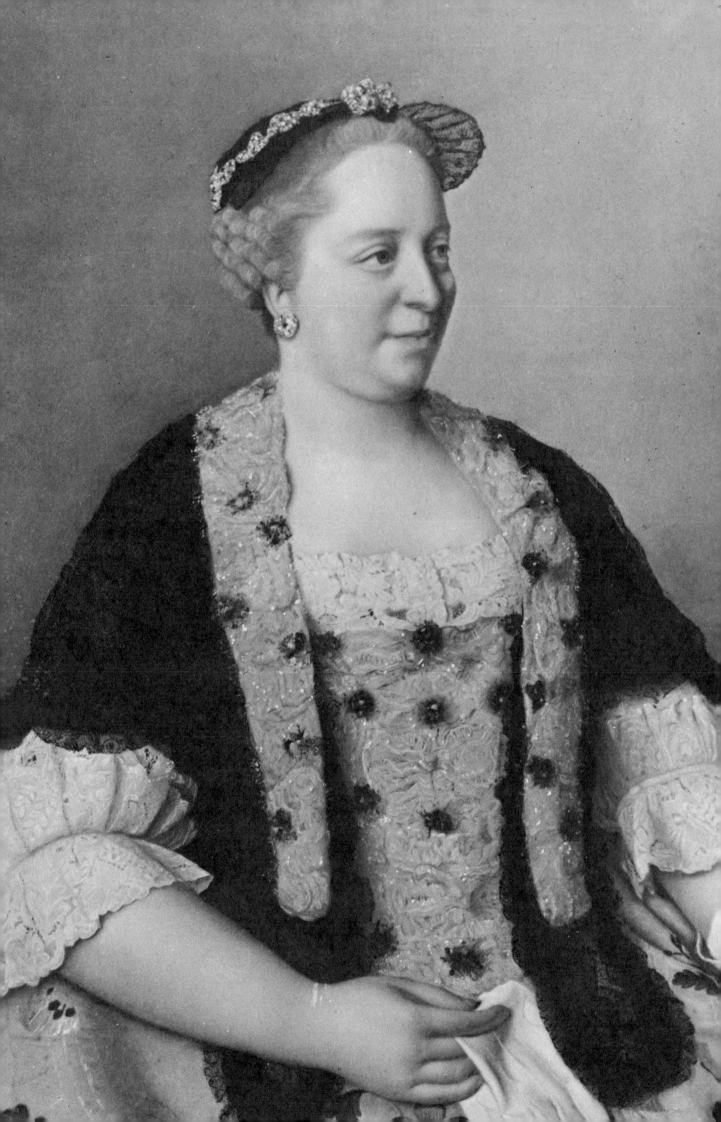

"MARIE-THÉRÈSE D'AUSTRICHE"
Jean-Etienne Liotard

This imposing looking figure was Archduchess of Austria, Queen of Hungary and Bohemia, and wife of the Holy Roman Emperor, Francis I. Any of these impressive offices could have consumed all of her time—but we learn that she also bore five sons and eleven daughters as well, and managed to exercise close supervision over their lives.

A dynamic woman in an exciting moment in history, Maria Theresa had all the instincts and abilities of a born ruler.

Location: Museum of Art and History, Geneva.
Size: 33¾in x 26¾in (0,86 x 0,68)

"PRINCIPESSA VITTORIA DI FRANCIA"
Jean-Etienne Liotard

This royal Princess was convent educated, and when she first appeared at court was described as quiet, mild mannered and "unobtrusive".

When, in 1791, her sister Adelaide fled from France, Victoria followed in her own spiritless fashion.

Location: Stupinigi Palace, Turin
Actual size: 24in x 19in (0,61 x 0,48)

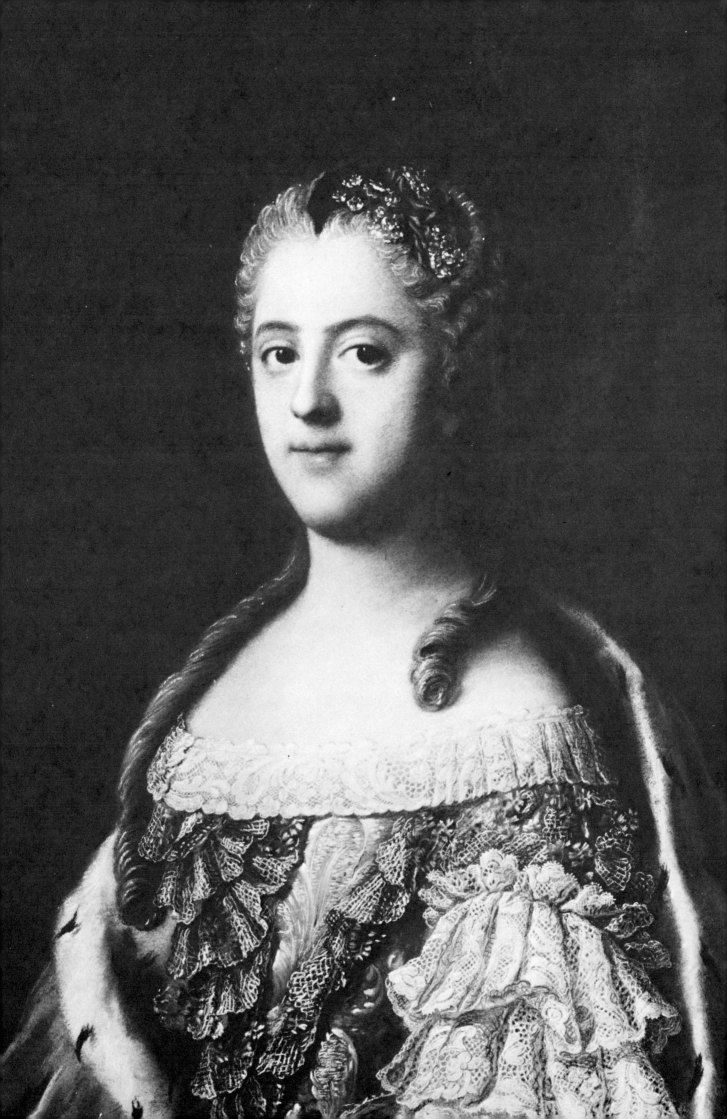

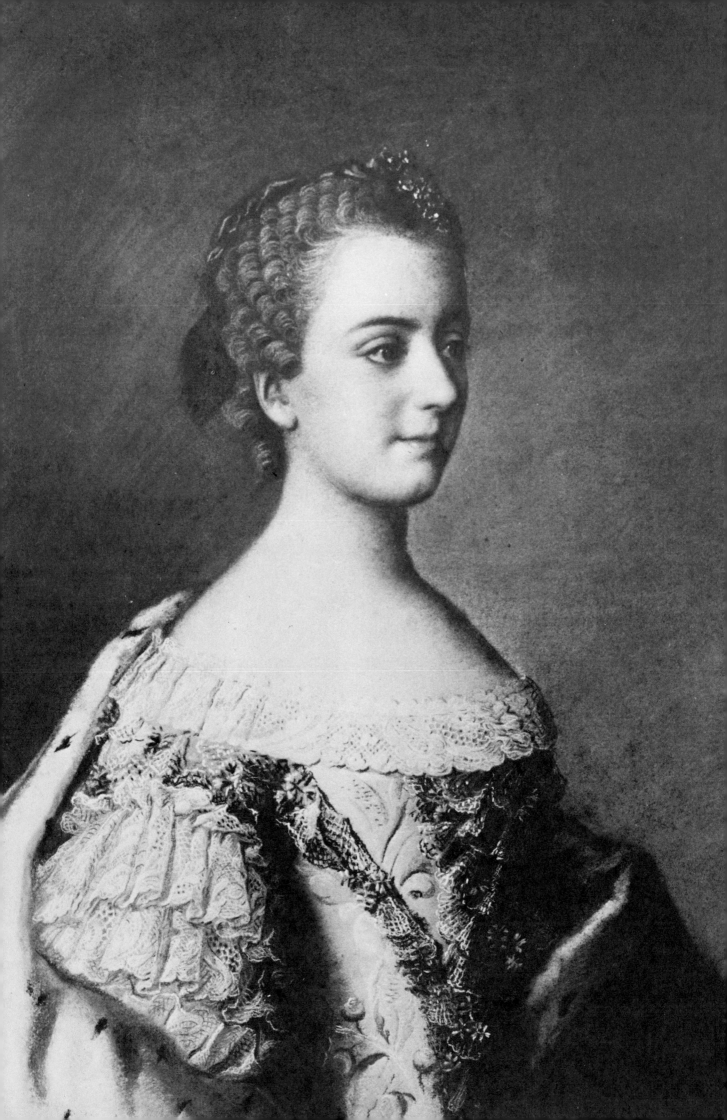

"LOUISA ELIZABETTA, INFANTE DI SPAGNA"

Jean-Etienne Liotard

The daughter of Marie Leczinska and Louis XV, Louise Elizabeth was married to the son of Philip V of Spain.

Of these velvet-clad Princesses whose portraits still hang in silent splendour on the walls of the royal hunting lodge in Turin, Louise Elizabeth is the fairest of them all.

Location: Stupinigi Palace, Turin.

Actual size: 24in x 19in (0,61 x 0,48)

"PORTRAIT DE SON FILS"

Jean-Etienne Liotard

This small oval portrait of his son, Jean-Etienne, is an example of the diminutive size in which Liotard made many of his pastels. Comparing the likeness with that of Liotard's own self-portrait—if one can circumvent the beard—there is a strong family resemblance.

Liotard's wife, Marie Fargues, and their several children happily accompanied the artist on many of his restless wanderings.

Location: Museum of Art and History, Geneva.

Actual size: 15in x 11in (0,38 x 0,28)

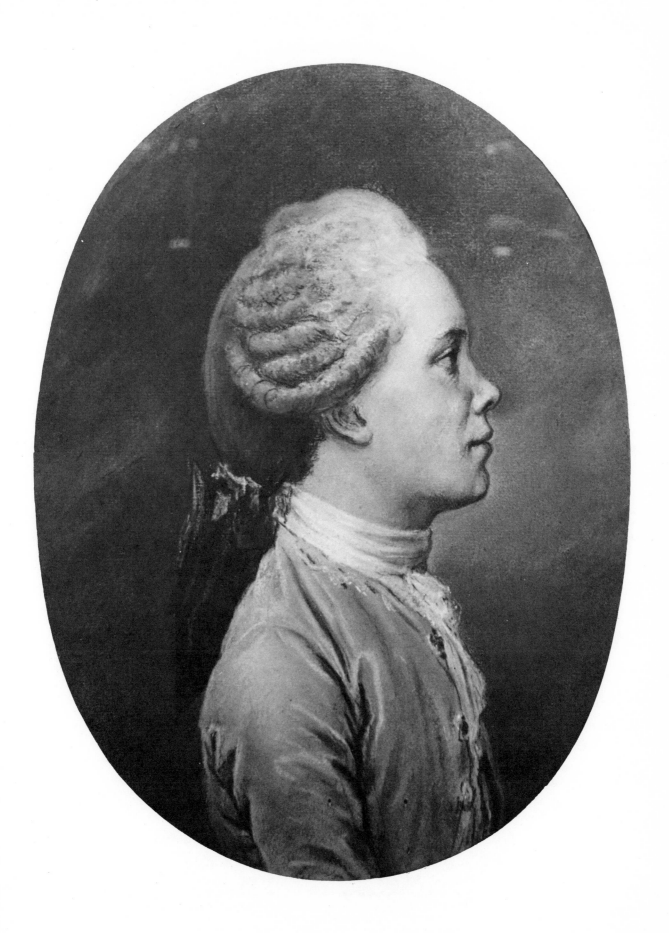

"PRINCIPESSA ADELAIDE DI FRANCIA"

Jean-Etienne Liotard

Princess Adelaide was Louis XV's third daughter, and his favorite. He admired her energy and enthusiasm, and nicknamed her "Madame Torchon". Historians have described her manner as perhaps too "free", and there is even shocking talk of an incident involving a garde du corps. Be that as it may, Adelaide of France spoke several languages, and was so well versed in mathematics she amused herself by making clocks!

Location: Stupinigi Palace, Turin.

Actual size: 26in x 21in (0,66 x 0,53½)

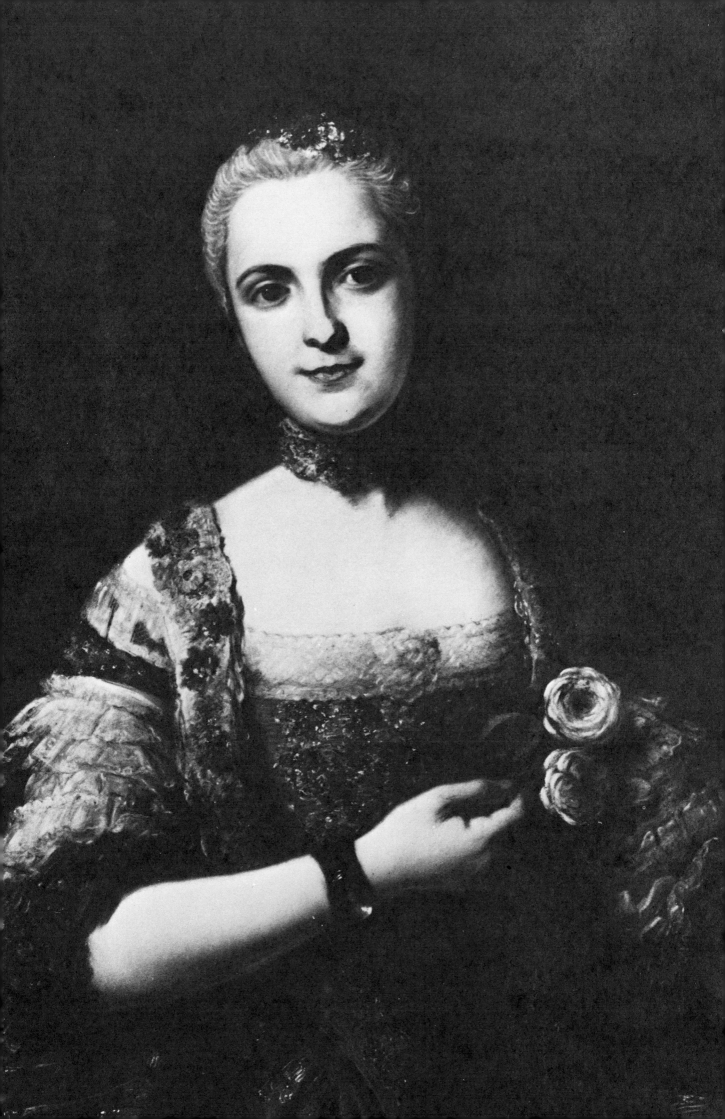

"MARC LIOTARD DE LA SERVETTE"

Jean-Etienne Liotard

In this pastel the hand and the letter are to be particularly noted. Though the quality of Liotard's work varied widely, at his best, he was an excellent draftsman, as well as a penetrating portraitist.

Location: Museum of Art and History, Geneva.

Actual size: 25½in x 20⅞in (0,65 x 0,53)

142

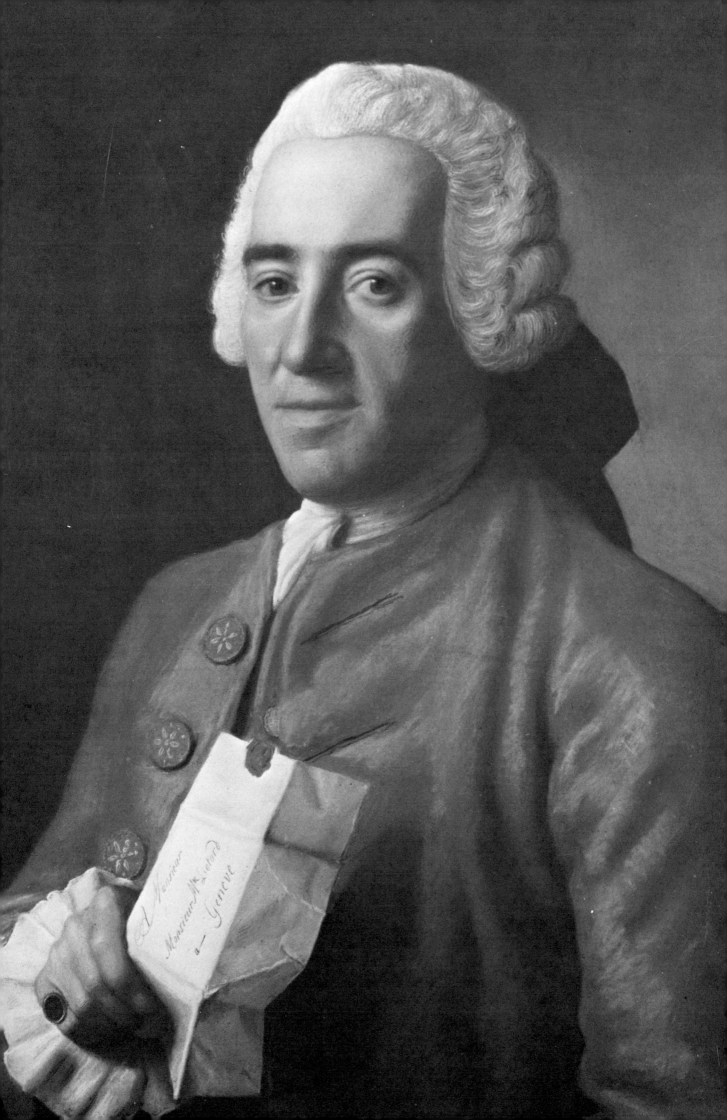

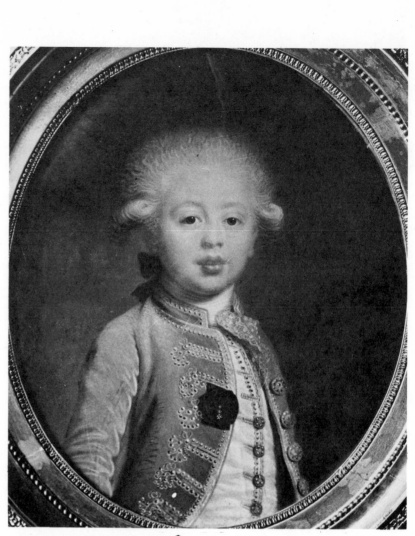

"LE DUC D'ANGOULÊME"

Joseph Boze

Here we have the little Louis Antoine de Bourbon, Duc d'Angoulême, looking like a true child of destiny. Unfortunately, however, his proved to be a minor role in the course of European history. Though he followed Wellington's troops in France and was the first to proclaim his uncle, "Louis XVIII", at Bordeaux, his own father, Charles X, renounced the throne.

As the eldest son of Charles X, Louis Antoine was called by the "Legitimists" "Louis XIX", but he never ascended to power, and finally, giving up all claims, went quietly into exile.

Location: Pavillon de Flore, Louvre Museum, Paris.
Actual size: 21¼in x 17¼in (0,54 x 0,44)
Cabinet des Dessins, Louvre Museum

"MADAME CAMPAN"

Joseph Boze

Here is Boze's charming portrait of Madame Campan, governess of the royal children. In her face we find tenderness, intelligence, and perhaps a touch of patience. We can be certain it is just the way she appeared, for no one surpassed Joseph Boze in the art of capturing resemblance. His old master, La Tour, might well have been proud of his favorite pupil.

Location: Versailles Palace, Versailles.
Actual size: 25½in x 19⅜in (0,65 x 0,50)

144

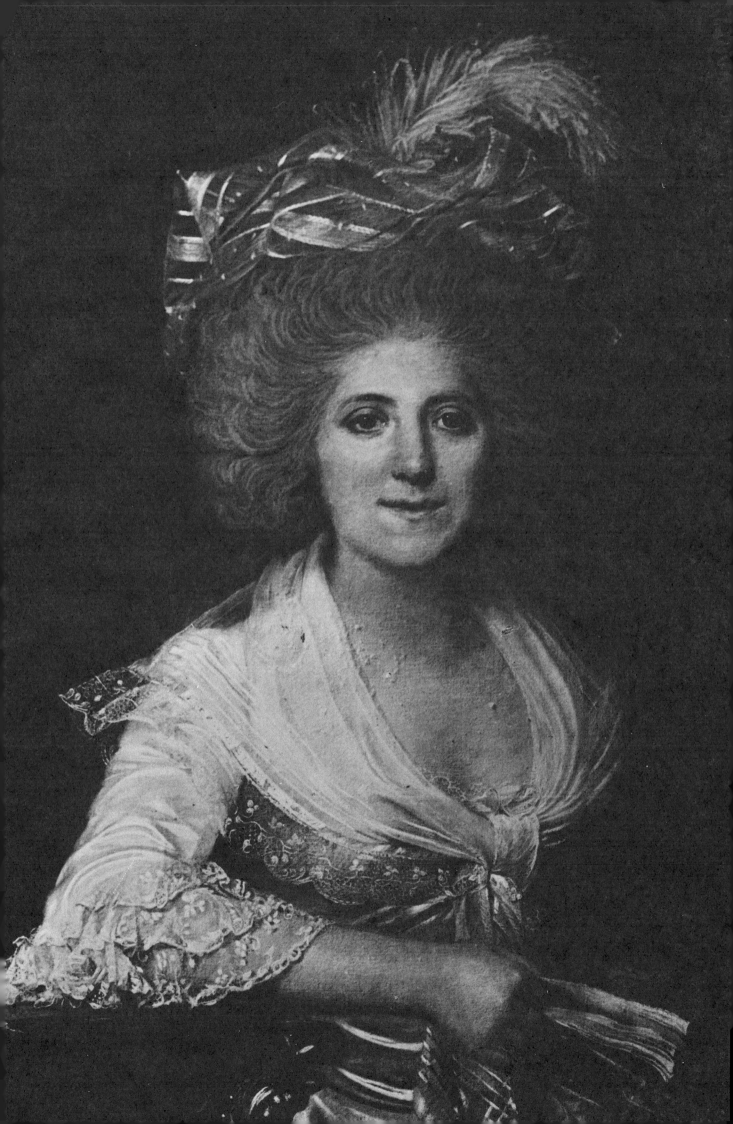

"AUTOPORTRAIT"

Joseph Boze

This splendid self portrait is without doubt an acknowledged masterpiece.

Boze was known to possess talent, inventiveness, a generous heart, and nobility of charcter. True portraitist that he was, he could do no less than record those excellent qualities he saw reflected in his mirror.

Location: Pavillon de Flore, Louvre Museum, Paris.

Actual size: 25½in x 19⅝in (0,65 x 0,50)

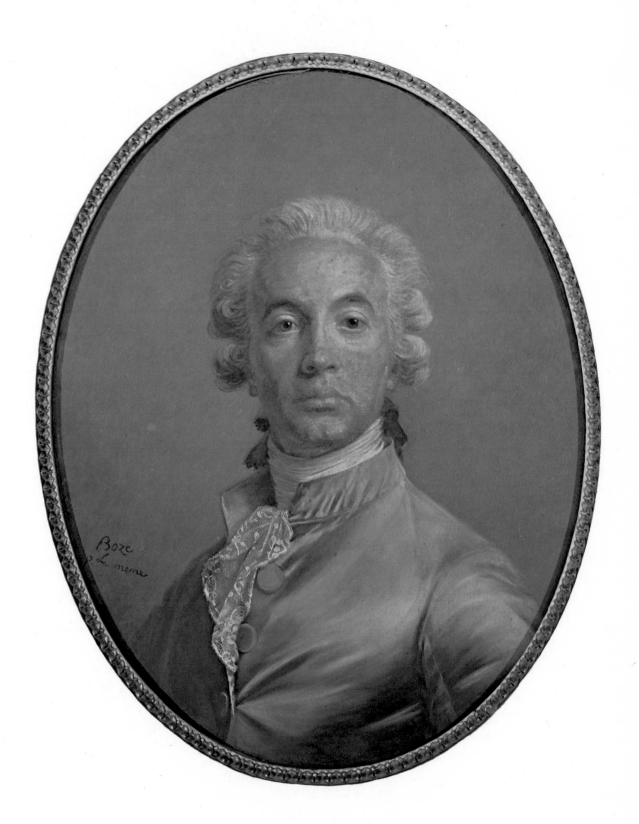

JOHN RUSSELL

(1745-1806)

England in the first half of the eighteenth century had little interest in the arts. A rigid puritanism prevailed, and life at every level of society was a pretty dreary affair. Whigs and Tories, locked in a ferocious political power struggle, gave scant thought to worldly pleasures and even less to the appreciation of beauty. Gloomy times indeed!

By the early 1750's England started to relax a bit. According to Robert René Sée, the House of Hanover was then secure and the court dared become more lighthearted. The young Prince of Wales, possessing great artistic taste, filled his receptions with painters, writers, musicians and philosophers. The aristocracy quickly followed his lead, until solemn old England, herself, was soon enjoying a sort of Golden Age. In portraiture, serenity and balance became the keynote, as artists portrayed generals, great ladies, actresses, and children with rare elegance and charm. Italy and France, having succumbed to the subtle magic of pastel, it is no surprise that the English painters were also curious to experiment. Such painters as Russell, Cotes, Gardner, Dowman, Hamilton, Hoare, Peters, Kauffman, Humphrey and Cosway—all became admirable pastellists; and even the great Gainsborough and Laurence, in their leisure time, successfully used the new medium. An impressive roll-call of names for sure —but John Russell's must always head the list, for he, of them all, was England's acknowledged "Prince of Pastels".

Through the years many art historians have discussed Russell, the pastellist, but it was George Williamson, in 1884, working from entries in Russell's diary, who has pieced together for us the paradoxical puzzle of Russell, the man.

Russell, like many of his contemporaries, had the good fortune to be born into an artistic family. His father, while four times mayor of the town of Guildford was, by profession, a prints and books dealer, so the Russell household abounded in talk of art and artists. Though young John's formal education was limited to the grammar school at Guildford, reading and study at home were strongly encouraged. History records that when still quite small, the little fellow climbed up the old church tower, holding a piece of chalk in his mouth, with which to put a mark at the very top. The daring incident seems prophetic of his career, for Russell was to reach the summit of success with his famous pastels. Even the choice of a church tower was also poetically in character, for we learn that his strong religious convictions influenced every phase of his future life.

Mayor Russell, aware of his son's artistic talent, arranged for him to study in London under the celebrated pastellist, Francis Cotes. A sincere friendship began between master and pupil, and Russell was always to give credit to Cotes for his excellent early instruction. A point of departure in their warm rapport, however, was Russell's narrow religious stand. Cotes' strong language continually outraged his pious young pupil, who often confided to his diary that "master disturbed me with oaths".* It must be here stated that Russell attempted to press his religious views on all who crossed his path! Even Cotes' housemaid, Molly, was not exempt, and an argument ensued when Cotes intervened and made the girl promise not to go near the Methodist Church again. Russell was furious, but, as always, repentance followed his angry outbursts, and he pleaded pathetically with Cotes to forgive him.

*Williamson, G., "John Russell, R.A." pp. 9

More and more turning to the medium of pastel Russell bought from Rosalba Carriera her exquisite pastels of "The Four Seasons" and gave them careful study. He was now working on his own and and had found lodgings with a watchmaker in Cavendish Square. In 1767 he received his first "country commission", typical of many that were to follow. The seventh Viscount Montague, impressed by his remarkable talent, invited the young artist to Cowdray, the Montague family seat, to make portraits of his large and illustrious family. Alas, Russell began preaching the minute he arrived, and Lord Montague, highly annoyed, remarked that Russell was very like a Methodist and that his manner would frighten anyone from religion. We are told that hardly had the easel been set up and the first portraits begun than one of the Montague servants suffered a sudden fit. Gleefully Russell offered to sit up with her for the night—in order, no doubt, to bombard the unfortunate creature with a monotonous religious harange.

Luckily, Russell had already completed several of the Montague portraits before his rantings aroused the resentment of the Roman Catholics at nearby Midhurst, with rather disastrous results. The township formally asked him to remove himself from the local inn—right in the middle of a portrait of Lord Montague's sister. The poor fellow had to stop, pack up, and return to Guildford, the only redeeming addenda to the episode being the opportunity it afforded him to preach to the coachman on the long journey back.

As Russell's personality became increasingly obsessive and difficult, his artistic technique seemed to grow in strength and beauty. His pastels were early characterized by their harmony of composition and rich glowing colors. The influences of Cotes and Rosalba Carriera were gradually being shaken off, and an original style of his own was emerging. His frenzied fanaticism seemed to have no ill effect on his brilliant talent for portraiture. In fact, with a sitter as captive audience for his evangelical ramblings he was never happier than when at work at his easel. It is only fair to note that the sitters were far less enchanted, and often registered vigorous complaints.

Once again with his family at Guildford, after the awkward Montague incident, religious quarrels inevitably started again. Russell strongly objected to his family's Sunday walks, and they, for their part, complained about his lengthy mealtime blessings, which continued long after the food was cold. His fellow townsmen, while applauding the twenty-two year old Russell's great artistic talent, studiously avoided his companionship, lest it lead to some sort of religious controversy. There was simply no other subject for conversation when he was around. Feeling unwelcome on his native soil, Russell decided to return to London by stagecoach, preaching to the other passengers during the entire journey.

Russell received a steady stream of portrait commissions in London, and his art was increasingly appreciated. It was at this time, in his early twenties, that he met the Faden family and was captivated by their pretty daughter, Hannah. Hannah found herself drawn to the serious minded young artist, despite the fact that her family was obviously bored by his incessant arguing and wild ideas for reforming the entire world. Strenuous parental opposition ensued when Russell was suspected of trying to convert Hannah to Methodism. Russell finally won out, and in 1770 the family reluctantly consented to their marriage, and starry-eyed Hannah henceforth embraced her husband's avid interest in all matters concerning the cloth.

That same year Russell was awarded the gold medal from the Academy for figure drawing, so his luck seemed to have taken a turn for the better.

The newlyweds moved to John Street, and their marriage from the onset was a happy one, despite Russell's continuous conscience searching and morbid introspection.

Two Esquimaux Indians, a mother and son, brought to England by Commodore Pilliser consented to pose for Russell in his new studio, and these unusual portraits were his first to be exhibited in the Royal Academy. They were an outstanding success, and soon members of the clergy and aristocracy were awaiting their turn to be limned by the brilliant young pastellist. Russell had a special genius for giving life to his models. The eyes of the women sparkled with health, the children he drew seemed bursting with happiness, and in all his works there was balance and purity of design. Scorning jewelry, furbelows and needless adornments, Russell began to introduce animals into his compositions, always with taste and careful attention to their drawing. A sitter was often depicted with his favorite dog, cat or bird.

Let it not be assumed that Russell's blossoming career in any way deterred him from his religious pursuits. He maintained a close connection with the Church of England, even while criticising its liturgy and ritual, and spent endless hours visiting other churches, arguing minor points with their pastors. Even at the Royal Academy, to which he was elected an associate member at only twenty-seven, he insisted on expounding his narrow views. Williamson notes that his one concern upon election was that it not be instrumental to his "soul's injury".*
*Williamson, G., "John Russell, R.A." pp. 29

It was at about this time that Russell came to know Sir Joshua Reynolds, president of the Academy and the most celebrated portrait painter of the day. Though few common interests besides art existed between these two diverse personalities, a strong mutual admiration sprang up between them. Somehow Russell restrained himself from arguing over controversial subjects with the great Sir Joshua, and the influence of Reynolds can be recognized in many of Russell's pictures.

Membership in the Academy, however, was not a great source of pleasure to Russell—the dinners there were an ordeal, with his fellow members often engaging in shocking blasphemies. He began to avoid the company of other artists altogether. Except for an occasional supper at the Turk's Head with Reynolds and Dr. Samuel Johnson, he preferred the society of persons with his same religious views. Once he mentioned a rather frivolous gathering into which he inadvisedly took his sisters, but added with relief that "they did not receive hurt".* He was sometimes invited to dine in a fashionable palace, but

was far more interested in the paintings on the walls than in the host or the other guests.

*Williamson, G., "John Russell, R.A." pp. 34

Russell made it a firm rule never to paint on Sunday, and even locked his studio doors to all visitors on that day. Despite poor health he insisted upon attending far away church services in the most inclement weather, and frequently exhausted himself by seeking out preachers whom he personally disliked in order to overcome what he felt was an unfair prejudice. Funeral services were his speciality; he tried to attend them all, coming away overwrought and emotionally upset. It is little wonder that he became increasingly nervous, and was sometimes given to outbursts of hysteria.

Russell was quite pleased, in 1772, when the philanthropic Lady Huntington consented to sit for him for her portrait. He intended to present it to an orphans' home in Georgia. Why he ever assumed that the portrait of a titled matron a continent away would excite a clutch of miserable orphans in Georgia will forever remain a mystery! In any event the pastel never arrived, as the vessel carrying it was sunk off the coast, so the orphans were spared this dubious beneficence. The majority of Russell's portraits, however, were executed with less charitable destinies in mind. He began commanding and receiving excellent fees for his work, and by his early thirties was considered a highly "successful" portraitist. Whenever he returned to Guildford the bells from the three churches rang out in welcome, and his fame was now well established.

At a certain stage, the long illnesses of his children left Russell's bank account depleted, but he resourcefully took in boarders and gave lessons in pastels to distinguished persons in his free time. This financial crisis was short lived, however; not only did commissions pile one upon another, but the will of a deceased cousin named Russell sole beneficiary of a freehold estate in Dorking, assuring him a steady income for life.

In 1788, he was made a full Academician, and the next year he became the King's painter, giving him legal title now to use "esquire" after his name. He moved to a larger house on Newman Street, and was literally inundated with requests for portraits.

The first pastel to be commissioned by the royal family was of the famous physician, Dr. Willis, who had attended the King during a long illness. The King was so highly pleased with the results that he instructed Russell to make portraits of the Queen and the Prince of Wales, and the artist was thenceforth known as painter to the King and the Prince of Wales. His portrait entitled "Her Majesty the Queen" exhibited at the Royal Aca-

152

demy's 1790 exhibition, was received with great enthusiasm. Two years later Russell was styled painter to the King and the Prince of Wales and the Duke of York. A royal command came in 1796 for a portrait of the Princess of Wales with the infant Princess Charlotte seated on her knee, to be sent as a gift to the Duchess of Brunswick. This was the beginning of a succession of pastels for the royal family, many of which are still property of the Crown.

Russell always had a pleasant time working at Buckingham House. Once when he dropped a pastel box, spilling powdery chalk in all directions, no less than the Queen, herself, joined the courtiers and Russell in retrieving the scattered colors from the floor. The Prince Regent, too, was always kind to him—considering Russell a likeable fellow, albeit a bit curious. When Russell expressed his longing to see a certain painting in a private palace, the prince immediately unbuckled his knee garter and gave it to him, to present in order to gain immediate entrance.

Russell also made several pastels for the Prince Regent while at Brighton. He had gone there with the philanthropic Lady Huntington to the opening of a chapel—so the trip proved to be a doubly rewarding one.

This introduction into court circles resulted in a friendship with the celebrated astronomer, Sir William Herschel. From the time of their meeting, Russell spent all of his leisure hours observing the surface of the moon. He borrowed a telescope from his friend, John Bacon, and with the help of his daughter mapped in detail every lunar mountain, valley and sea. The map, drawn by hand to actual measure, became a treasured possession of the observatory at Oxford, and must surely have afforded Russell a great deal of personal satisfaction. Following this tremendous undertaking, he next invented a complicated apparatus called a Selenographia—for showing the phenomena of the moon. Unfortunately, the invention was far ahead of the public's interest and was awarded scant recognition or notice.

In 1799, Russell received an invitation to Burleigh House. On the morning of his departure he was so taken up with a funeral passing his door he almost missed the coach. Once there, however, he made portraits of the Earl and his three children, which were among the finest examples of his work.

With a sound knowledge of chemistry, Russell always prepared his own pastels, never adding any oil or resin. In his later years his colors grew less florid and can best be described as "brilliant" and "luminous",[1] with highly subtle gradations. His whites—often a stumbling block for pastellists—were never chalky. He applied his color very thickly, in order to have a strong, solid base, and then used his fingers to blend and soften.

[1] Sée de Saint-Hilaire, R.R.M., "English Pastels, 1750-1830" pp. 22

Russell was well aware of the damage the English climate could wreck upon pastels. His biographer notes that he took great care to preserve his works, attaching detailed instructions on their backs before giving them over to the patrons. One such admonition read, "Should a Spot of Milldew appear, a Leather Drawing Stump or Cork Pointed will take it off instantly, but this will never happen but from being placed in a damp situation".[*2] Russell was meticulous in his preparation for work, often rubbing the steel blue paper he preferred with pulverized pumice stone to be sure it was completely smooth. His paper was usually attached to a piece of canvas, on the back of which he sometimes spread a thin coat of gelatin. Russell found that careful attention to the drapery, the lace, or gauze in a portrait gave it a refined sense of finish. He generously passed on all his secrets to other artists in a book entitled, "Elements of Pastel Painting".

[*2]Williamson, G., "John Russell, R.A." pp. 89

In middle age, Russell revisited York then Leeds, and he seems to have had more commissions in Leeds than anywhere else. While happily wandering about the city he inspected the Sunday schools, and noted in a journal of the visit that some two thousand boys and girls were "restrained" there. He went on to state, "I do not hear the evil language in the streets of Leeds as in London!"[*] His trip to York also provided a pleasant entry in his diary. "—people spend their time in religious exercises",[*] and "very little but what may be called orderly behavior"[*] was observed in public places.

[*]Williamson, G., "John Russell, R.A." pp. 66, 73, 74

Russell's easily aroused temper was a constant source of self guilt. The poor fellow worked so hard at keeping it under control that he was often accused of being indifferent and cold. To counteract the impression, he began to fain a humor and vivacity he rarely felt; but in his last years this evolved into a genuine sweetness of disposition and a real sympathy for his fellow beings. It is quite surprising that none of Russell's fierce inner struggles were ever reflected in his art. His portraits, from the beginning, were distinguished by harmony and balance.

For years Russell had, of course, known every preacher for miles around, be he of the establishment or a non-conformist; but suddenly, in his old age, he began to have acquaintances in theatrical circles as well. The great Mrs. Siddons and many other dinosaurs of the footlights came to him for portraits in pastel. It is hard to imagine that he found any real camaraderie with these more worldly souls, but business was business. Once, at an exhibition of paintings he was brightly accosted by a fashionable young woman whom he had recently sketched. She nodded toward a picture showing nymphs at their bath, and asked the aging master if he didn't find it well painted. "I'm

ashamed to look at it, Madame",* Russell coldly replied, and removing his spectacles marched rapidly in the opposite direction.
*Williamson, G., "John Russell, R.A." pp. 84

By the turn of the century, Russell was rapidly losing his hearing, and his health, never robust, began to fail. He contracted typhus fever and died at the age of sixty-three, leaving as a memorial the finest pastels England can boast. His surviving son, William, himself a gifted artist and his father's pride, decided to give up pastels and paints for ever—lest the pursuit of art "might be exercised to the detriment of his spiritual duties".*
*Williamson, G., "John Russell, R.A." pp. 99

FRANCIS COTES
(1726-1870)

Francis Cotes, often called the father of English pastels, remains for us something of a mystery. Few records exist from which to draw a clear picture of his personality or his life. A miniature his younger brother painted from memory shows a slender, aristocratic nose, a high slanting forehead, and gentle eyes. We know that Cotes' father had been mayor of Galway, but after an altercation with the Irish parliament moved bag and baggage to London where his two sons were born. Young Francis, showing an early predilection for the arts, was packed off to study under the famous portraitist, George Knapton, and soon, himself, decided on portraiture as a career.

Once he began practicing on his own, Cotes became widely recognized for his superb works in pastel. No less than Horace Walpole was moved to say of them, " if they yield to Rosalba's in softness, they excel hers in vivacity and invention".* Such a flattering comparison must surely have delighted Cotes, for he always considered Rosalba Carriera the supreme genius in their field, rivaled by none. In his choice of colors Cotes differed from other pastellists; he preferred brown, stone colors, and golden tans, while always working on a brown or olive paper. Though some of his portraits have been labeled "cold" and "stiff", others were hailed as "Reynolds in chalk".* He was fond of adorning his women with glowing pearls and jewels, their opulence reflected in his translucent skin tones. Needless to say, he was never without sitters.
*Sée de Saint-Hilaire, R.R.M., "English Pastels, 1750-1830" pp. 42

Cotes settled in a comfortable house on Cavendish Square, and along with his successful practice of portraiture took on an occasional pupil—among them, young John Russell of Guildford, who would one day surpass him. Cotes grew extremely fond of the overtly religious young man and attempted to teach

him everything he knew about the techniques of pastels and portraiture. Their only arguments arose over Cotes' frequent use of "intemperate" language. Russell, whose pious sensibilities were offended by any sort of rash imprudence, would explode into unreasonable temper tantrums, only to beg forgiveness a moment later. Years after Russell had gone on to fame and glory in his own right, he constantly gave credit to his old master and deeply cherished their friendship. Though Cotes' personality remains shadowy, he must surely have possessed some most endearing qualities to have inspired such devotion. Peter Toms, who also worked in his studio and is said to have painted most of the draperies in Cotes' portraits, felt such a deep melancholy at his death that he later committed suicide!

Cotes' finest work was done during the last ten years of his life; a pastel of Queen Charlotte with the Princess Royal asleep on her lap has long been considered a masterpiece.

Francis Cotes' one recorded public act was the signing of a petition to George III for the forming of the Royal Academy. In his forty-fifth year Cotes proudly became a founding member of the Academy, but only lived for a short time afterwards, leaving his old house on Cavendish Square vacant for its next illustrious occupant, George Romney. Among the possible causes of Cotes' death was listed "accidental poisoning by soap"! A sad footnote to this rather inglorious end came from his beloved former pupil, on whom fell the task of 'informing' the deceased's parents and aunts. According to Russell's indignant entry in his diary, they "expressed themselves like brutes".*
*Williamson, G., "John Russell, R.A." pp. 11

Of Cotes' life and death our knowledge is fragmentary and illusive, but of his art we can say with all assurance—he ranked among the greatest of his time.

WILLIAM HOARE
(1706-1792)

William Hoare is representative of a large group of English pastellists who, though they never rivalled such masters as Russell and Cotes, did create a number of delicate and charming pastels, which today evoke for us a faraway time of leisure and grace.

Hoare's father was the owner of a large farm estate in Suffolk, and so could afford to send his son to the excellent school at Farringdon in Bershire. It was later arranged that the Florentine artist, Grisoni, ensconced in England at the time, should give young William lessons in painting to complete his education.

Grisoni soon recognized the boy's decided talent and encouraged him to visit Rome—thus making William Hoare the first of a long series of English artists to be trained in Italy.

Hoare was immediately intrigued by the portraiture of Rosalba Carriera and began to base his style on hers. In 1730, when about twenty-four years old, he went to work in the studio of Ferdinandi, and remained with the reverend old "Imperiali" for nine years before returning to England.

Once back on native soil, Hoare set himself up as a portrait painter in Bath, and for the next fifty years made portraits of every illustrious visitor to the city. When the Royal Academy was founded in England, Hoare was named among its founding Academicians. Having come to pastels through his admiration of Rosalba Carriera, every year he sent portraits in this medium to the exhibitions. They were all characterized by a great tenderness and charm; his "Prudence Teaching Her Pupils", exhibited in 1774 and "A Child On a Sofa" in 1779 received enthusiastic acclaim. The artist's gentle nature and love of children are clearly seen in these sensitive works.

Though Hoare's pastels were somewhat dry, and the influence of the Italian masters unmistakable, his work was always elegant and pleasing. The beloved old artist died at Bath at the age of seventy-seven, leaving his son Prince Hoare, to become one of England's most amusing eighteenth century playwrites.

Sir Peter William Hoare, the present Baronet of Luscombe, Devon, is a direct descendent of this artistic and delightful family.

HUGH DOUGLAS HAMILTON
(1739-1806)

Hugh Douglas Hamilton, the soft-spoken Irishman, had a career unlike our other pastellists. He 'began' with pastels and later came to oils, instead of the reverse. Perhaps it is not too surprising, for by the time he commenced his study of art, half the century had passed and pastels were well established.

But let us go back to a little house on Crow Street in Dublin, in 1739, when a peruke-maker and his wife announced the birth of an infant son. The child grew to exhibit such a marked talent for drawing that the Dublin Society became aware of him, and decided to place young Hugh Douglas Hamilton in a proper drawing school in George's Lane, under the tutelage of Robert West. During this period of early training Hamilton won several prizes for his sketches, and by the time he left his old teacher he was already drawing excellent portraits in pastel.

From the beginning, Hamilton's likenesses were full of charm and animation, usually done on grey paper in black and white chalks, and finished off in colors. Most of his portraits were oval in shape and small. He was able to do them so quickly that the amount of work turned out during those early years was enormous. It must be added that his fees were quite modest, which may have had an influence on his sudden success.

When Hamilton was twenty-five, the young man from Dublin decided to try his luck in London. There his talents were not confined to small oval portraits of smiling faces. In his first two years Hamilton won premiums for works bearing such doleful titles as "Priam and Hercules Lamenting over the Corpse of Hector" and "Boadicea and Her Daughter in Distress." His portraits, however, were his great forté, and became as sort after in London as they had been in Dublin.

After several moves, which took him from Long Acre to Broad Street, Hamilton finally settled himself in Pall Mall, in the house of a successful apothecary. By luck, a fashionable milliner also had lodgings there, and it proved a wise move on the part of Hamilton to sketch her portrait shortly upon arriving. The little pastel was so admired by the milliner's customers that countless commissions followed. Poor Hamilton was soon so overworked that he had no time to pocket his fees, and would toss the guineas into his chalk box, to be sorted out after the last sitter had left each day.

Hamilton was never hesitant to include several figures in a single composition, and he often attired the women in his portraits in the dress of mythical goddesses. His female heads were characterized by grace and refinement, but he was to be seen at his best in his faces of elderly men. Only when Hamilton attempted figures in full length was his hand uncertain, and one suspects that many an unsolved problem of anatomy has been concealed by a clever arrangement of drapery.

After two busy years in Pall Mall the artist moved to a house in St. Martin's Lane, adding a large studio at the back where he continued to pursue his artistic career. The next few years were exhilarating ones. From his marriage, a little daughter, Harriott was born in 1769, and to this joy was added the ever mounting evidences of worldly success. Even the King and Queen commissioned portraits from him, and various members of the nobility were counted among his patrons. He was considered an important member of the English School of Pastellists, and as W. G. Strickland describes it, he was "fully occupied in an extensive and fashionable practice".

In 1778, Hamilton took his adored nine-year old daughter, and the sizable fortune he had acquired, and set out for Rome.

Though inspired by the glories of Florence, he decided to make the "Eternal City" his home. It was there that he met Flaxman, who, feeling that Hamilton's talents needed wider expression, persuaded our pastellist to turn to oils!

Now, all but abandoning his chalk box, he began to 'paint' the portraits of the various Irish and English visitors who found their way to Rome.

Not all of his time was spent at an easel; Hamilton's impeccable manners and genial disposition made him a sought-after favorite in Roman society. Nor was his little daughter Harriott overlooked by the discerning Italians. Not only pretty and charming, she was fast becoming an accomplished painter in her own right.

Father and daughter remained in Italy for twelve happy years, finally returning to Dublin and a handsome house in Claire Street.

In years past, Hamilton had always faithfully exhibited with the Society of Artists in Dublin—but always his pastels. Now for the first time, to the surprise of his old friends, his entries were in oils. One, bearing the title, "Dean Kirwan Pleading the Cause of the Destitute Orphans" was declared a masterpiece.

After the turn of the century, Hamilton's health began to fail, and he had little strength for painting. During his last years, with Harriott at his side, he concentrated on the study of chemistry, particularly the composition and behavior of pigments.

At the time of his death, Hamilton was at work on his last portrait—commissioned by the same Dublin Society which had first recognized his great talent as a child.

DANIEL GARDNER
(1750-1805)

Unlike most of our pastellists who reached the height of their fame while still alive to enjoy it, Daniel Gardner was not to be fully appreciated until after the turn of the twentieth century, when the auctioneers' hammers suddenly began to 'knock down' fantastic prices for his frail masterpieces. Much of their charm lies in Gardner's use of his medium, combining pastel with water-color and gum into sort of a mysterious gouache. Whatever the procedure may have been, the loveliness of Gardner's portraits glow in silent testimony to the fact that he certainly knew what he was doing!

But let us go back to 1750 to the town of Stricklandgate, Kirkby-Kendal, when a son was born to a happy artistic family with a passion for collecting pictures. The Gardners named the boy Daniel, and Mrs. Gardner, an amateur painter, was delighted when the child began to show a precocious talent for drawing. Daniel's favorite playmate was George Romney, another budding genius in Kirkby-Kendall, and it was energetic Mrs. Gardner who persuaded the Romney family to give young George art lessons to encourage his obvious talent. The two boys sketched side by side, and George Romney's first portrait was of Daniel Gardner's mother.

After Romney, the elder of the two went off to London for further study, little Daniel could hardly wait to do the same. His school books became covered with the word "London", printed and scrawled in a hundred different ways. He slowly began to earn the necessary train fare by making portraits of his classmates, and even persuaded some of the masters to sit for him in interest of the cause.

Young Daniel Gardner finally arrived at London in his twentieth year, and was admitted as a student in the newly formed Royal Academy—the dream of every aspiring artist. It was here that Gardner was discovered by the great Sir Joshuah Reynolds. The kindly dean of English portraiture not only took him into his studio, but often allowed Gardner to prepare the landscapes and foliage in the backgrounds of his own canvasses before he, himself, took up his magic brush to draw in the figures. It is understandable that Reynolds should have had a great influence on Gardner's style, and though he never consciously imitated him, Gardner naturally applied Reynolds' theories in his own work. One strongly suspects that many an early painting by Gardner has been falsely attributed to Reynolds.

Gardner seems to have enjoyed immediate success as a portraitist, working usually on small oval canvases. Oils, however, never really appealed to him, and he soon turned to pastels, sending to the Academy's exhibition of 1771 a remarkable portrait of a time weathered old gentleman, limned in the new medium. From the beginning of his acquaintance with pastel Gardner experimented with gouaches, working out special techniques for preparing and applying his materials. It would appear that he first roughly painted the entire picture in water-color— to give the paper an overall covering before the addition of his heavy strokes of chalk. Some critics believe that the pastels were mixed with a gum medium to give them their great transparency, and over the first surface still more pastel applied, allowing the original drawing to glow through the latter. One thing is certain, we shall never really know the formula, for Gardner accepted no pupils, allowed no one to watch him work,

and never even admitted a visitor to his studio door—a secretive alchemist in the old tradition!

The actual time of his meeting with Gainsborough is not sure, but he did work for a while in the great man's studio, and certainly Gainsborough's influence on Gardner's style is undeniable. An easy elegance marks both their works, but as Speilmann, the art historian, observed, Gardner's brush strokes were more deliberate and lacked the feathery touches so characteristic of the older man. The friendship between the two artists came to a sudden impasse when Gainsborough ventured an unflattering remark about Sir Joshuah Reynolds. Gardner's fierce loyalty to his early master never forgave it.

At the age of twenty-six Gardner married a lovely, cultivated young scholar named Nancy Howard and settled into a happy routine life. Gardner was careless in his dress and often abrupt in manner, but Nancy adored her talented husband and the birth of a son made their idyl complete. Suddenly, as if fate had rearranged the cards, Gardner's blissful world came crashing to an end—a second little son was born to die in early infancy and his precious Nancy died shortly after. These bitter losses, so unprepared for, seemed to cause a complete change in the artist; he became withdrawn, eccentric, and overly penurious in matters involving money. Life no longer seemed worth living.

Perhaps in order to escape the memories his own house held for him, Gardner began to stay always in the houses of the persons he painted. He spent a great deal of time with a family named Heathcote, sketching the various members of its large household. In the late afternoon he would slip silently out into the great woods bordering the Heathcote estate, and wander for hours gathering fungi, berries, and odd bits of roots and bark from which to concoct his mysterious compounds. Needless to say such nocturnal forays hardly mitigated his reputation for idiosyncrasy.

Gardner's commissions often took him to Norfolk and Suffolk where he used the earnings from his painting to buy up various lands and properties. These real estate ventures continued until Gardner—successful in his work and canny in his investments—became a surprisingly rich man, spending his carefully hoarded guineas only for an occasional rare book to enhance his library. He allowed himself no amusements, except to play with the small children of his few loyal friends. Often after a lighthearted caper in the nursery, he would rush to his studio, hoping to work away the ever recurring waves of grief. Gardner grew rigid in his habits, accepted no invitations and was always in bed by nine each evening, so as to start his painting in the hours of early dawn. He sometimes suggested to a horrified patron that he be ready to pose by five!

When painting a single figure, Gardner usually placed his subject leaning against a column or a pedestal belonging to the sitter. In his group pictures, the principal woman was always depicted wearing an enormous hat or an elaborate coiffeur, by which to distinguish her from the others. The foliage in his backgrounds was treated in a way typical only of Gardner, and his excellent gift for composition have made his works ideal subjects for engravings. In these exquisite portraits the trees, clouds, rocks and drapery were done in a gentle water-color wash, with the figures, finely modelled and finished in pastel, seeming to stand out against their backgrounds. It appears that a half tone of pastel was applied over the entire surface to complete the painting and soften the effects of light and shadow. Whatever the various ingredients used and in what order, Gardner's portraits still remain as fresh and animated as the day they were painted —time acting only to enhance their value.

Growing richer and more eccentric by the year, Gardner finally became critically ill, and at the age of fifty-five went to join his beloved Nancy. One imagines that he had few regrets at leaving this world, and certainly never suspected that two centuries later his delicate works would become the coveted pride of a host of collectors, and fetch prices beyond his wildest dreams.

The illustrations

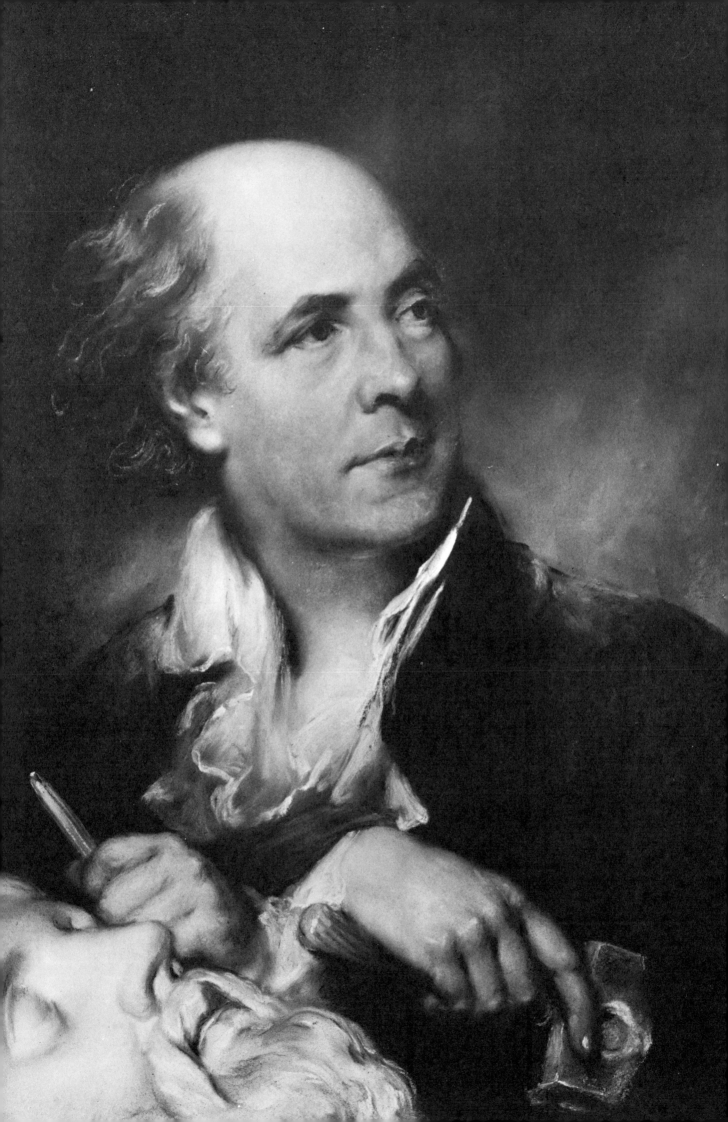

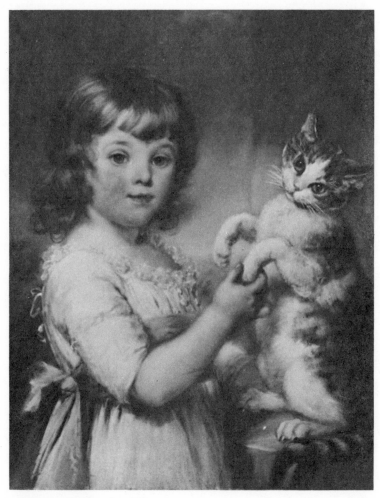

"GIRL AND CAT"
John Russell

John Russell was fond of depicting his little subjects with their favorite animal or bird. He always gave special attention to the anatomy of the pet, and made it an integral part of the composition.

Location: Tate Gallery, London.

Actual size: 23⅛in x 17½in (0,58½ x 0,44½)

JOHN BACON, R.A.
John Russell

John Bacon was a gifted sculptor, and a revered member of the Royal Academy. In fact it was he who received the first gold medal for sculpture ever presented by that illustrious group. Bacon's most important works can be seen today among the monuments at Westminster Abbey.

Though our Russell was also a member of the Royal Academy, he seldom fraternized with his fellow artists.

Location: Victoria and Albert Museum, London.

Actual size: 23½in x 17½in (0,60 x 0,44)

Victoria and Albert Museum, Crown Copyright

"REVEREND ROBERT WELLS, D.D."

John Russell

The Reverend Wells was the Rector of Willingham, and no doubt one of the vast number of Protestant ministers whom Russell knew personally. The artist was never happier than when involved in a religious discussion or controversy, so one imagines this commission afforded him much pleasure.

Despite his nervous temperament and erratic outbursts, when Russell approached the easel he was a master in full control of his talents.

Location: Victoria and Albert Museum, London.
Actual size: 30in x 25in (0,76 x 0,63½)

"COL. EIDINGTON IN UNIFORM"

John Russell

This portrait contains all the most distinguishing features of Russell's pastels. It has a luminous purity of color, with the rich sky-blues for which he was famous. The composition is balanced, with careful attention to the anatomy of the hands and arms. The red of the coat is typically strong and vigorous, giving the impression of having been drawn yesterday.

This handsome portrait was in the collection of the late Claude Roth, who bequeathed it to the Victoria and Albert Museum.

Location: Victoria and Albert Museum, London.
Actual size: 36in x 28in (0,91½ x 0,71)
Victoria and Albert Museum, Crown Copyright

166

"LOUIS WELTJE"
John Russell

The Royal Pavilion at Brighton was constructed in the late 1780's as a residence for the young and extravagant Prince of Wales (later George IV). It was in the cellars of the old Pavilion that this pastel of Louis Wèltje, clerk to the Prince of Wales' kitchen, was found. The portrait, though interesting, certainly lacks the quality of Russell's best work.

 Location: Brighton Art Gallery, Royal Pavilion, Brighton.
 Actual size: 24in x 20in (0,61 x 0,51)

MARTHA (NÉE HOLLAND) BACON
John Russell

Martha Bacon was the second wife of the sculptor, John Bacon, and this glowing portrait of her gives a fine example of what Robert René Sée calls the "light and luminous texture" of Russell's work.

 In their freshness, Russell's pastels have proven to be the most durable of the English school.

 Location: Victoria and Albert Museum, London.
 Actual size: 23½in x 17½in (0,60 x 0,43)
Victoria and Albert Museum, Crown Copyright

"JOHN ('SMOAKER') MILES"

John Russell

The simple fishing town of Brighton, south of London on the English Channel, became a fashionable summer resort in the late eighteenth century, frequented annually by the royal family and distinguished visitors.

John Miles, a bathing attendant known as "Old Smoaker", was a familiar figure on Brighton's beaches in those early days, and posed for this delightful portrait during Russell's visit to the popular waterfront city.

Location: Brighton Art Gallery, Royal Pavilion, Brighton.

Actual size: 29½in x 24½in (0,75 x 0,62⅓)

"PORTRAIT OF LADY ISABELLA SUMERSET AS A CHILD"

John Russell

The English artists were called the poets of childhood. Certainly in this pastel of little Isabella Sumerset, Russell shows the reputation well deserved. Working on a steel blue paper, which he always preferred, he demonstrates his ability to breathe life into his subjects, and to capture the delicacy and sweetness of the very young—without an overdose of sentimentality.

The pastel was formerly in the collection of the Duke of Devonshire.

Location: Victoria and Albert Museum, London.

Actual size: 15¾in x 13⅛in (0,40 x 0,33½)

Victoria and Albert Museum, Crown Copyright

170

"THE FORTUNE TELLER"

John Russell

One wonders what rigid views Russell held on the practice of fortune-telling, and if the subject of this portrait received a lecture while posing.

For all the tranquility and balance to be found in Russell's work, his religious and emotional life was in a constant state of turmoil.

Location: Tate Gallery, London.

Actual size: 36in x 27¾in (0,91½ x 0,70½)

"SAMUEL RUSSELL"

John Russell

A brother of the artist, Samuel Russell was a municipal official at Guildford, and officiated at its famous Jubilee celebration when an ox was roasted whole.

For years, the portrait was mistakenly thought to be that of a dramatist and parliamentary orator named Sheridan, but the identity confusion was eventually sorted out, and we now know the subject to be the artist's own brother, Samuel.

Location: Victoria and Albert Museum, London.

Actual size: 30in x 25in (0,76 x 0,63½)

Victoria and Albert Museum, Crown Copyright

173

"PORTRAIT OF CORNELIA CHAMBERS"
Francis Cotes

The stately beauty of Cornelia Chambers is particularly suited to the rather cool and precise technique characterizing the best works of Francis Cotes. The warm tan and rose tones used here were Cotes' favorite.

A daughter of Sir William Chambers, the subject was born in Rome, but later moved to England. She married John Milbank, son of Sir Ralf Milbank, and remained in England until her death in 1795.

Location: Ostia House, London.
Actual size: $21\frac{7}{8}$in x $17\frac{7}{8}$in ($0.55\frac{2}{3}$ x $0.45\frac{1}{2}$)
Victoria and Albert Museum, Crown Copyright

174

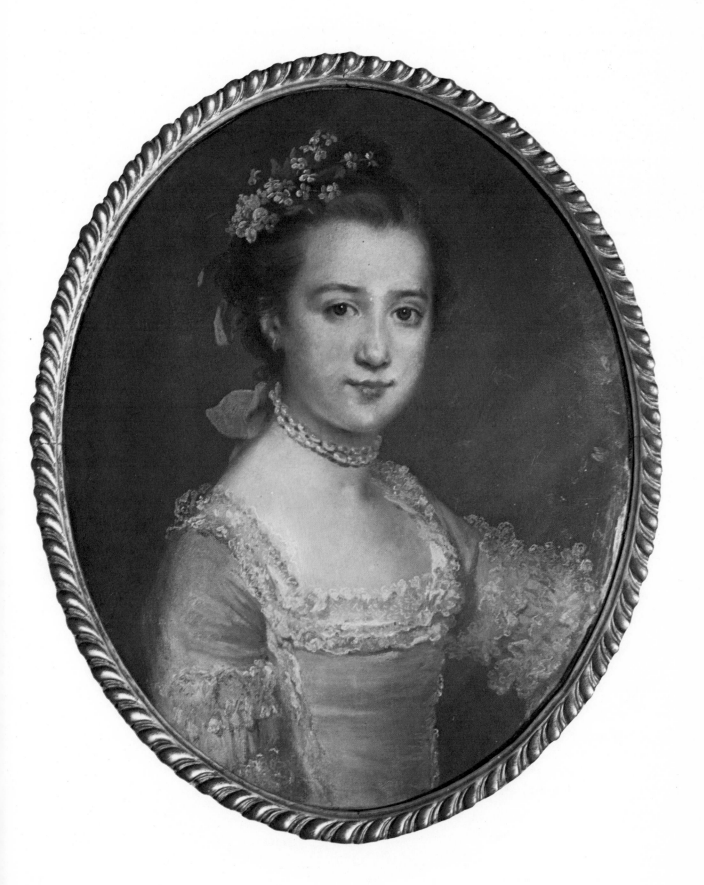

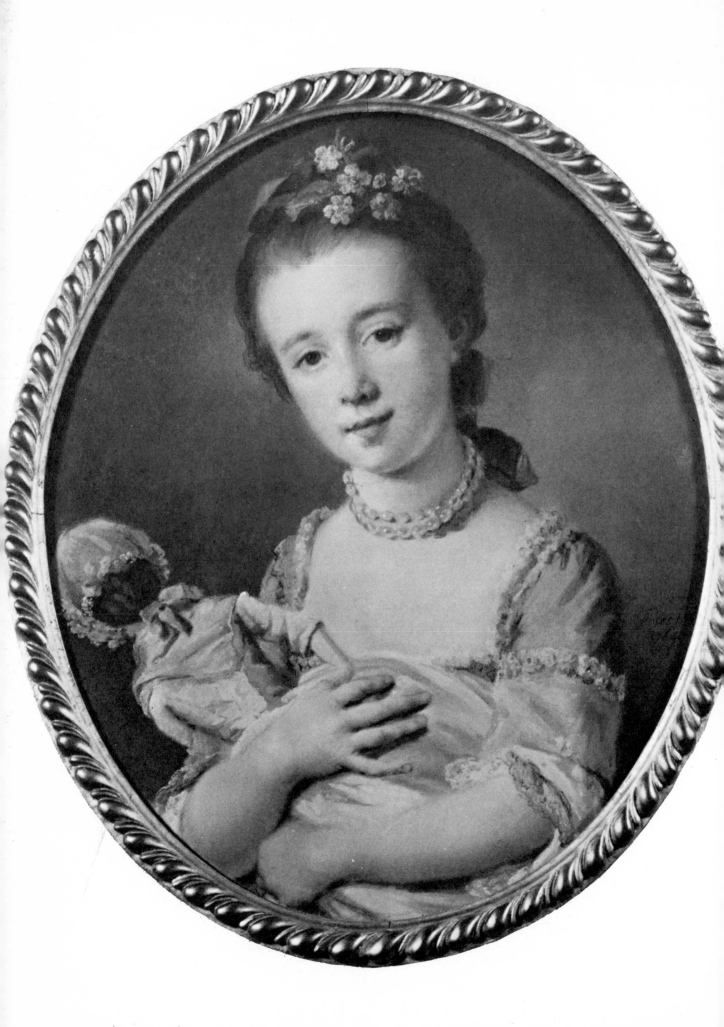

"SELINA CHAMBERS"

Francis Cotes

Here is another attractive daughter of Sir William Chambers, the brilliant architect of Somerset House. This one married William Innes of Jamaica.

The most severe criticism leveled at Cotes' work is that it creates an impression of "coldness"—on the other hand, many of his pastels have been described as "Reynolds in chalk".

Location: Ostia House, London.

Actual size: $21\frac{7}{8}$in x $18\frac{1}{8}$in ($0{,}55\frac{1}{2}$ x $0{,}46\frac{1}{4}$)

Victoria and Albert Museum, Crown Copyright

"PORTRAIT OF A LADY OF THE VAUX FAMILY"

Francis Cotes

The Vaux family of England was an old and illustrious one, boasting among its ranks, Thomas Vaux, the poet.

Cotes' pastels are rather simple in their composition, but one always finds in them an exactness of drawing and his own particular sense of color.

Location: Victoria and Albert Museum, London.

Actual size: 25in x 19in (0,65 x 0,48)

Victoria and Albert Museum, Crown Copyright

178

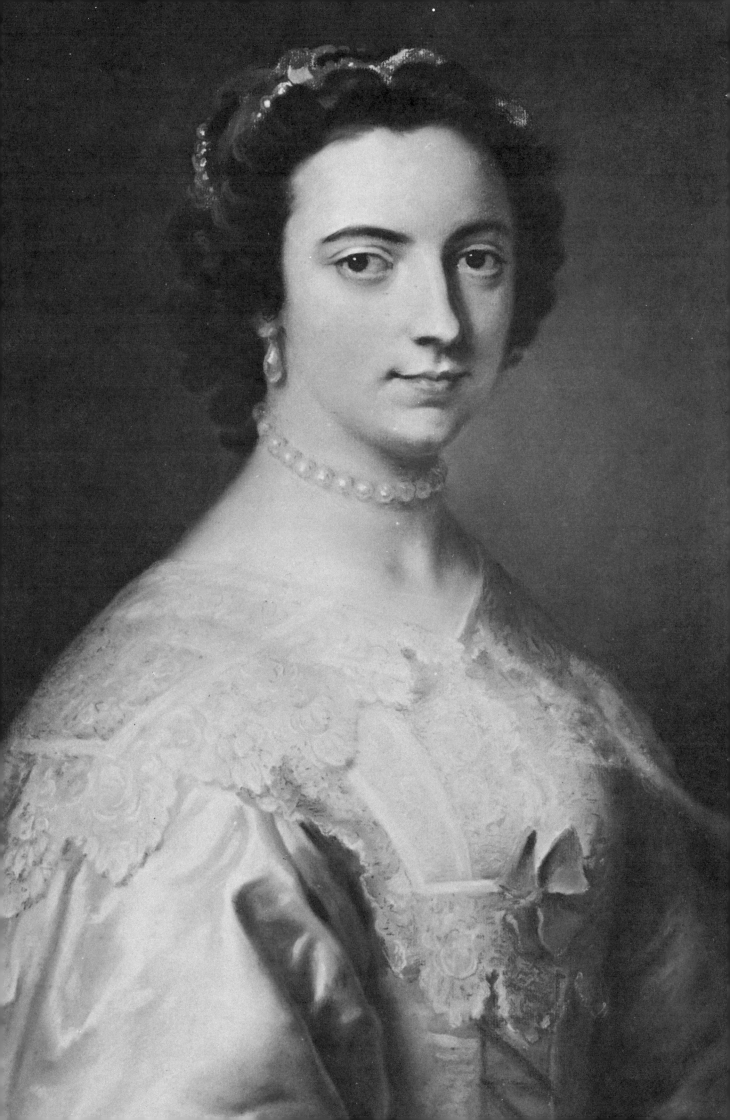

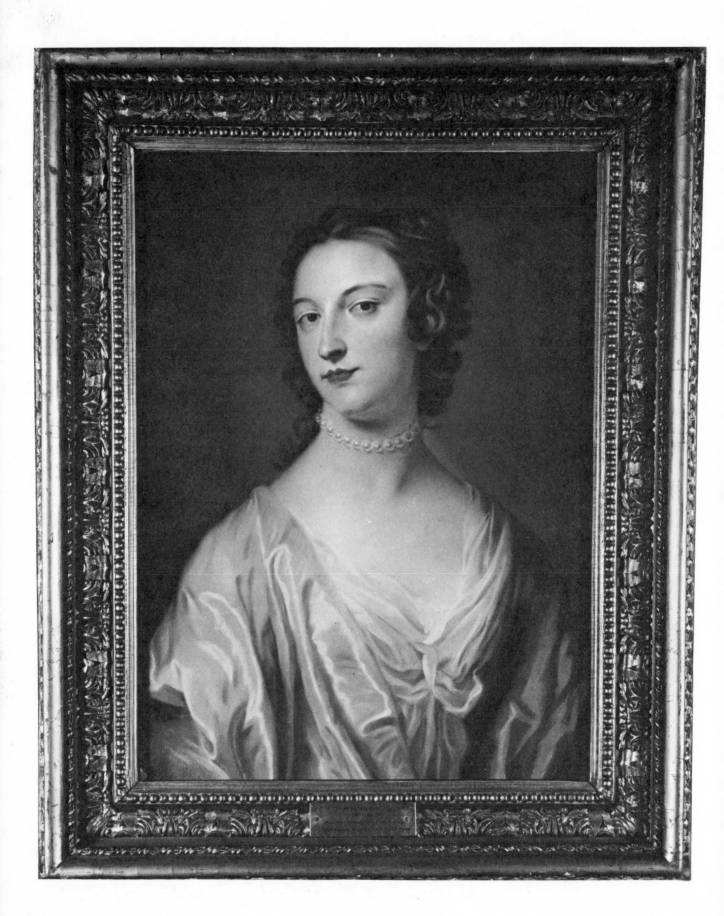

"MISS GOWER"

William Hoare

Hoare had always been a dedicated admirer of Rosalba Carriera, and one sees a strong influence of the Italian school of painting on his work.

His pastels were often criticized for their "dryness", but they surely compensated for this fault of technique by their great sensitivity and charm:

Location: Victoria and Albert Museum, London.
Actual size: 25¼in x 19in (0,64 x 0,48)
Victoria and Albert Museum, Crown Copyright

"PORTRAIT OF PRINCE HOARE AS A CHILD"
William Hoare

This delicate portrait of a little son drawn by his father contains all the gentleness of childhood for which pastels are so well adapted. The subject grew up to become a humorous writer of popular farces, his best known being "No Song for Supper". As Locke once said, "The peculiar physiogomy of the mind is most discernible in childhood". Certainly a mischievous twinkle was already evident in Prince Hoare at this early age.

 Location: Victoria and Albert Museum, London.

 Actual size: $23\frac{7}{8}$in x 18in $(0,60\frac{2}{3}$ x 0,46)

Victoria and Albert Museum, Crown Copyright

182

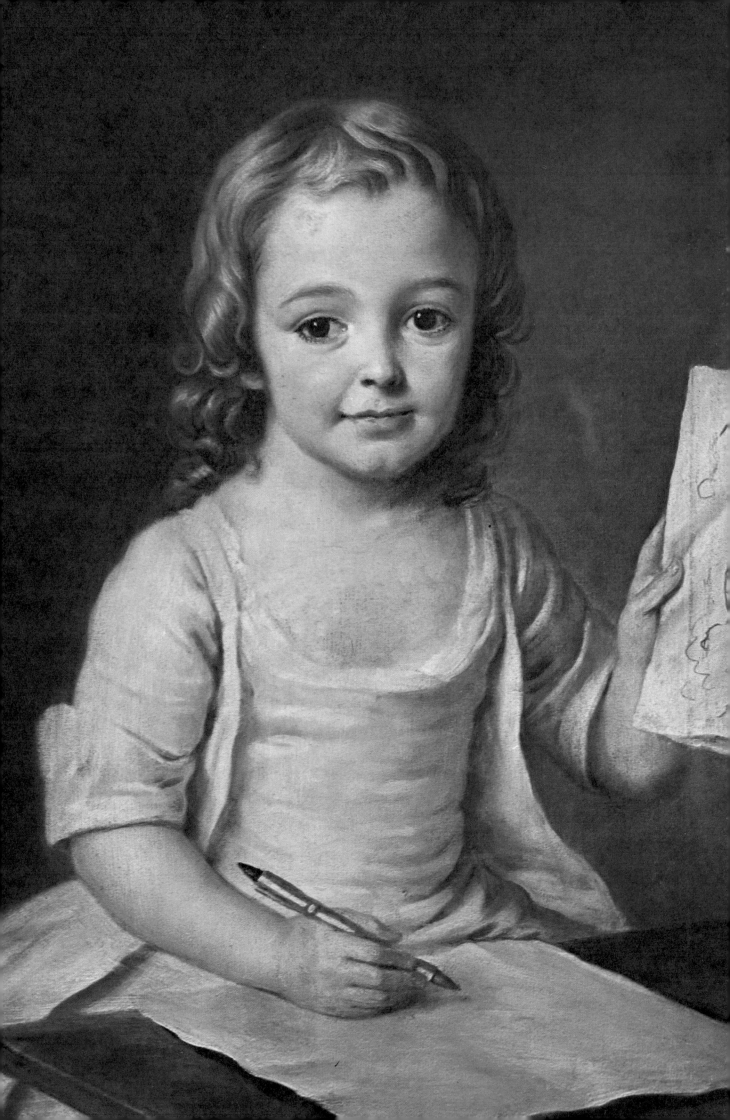

"SELF PORTRAIT"

William Hoare

Artists have always made portraits of themselves—perhaps not out of vanity, but for the sheer joy of having a subject whom they can completely control.

This excellent likeness William Hoare sketched of himself at the age of thirty-five. A beloved citizen of Bath, Hoare presented the pastel to a hospital at the fashionable watering-place, where it still hangs today.

Location: Royal National Hospital for Rhumatic Diseases, Bath.

Actual size: 30in x 25in (0,76¼ x 63½)

184

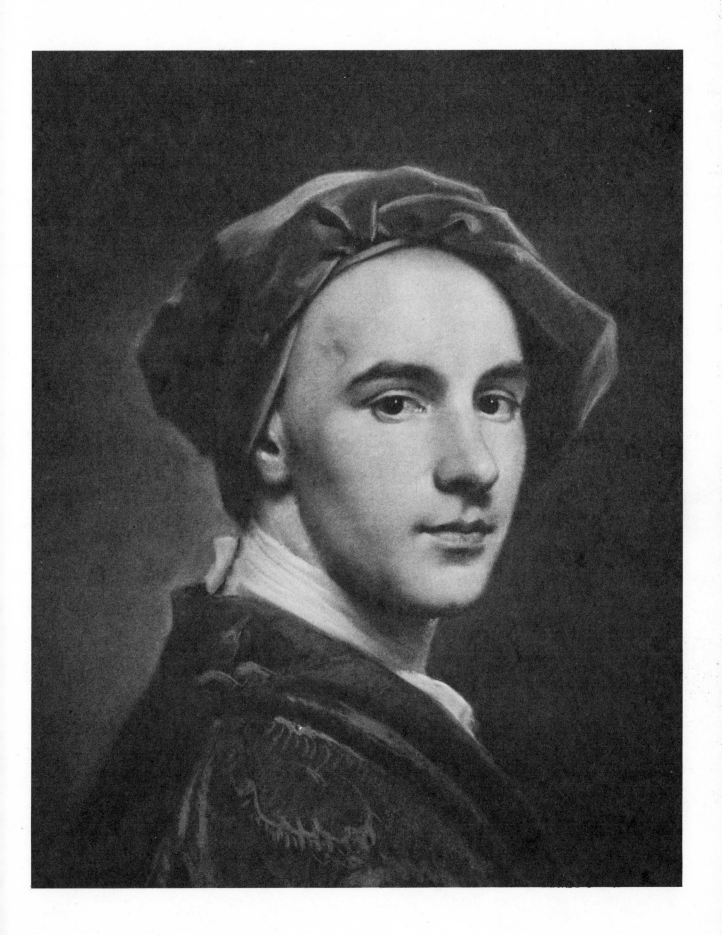

"PHILIP, EARL OF CHESTERFIELD"

William Hoare

Lord Chesterfield, the brilliant politician, diplomat and statesman, is best remembered for his canny instructions in the art of worldly wisdom, and the emphasis he placed on flawless manners.

Though deaf and blind at the end of his life, his last words were that a friend at his deathbed be given a chair to sit in.

Location: National Gallery of Ireland, Dublin.

Actual size: $24\frac{1}{8}$in x 18in ($0,61\frac{2}{5}$ x $0,45\frac{1}{4}$)

HENRY FRANKLAND, SON OF
SIR THOMAS FRANKLAND (b.1717, d.1784), ADMIRAL OF THE FLEET.
b.1734?] HUGH DOUGLAS HAMILTON [d.1808.
R.H.STEPHENSON BEQUEST. P.129-1929.

"HENRY FRANKLAND"
Hugh Douglas Hamilton

Henry Frankland was the son of Sir Thomas Frankland, Admiral of the Fleet and a handsome son, indeed.

Hamilton's pastels were usually quite small. In the beginning, he worked so rapidly and charged so little that he was literally inundated with commissions.

His portraits of men are considered his finest.

Location: Victoria and Albert Museum, London.

Actual size: 10 1/16in x 8¼in (0,25½ x 0,20½)

Victoria and Albert Museum, Crown Copyright

"THE ELLIOT FAMILY"

Daniel Gardner

Here we see Gardner at his best—with a charming quartet of women, Mrs. Samuel Elliot of Antigua and her three daughters. Characteristically, the artist has posed his subjects against a background of columns and foliage, with Mrs. Elliot, the principal woman, distinguished by an elaborate treatment of the hair. The Misses Elliot later became respectively Lady Crosby, Lady Le Despencer and Lady Erroll.

Location: Victoria and Albert Museum, London.

Actual size: $42\frac{1}{2}$in x 35in (1,08 x 0,89)

Victoria and Albert Museum, Crown Copyright

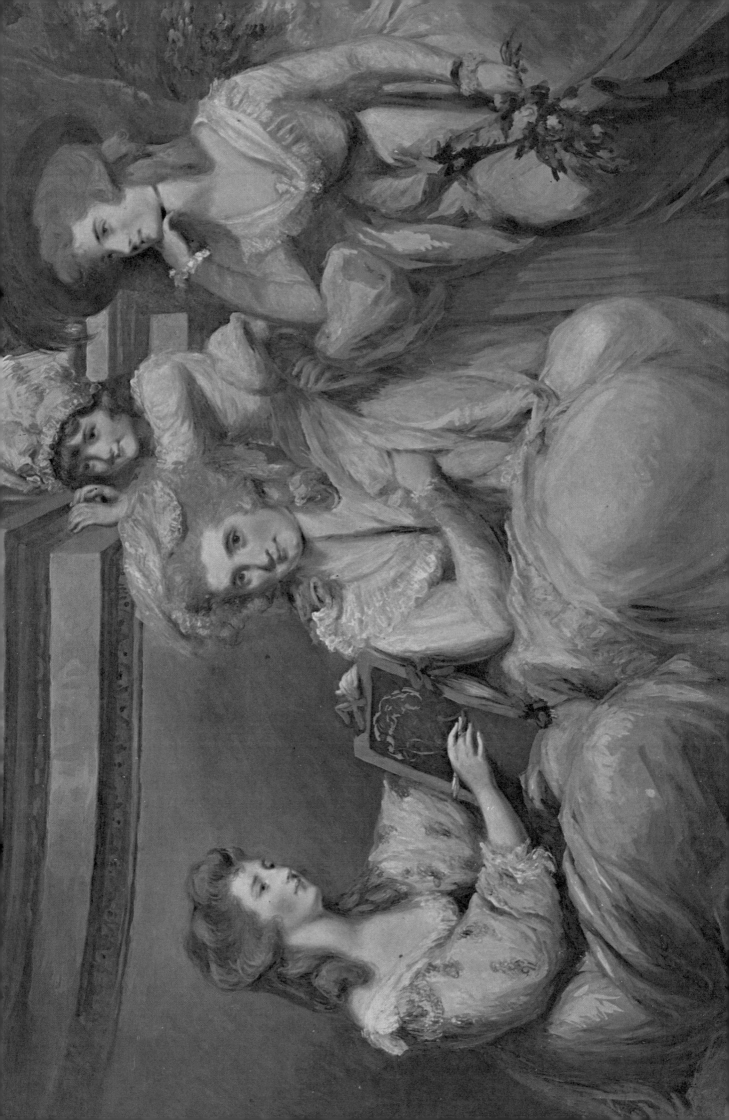

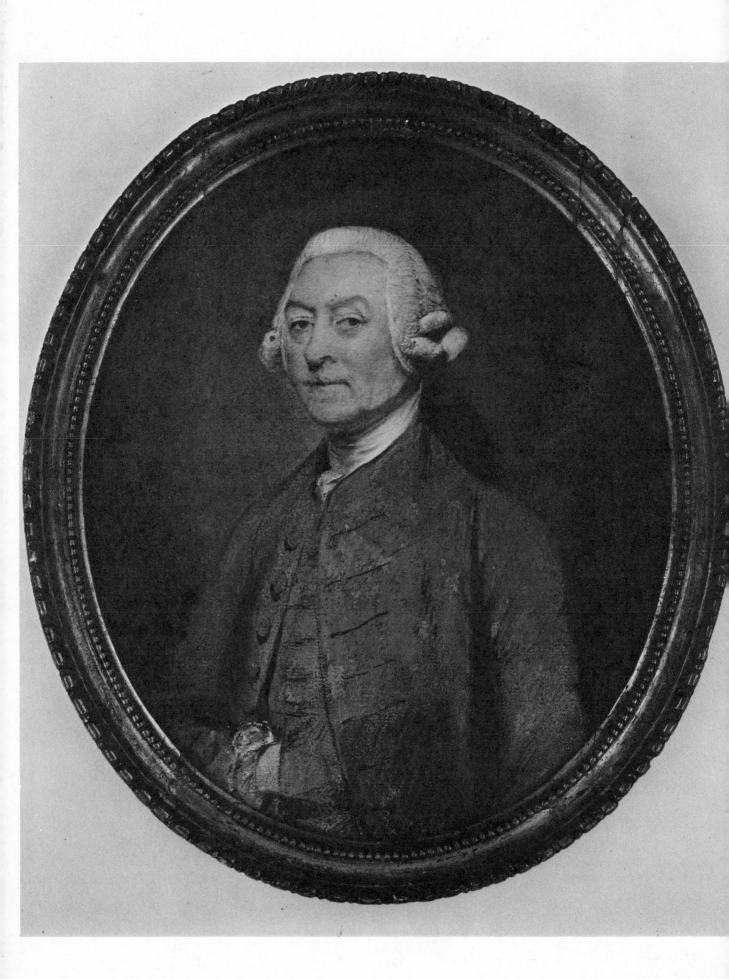

"SIR WILLIAM CARR"
Hugh Douglas Hamilton

Sir William Carr was the Baronet of Etall, Northumberland, and one of the parade of illustrious gentlemen who sat for the Irish pastellist.

Hamilton came to enjoy the patronage of the royal family, and a fashionable following ensued.

Location: Victoria and Albert Museum, London.
Actual size: 12in x 10¼in (0,30½ x 0,25¾)
Victoria and Albert Museum, Crown Copyright

"PORTRAIT OF AN UNKNOWN WOMAN"

Hugh Douglas Hamilton

A small oval, such as this, was the size and form of many of Hamilton's earlier pastels.

The artist was particularly adept at drawing the head. It was only in his "half-length" portraits that his knowledge of anatomy is shown to be uncertain.

Location: Victoria and Albert Museum, London.

Actual size: $9\frac{1}{4}$in x $7\frac{1}{2}$in ($0,23\frac{1}{8}$ x $0,19$)

Victoria and Albert Museum, Crown Copyright

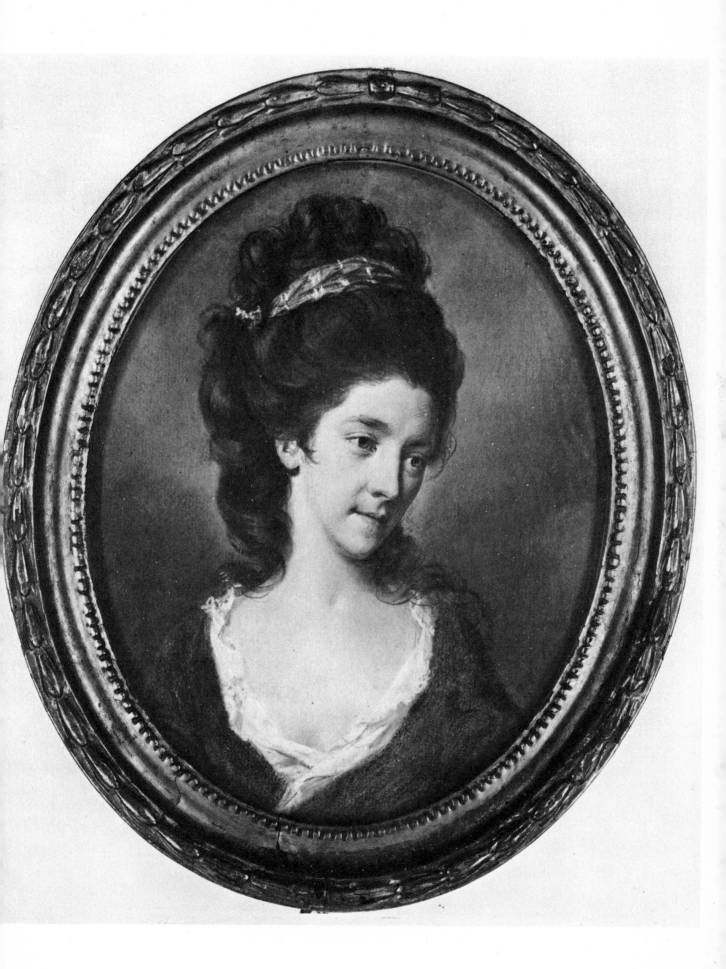

"WIFE AND CHILDREN OF JOHN MOORE, ARCHBISHOP OF CANTERBURY, 1783-1805"

Daniel Gardner

John Moore was the eminent Archbishop of Canterbury during the latter years of Daniel Gardner, and this portrait of his wife and children is just the sort of commission most suited to the artist's talents. Gardner was especially gifted at including several subjects in a single portrait, and his compositions are always pleasing and balanced.

Location: Tate Gallery, London.

Actual size: $24\frac{1}{2}$in x $33\frac{1}{2}$in ($0,62\frac{1}{4}$ x $0,85$)

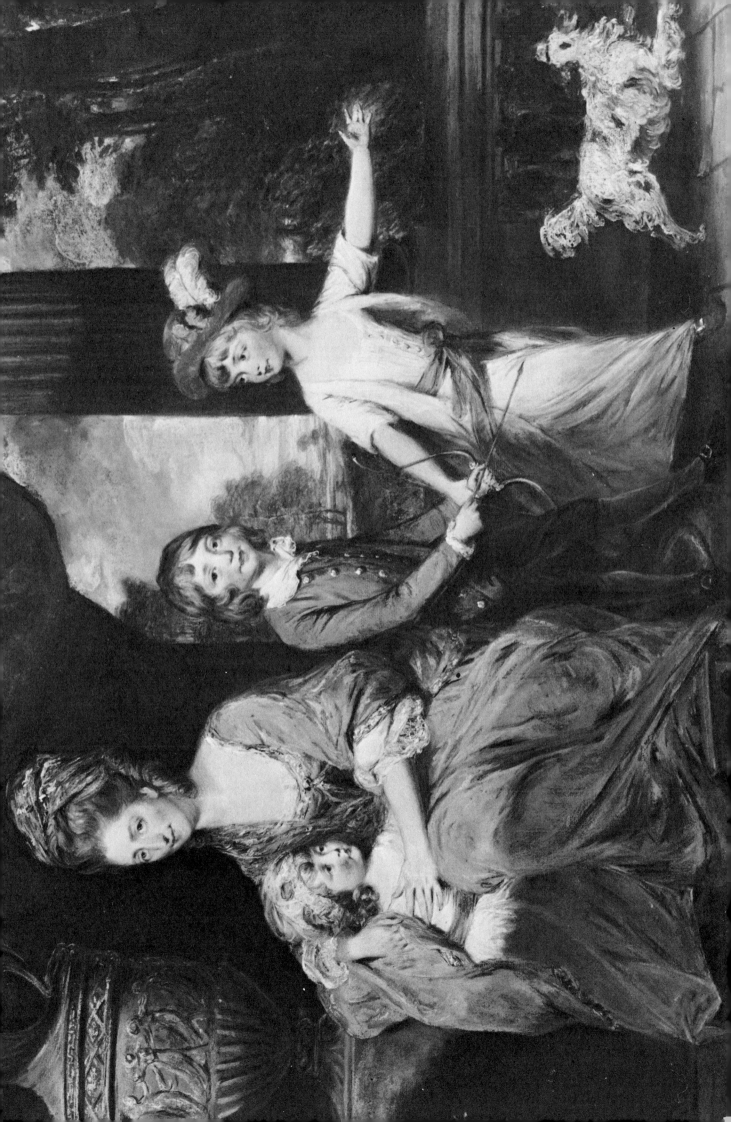

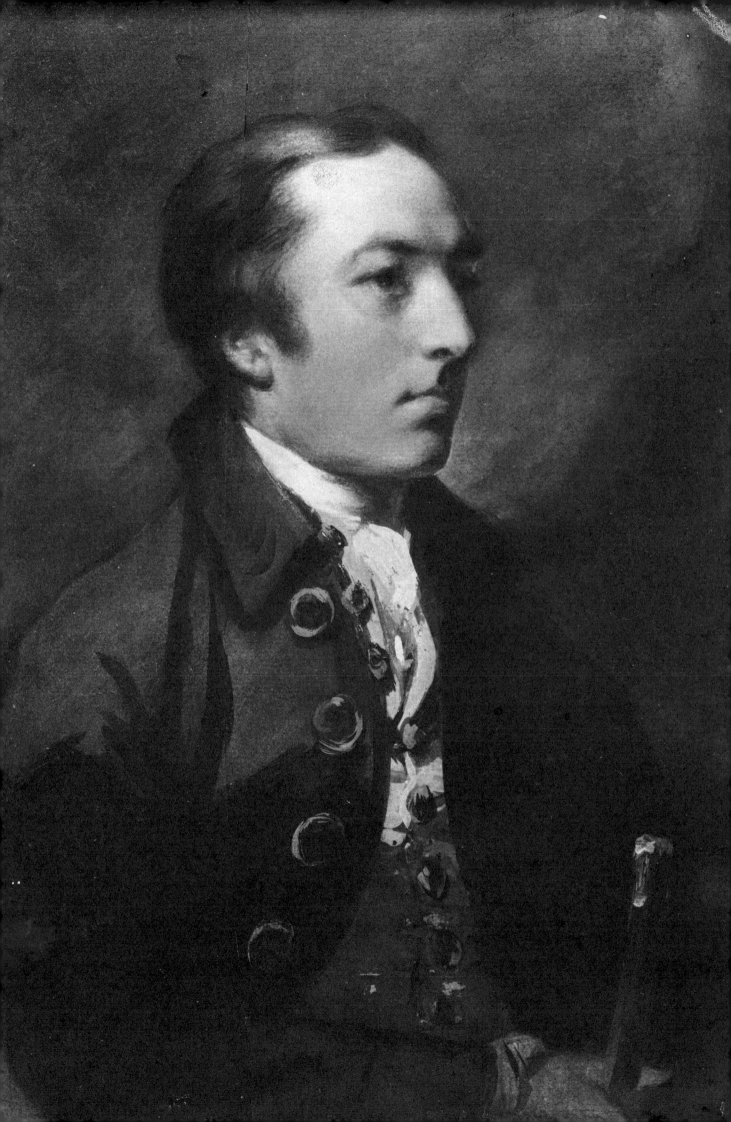

"PORTRAIT OF A GENTLEMAN"

Daniel Gardner

Here is Daniel Gardner up to his old magic again, always experimenting and trying out new methods and combinations. This time he has mounted his pastel paper on canvas.

Gardner never discussed or shared his "secrets" with anyone—and never allowed a visitor past his studio door.

Location: Victoria and Albert Museum, London.

Actual size: 14⅜in x 12⅛in (0,37½ x 0,31)

Victoria and Albert Museum, Crown Copyright

Epilogue

So these were the giants in France, England and Italy, which, of course, by no means tells the whole story. True to our promise we have only examined a few lives, thrown open a few studio doors, and attempted to catch the merest glimpse of the times in which our geniuses of the medium worked and lived.

During the nineteenth century, Europe was to witness a violent chiaroscuro of events – and the little pastel boxes were gradually put away. The quality of portraiture itself began a slow but inevitable decline, as the portraitist competed more and more with the versatile wit of the camera. Certainly the creative artist is still very much in our twentieth century world, but his imagination is now sort in other fields – propaganda, industrial design, television, cinema. To the old axiom, 'genius does what it must', might be added – where it pays the most. Who, indeed, today will take the time to trace in gaily coloured chalk the intricate patterns in hand-made lace, or the silken design on a brocade waistcoat? In parting, though, let us think back on these charming portraits of effete and exquisite delicacy and recall the words of Schopenhauer when he said: "The mother of the useful arts is necessity; that of the fine arts is luxury. – The former have intellect for their father; the latter, genius, which itself is a kind of luxury."

Index of Artists

Bibliography

Augé, Gillon, Hollier-Larousse, Moreau et Cie.
"Larousse du XXe Siècle"
Paris, 1932

Boucher, François
"An Episode in the Life of the Academie de France a Roma"
The Connoisseur, October 1961, Vol. CXL VIII

Boyer, Ferdinand
"Les Debuts du Piêntre Joseph Boze"
Gazette des Beaux Arts, September 1969

Catalogue: "Collection Maurice Quentin de La Tour"
Saint-Quentin, 1954

Gallo, Clara
"Rosalba Carriera Ovvero la Gracia del Settecento in un Galleria dei Tipe"
Arte Figurative, Anno VI, 1958 (September-October)

Goncourt, Edmund and Jules de
"French Eighteenth Century Painters"
London, 1948

Grosse, Edmund
"British Portrait Painters and Engravers"
London, 1906

"Journal de Rosalba Carriera Pendant Son Séjour a Paris en 1720 et 1721"
Paris, J. Jeckener

Kent, Rockwell
"World Famous Paintings"
New York, 1939

La Pauze, Henri
"Les Pastels de Maurice Quentin de La Tour du Musée Lécuyer a Saint Quentin"
Paris, 1919

Le Clerc, René
"Maurice Quentin de La Tour"
Saint-Quentin, Imprimerie Raspail

Lespinasse, P.
"Les Artistes Suédois en France"
Paris, 1929

Levertin, Oscar
"G. Lundberg"
Stockholm, 1902

Lundberg, Gunnar
"Allgemeines Lexikon Der Bildenden Künstler"
Leipzig, 1929

Macfall, Holdane
"The French Pastellists of the Eighteenth Century"
London, 1909

Malamani, Vittorio
"Rosalba Carriera"
Bergamo, 1910

Marconi, Sandra Moschini
"Gallerie Dell'Accademia di Venezia"
Rome, 1970

Michel, Andre
"F. Boucher"
Paris, 1912

Maze-Sencier, Alfonse
"Le Livre des Collectionneurs"
Paris, 1885

"Nouvelles Archives de L'Art Francais"
Vol. I, 1917

Ouspensky, P. D.
"In Search of the Miraculous"
London, 1950

Pignatti, Terisio
"Il Museo Correr di Venezia"
Venice, 1960

Posse, Hans
"Meisterwerke der Staatlichen Gemäldegalerie im Dresden"
Munich, 1924

Ratouis de Limay, Paul
"Le Pastel en France"
Paris, 1946 ..

Richmond, L. and Littlejohns, J.
"The Art of Painting in Pastel"
"The Technique of Pastel Painting"
London, 1931

Robert, Karl
"Le Pastel"
Paris, 1950

Rogers-Milès, L.
"Cent Pastels"
Paris, 1908

Sée de Saint Hilaire, Robert René Meyer
"English Pastels, 1750-1830"
London, 1911

Speilman, Marion
"British Portrait Painting"
London, 1910

Strickland, W. G.
"Hugh Douglas Hamilton"
London Walpole Society, Vol. II, 1913

Tiozzo, Iginio
"Celebrazione di Carlo Goldoni e
Rosalba Carriera"
Chioggia, 1941

Vaillat, Léandre
Ratouis de Limay, Paul
"Perronneau"
Paris, 1909

Williamson, George C.
"Daniel Gardner"
"John Russell, R.A."
London, 1894